LINKS

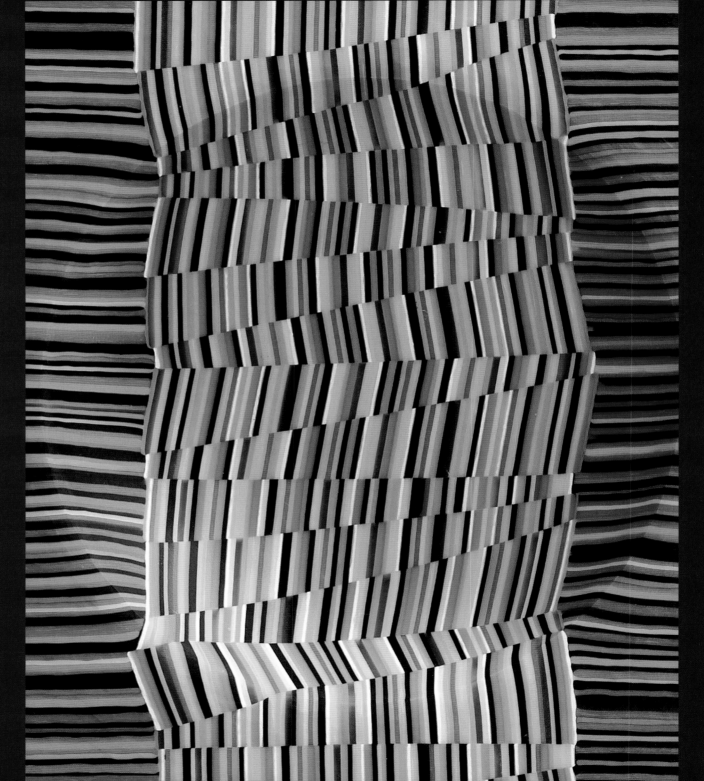

LINKS

AUSTRALIAN GLASS AND THE PACIFIC NORTHWEST

VICKI HALPER

WITH ESSAYS BY
MARGOT OSBORNE
LANI McGREGOR
GRACE COCHRANE

MUSEUM OF GLASS, TACOMA *in association with* UNIVERSITY OF WASHINGTON PRESS, SEATTLE AND LONDON

Links is published in conjunction with the exhibition of the same name, organized by and presented at Museum of Glass, Tacoma, Washington, from May 2013 through January 2014, with an exhibition tour through 2015.

Library of Congress Control Number: 2012953725
ISBN 978-0-295-99265-5

Frontispiece: Klaus Moje, *Untitled, 2003-05* (from *Impact* Series), 2003

Susan Warner, project editor, Museum of Glass
Rebecca Engelhardt, registrar, Museum of Glass

John Pierce, copyeditor
Sherry L. Smith, indexer
Adrian Kitzinger, mapmaker

Michelle Dunn Marsh, design

Pamela Canell, production management,
University of Washington Press

Printed and bound in China

Published by
University of Washington Press
P.O. Box 50096
Seattle, WA 98145-5096
www.washington.edu/uwpress

Museum of Glass
1801 Dock Street
Tacoma, WA 98402-3217
www.museumofglass.org

CONTENTS

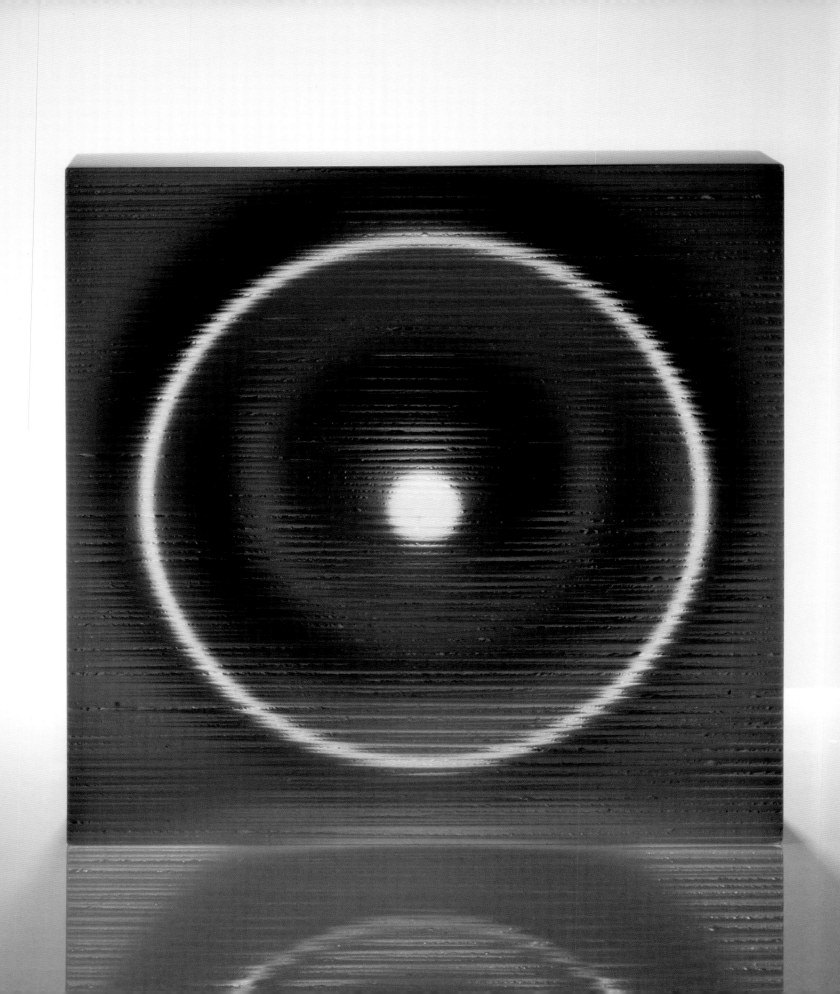

FOREWORD

SUSAN WARNER

Director and Curator, Museum of Glass

Links addresses an international glass community seen through the filter of two places, Australia and the Pacific Northwest. This focus was chosen for its richness, as it encompasses key artists, new centers of artistic production and education, and innovative technologies beginning in the 1970s. The art produced in Australia that was fostered by this context is extraordinary, and is introduced to American museum audiences for the first time here.

The exhibition was initiated when Seattle curator Vicki Halper fortuitously met Richard Whiteley, head of the Australian National University's (ANU) glass workshop, at Pilchuck Glass School in 2009. With Whiteley's instigation, Halper received a grant from Craft Australia in 2011 to tour four urban centers and learn about the region's makers. In Australia, Halper met most of the artists, collectors, curators, and writers who are participants in *Links*. A second trip in 2012 allowed her to interview artists and see additional work.

Seed money for the exhibition was provided by the ANU Canberra School of Art, from which most of the artists in *Links* graduated, and Lani McGregor and Dan Schwoerer of Bullseye Glass in Portland, Oregon. A grant from the Australia Council for the Arts ensured that the exhibition would proceed. Other contributors to *Links* are David Kaplan and Glenn Ostergaard, the Ben B. Cheney Foundation, Bullseye Glass Company, and the Robert Lehman Foundation. We are deeply grateful to them all.

The commitment of lenders who share their art and, in the process, honor the artists and the Museum, is extremely impressive. Our sincere gratitude goes to Susan Armitage, the estate of J. Michael Carroll, Cohen Collection, David Kaplan and Glenn Ostergaard, Pam Biallas, Jaycen Fletcher and Peter Reeve, Julius Friedman, Barrie and Anne Harrop, Jon and Judith Liebman, Manocherian Collection, Dante and Alison Marioni, Johanna Nitzke Marquis, Lani McGregor and Daniel Schwoerer, Christine Procter, Andy and Deidre Plummer, Lorraine Sheppard, Ruth T. Summers and Bruce W. Bowen, and Serge and Isabelle Wittock-Merenne; to our esteemed colleagues at Art Gallery of Western Australia, Perth; Canberra Museum and Gallery; Carnegie Museum of Art, Pittsburg; The Corning Museum of Glass, New York; Museum of Arts and Design, New York; National Gallery of Australia; Powerhouse Museum, Sydney; Queensland Art Gallery; to Bullseye Gallery, Portland; Foster/White Gallery, Seattle; Jane Sauer Gallery, Sante Fe; Palette

Contemporary Art and Craft, Albuquerque; and Traver Gallery, Seattle.

Peta Mount was our accomplished researcher and interviewer in Australia. Grace Cochrane, the remarkable chronicler of Australian craft history, was our advisor. No one knows more than Grace, although Lani McGregor of Bullseye Glass may be her match in speed and organization. Margot Osborne's book *Australian Glass Today* introduced us to artists. We are extremely fortunate to have had all of them intimately involved with *Links*.

Artists have been incredibly gracious about the demands of a major exhibition—suggesting work, granting interviews, confirming dates. In particular we thank Richard Whiteley for his advocacy and advice. Klaus Moje, Nick Mount, Dick Marquis, Dante Marioni—without you, there wouldn't be this set of *Links*.

My thanks and appreciation go out to the Museum of Glass Curatorial, Hot Shop, and Education Teams: Rebecca Engelhardt, Lynette Martin, Katie Phelps, Benjamin Cobb, Gabe Feenan, Niko Dimitrijevic, Sarah Gilbert, and Rebecca Jones. Special thanks to Ruth King, artistic director of Pilchuck Glass School

Finally, I would like to express my gratitude to University of Washington Press for continuing our ongoing collaboration.

Richard Whiteley, *Light Mass*, 2011 (cat. 93)

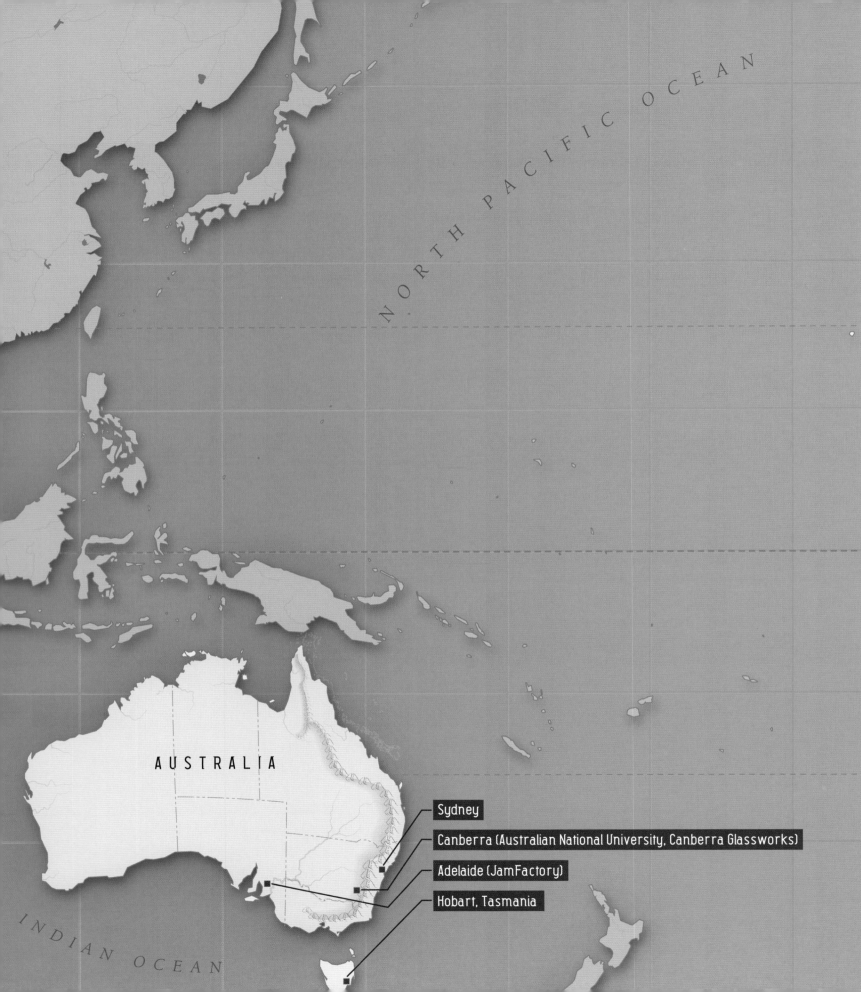

NORTH PACIFIC OCEAN

AUSTRALIA

Sydney

Canberra (Australian National University, Canberra Glassworks)

Adelaide (JamFactory)

Hobart, Tasmania

INDIAN OCEAN

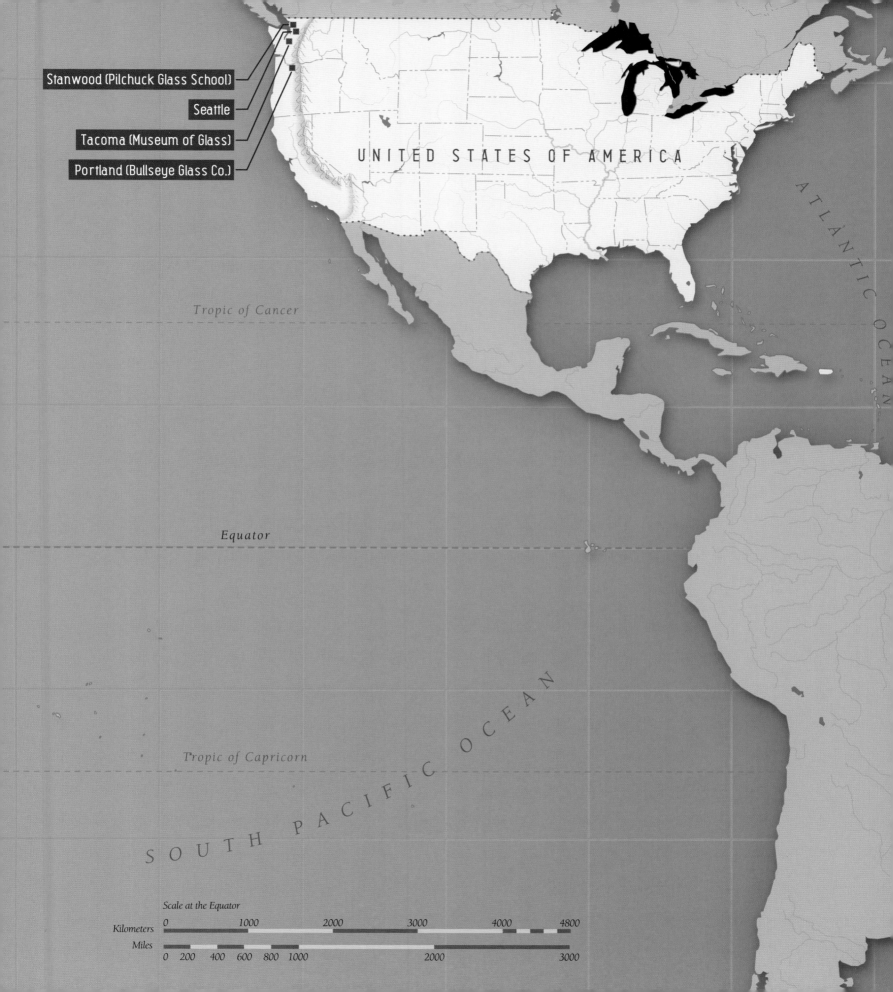

Stanwood (Pilchuck Glass School)

Seattle

Tacoma (Museum of Glass)

Portland (Bullseye Glass Co.)

UNITED STATES OF AMERICA

Tropic of Cancer

ATLANTIC OCEAN

Equator

Tropic of Capricorn

SOUTH PACIFIC OCEAN

Scale at the Equator

Kilometers 0 1000 2000 3000 4000 4800

Miles 0 200 400 600 800 1000 2000 3000

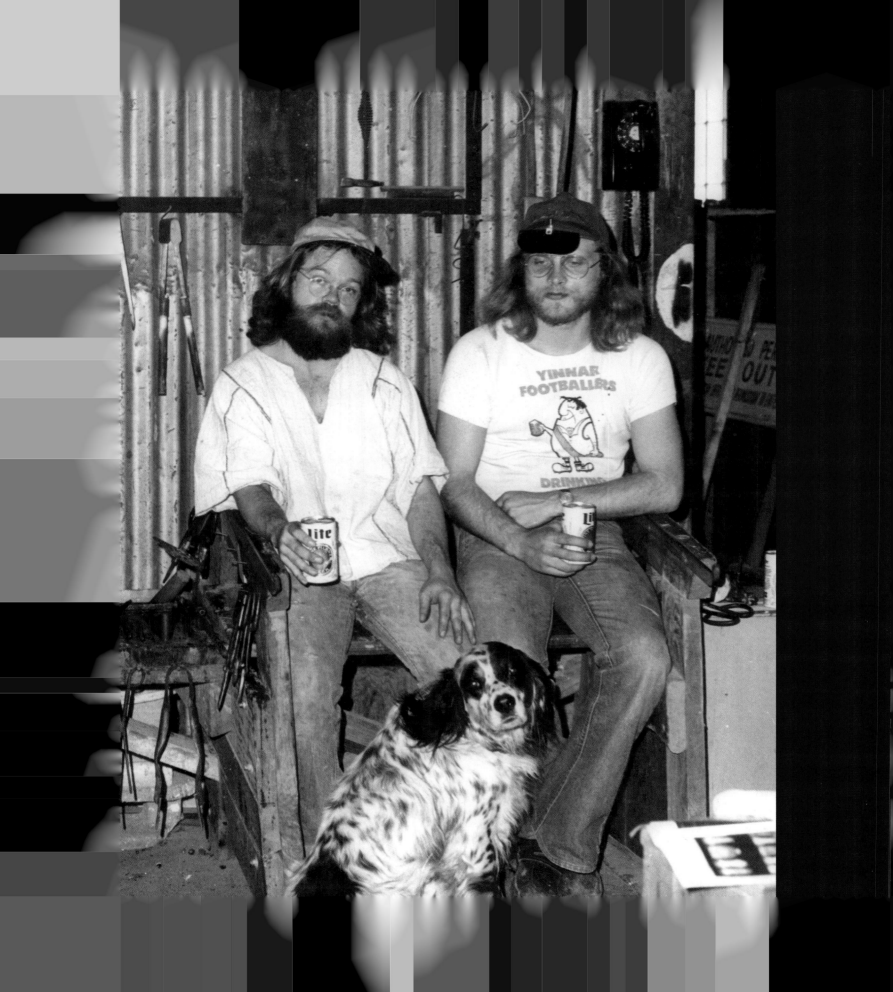

ALL IN THE FAMILY: TRANSPACIFIC HOT GLASS

VICKI HALPER

NICK AND DICK

It's 1974. The Vietnam War is coming to an end. The culture of the Summer of Love, 1967, a San Francisco Bay Area celebration of flower children, drugs, and sexual liberation, is coming face to face with feminism. It is the heyday of studio crafts, a field associated with individual freedom and economic independence that blossomed in reaction to mid-century wars and corporate conformity. The Studio Glass movement, generally considered to have started in Toledo, Ohio, in 1962, is in its preteen years. Pilchuck Glass School is a three-year-old toddler. A lot of energetic, misshapen glass bubbles are still being blown. Americans like to quote glass pioneer Harvey Littleton's 1972 dictum, "Technique is cheap."

In this period two Americans traveled to Venini Fabrica in Venice to learn glass-blowing practices that had formerly been tightly guarded by the Italians—Dale Chihuly in 1968 and Richard (Dick) Marquis, fresh from the University of California at Berkeley, a year later. Chihuly acted as a designer at Venini, with factory workers producing his pieces. In the process he learned about teamwork, an essential component of traditional glassblowing that those in the nascent Studio Glass movement mistakenly thought they could abandon. Marquis, in contrast, worked on the floor with the Italian glassblowers, who wondered why he wasn't upstairs making drawings and flirting with the secretaries.[1] In 1974, when Dick was invited by the Australian government to lecture, demonstrate, and build glass studios there, he was, thanks in part to his Venetian sojourn, among the most skillful Americans working in the medium—master and master teacher of the murrine technique, and a glass artist with an intensity, humor, and conceptual breadth that was unexcelled. He embarked from his home base in Berkeley (Marquis moved permanently to the Seattle area in 1983) with his girlfriend Rafaella (Raffi) Del Bourgo and a few tools. They arrived to a press conference, radio talk show, and TV interview.[2]

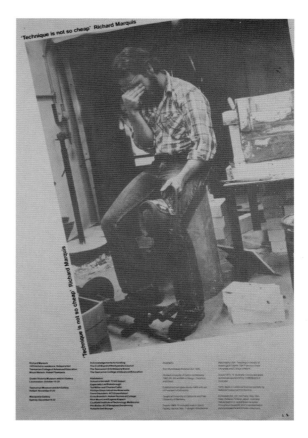

Australian poster for the exhibition *Technique is not so cheap, Richard Marquis*, 1976.

OPPOSITE: Richard Marquis (left) and Nick Mount in Marquis's studio, Benicia, California, 1975.

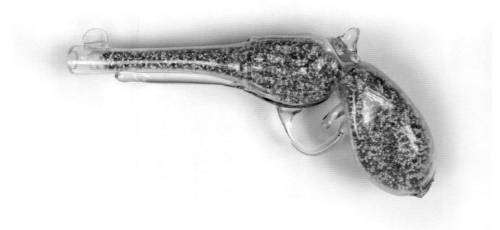

Richard Marquis, *Pistol*, 1976.

OPPOSITE: Richard Marquis, *Crazy Quilt Coffeepot*, made in Australia, 1974 (cat. 53)

Marquis did not introduce blown glass to Australia, although he is widely considered to have been the most adept and subtle practitioner yet seen in the country. In his assessment, "dip and drip" was the dominant glassblowing mode of the few Australians and foreigners working there.[3] Dick inherited a mobile glass studio decorated with crossed American and Australian flags, which he used mainly in Tasmania (page 142). It had been built by Crown Corning for an American predecessor, Bill Boysen, a freeform glassblower then teaching at Southern Illinois University, whose tour of New South Wales briefly overlapped with Dick's visit. The invitations to Americans were part of a top-down strategy by the Australian government to encourage crafts. Marea Gazzard, chair of the Crafts Board at the time, wrote in support of the "artistic potential" of glass: "Glass blowing is still a largely unexplored art form in Australia and therefore one that the Crafts Board of the Australian Council [for the arts] wants to encourage."[4]

When Marquis arrived in Melbourne he found almost none of the supplies he'd asked his hosts to collect. Del Bourgo wrote a June 20 journal entry citing "a long and disappointing week with mechanical mishaps." On June 21, "Dick finally demonstrated today. . . . Extra stressful with TV cameras running." At the Gippsland Institute of Advanced Education (eventually part of Monash University), a free-wheeling new art school without strict academic requirements, Dick and Raffi met Nick Mount and his wife, Pauline. In what turned out to be a comical understatement, Raffi wrote that Nick "looks like he might be helpful to Dick."

Mount, who had never blown glass, was a superior handyman originally valued by Dick for his welding skills. He blew a lovely glass cup the first time he picked up a blowpipe, then threw it away, unimpressed with his own natural skill.[5] Mount quickly replaced Raffi, a weaver with no glass training, as Dick's primary assistant, and with Pauline joined Dick and Raffi for the tour. Raffi wrote that Nick had at first seemed like an art student who hadn't found his path. On August 19 she asserted, "I think he has now found it." Nick has since become a major figure in the Australian glass community and the 2012 Living Treasure of Australian crafts.[6]

Marquis and entourage built about six hot shops, assembling kilns he designed and cast from refractory material. The shops were associated with technical schools in the Melbourne area, Perth, and Hobart. In 1976 Marquis returned to Hobart, his favorite locale, for a year's residency, with the continued support of Les Blakebrough, head of the ceramics department at the Tasmanian College of Advanced Education and the 2005 Living Treasure in ceramics (page 131).

In Tasmania Dick felt free to experiment with his wide-ranging aesthetic interests, particularly his delight in found bric-a-brac. He

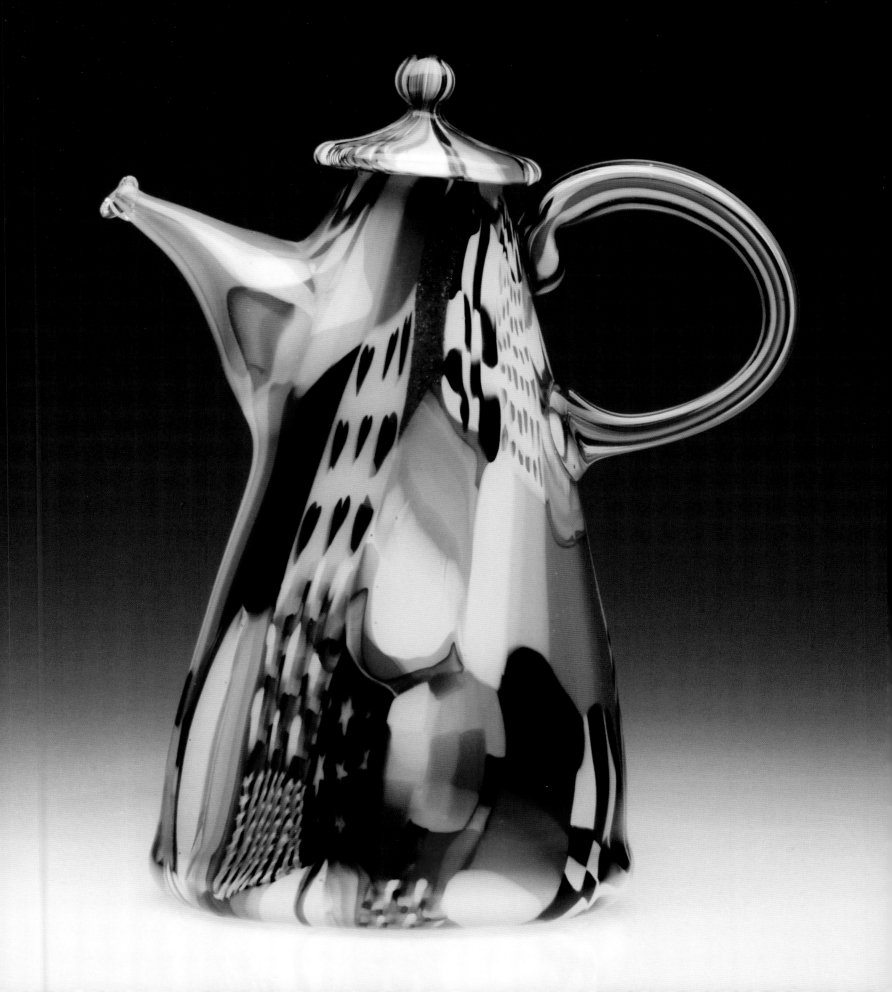

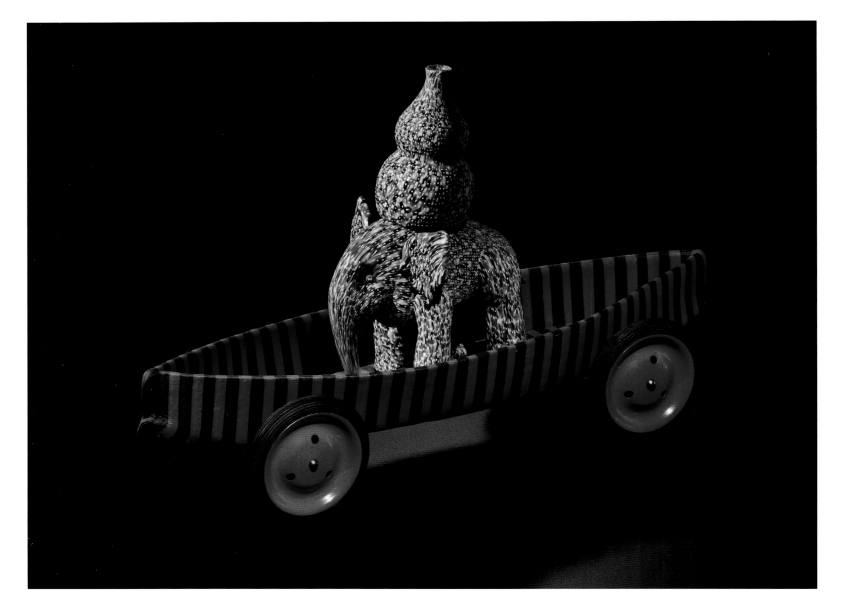

Richard Marquis, *Elephant in Boat on Wheels*, 2004–2009 (cat. 56)

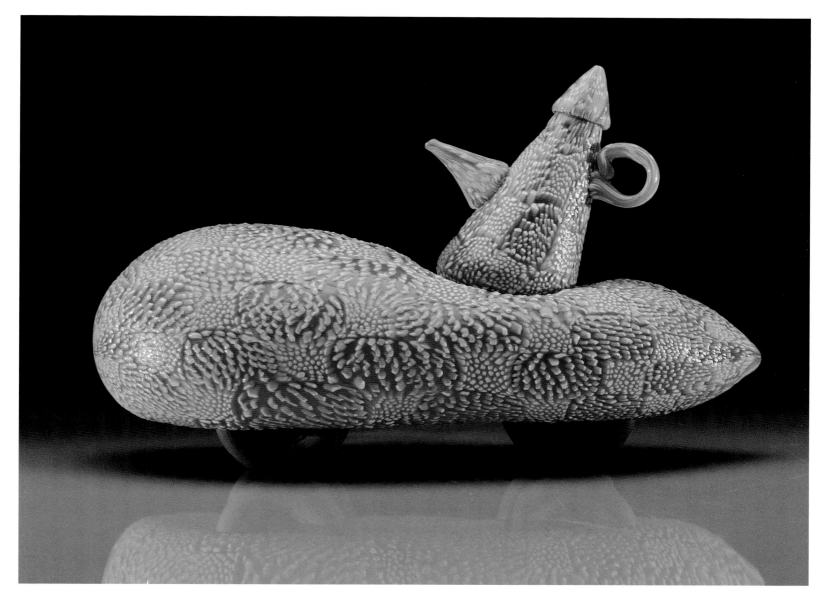

Richard Marquis, *Teapot Cartoon Car*, 2009 (cat. 58)

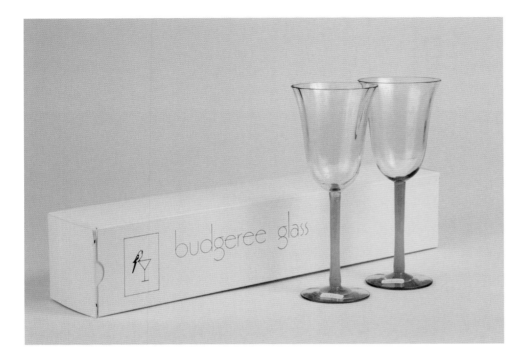

Nick Mount, Budgeree glass goblets, production line, 1980s.

OPPOSITE: Nick Mount, *Scent Bottle #060907*, 2007 (cat. 77)

made a glass gun and filled it with candies in emulation of 1940s toys that spill tiny treats directly from the barrel into a child's mouth (see page 12). He also continued what would be a lifelong engagement with murrine.

NICK IN AUSTRALIA

At the end of Marquis's first Australian trip, Nick Mount received a grant to visit the States. In 1975 he arrived in Berkeley with Pauline, and began intensive work with Dick and other glassblowers, for whom he was well-appreciated free labor. When Nick returned to Australia, he brought with him a model for the glass community he wanted to create based on Dick's influence and the example of the California glassblowers: the community would freely share techniques and equipment—no secrets or territoriality as was the norm in, say, the early Jam Factory; the community would be self-supporting through production glass-work; and the community would be self-sustaining through the training of students and apprentices in glassblowing techniques.

By the time Mount returned to California in 1980 to work with Marquis for six months, he had been exhibiting his work for three years and had established one of the first private glass studios in Australia, eventually called Budgeree Glass. By 1988 Budgeree had relocated to a large factory space in Port Adelaide. With as many as fifteen employees, it had become a small manufacturer with limited runs of production ware, and a training grounds for Australian glassblowers. In 1991 Budgeree closed after its principal backer went bankrupt. Mount, who saw himself as a worker and mentor, not an artist, felt obligated to

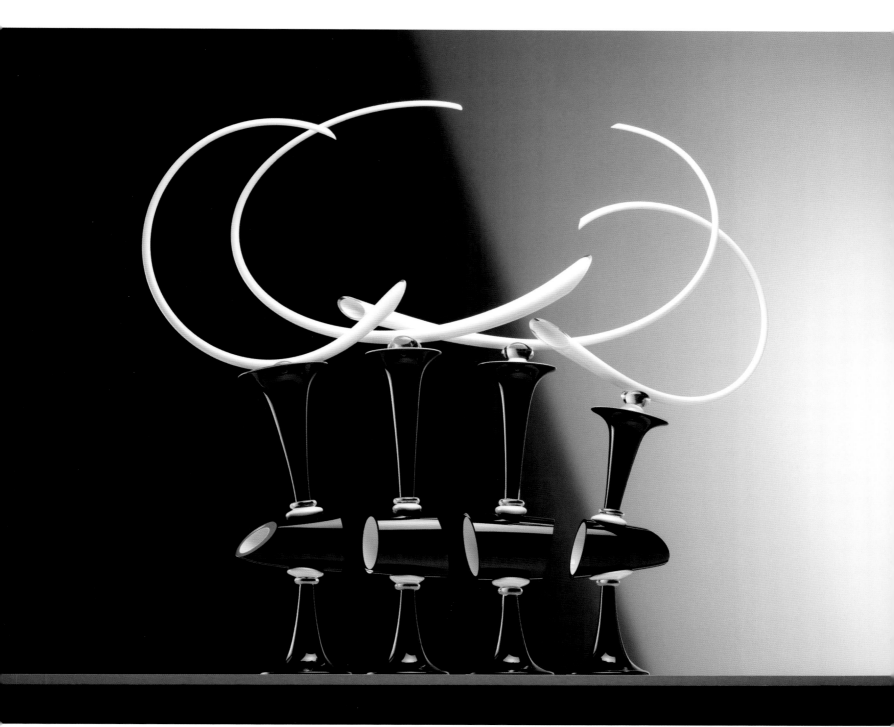

reestablish a private glass studio out of necessity rather than desire.

Mount's appointment as head of the glass studio at Adelaide's JamFactory (commonly called "the Jam") from 1994 to 1997 reignited his entrepreneurial spirit. Margot Osborne summarized his activities there:

> [Mount] *fosters cooperative teamwork approach to glass production; undertakes high volume of studio commissions; encourages use of facilities on an access [rental] basis for professional glass artists; international glass artists Lino Tagliapietra, Dante Marioni, and Richard Marquis invited for workshops.*[7]

The influence of Mount on the Adelaide glass community cannot be overestimated. Technical finesse and business acumen were gained by the hot-glass makers as he gave the Jam's glass program coherence and stature. Camaraderie in the glass community was his legacy to all. As a member of Pilchuck's International Council since 2000, and its current cochair, Mount's influence is transcontinental.

Nick's more recent studio practice is sculptural rather than centered on commissions and

Nick Mount, *Cylinders and Funnels*, 1980 (cat. 74)

production work, although the memory of function remains. His scent bottles, often glued together from mix-and-match parts, are flamboyant testimonials to Venetian technique on a mammoth scale. The romance of a perfumed wand applied to a neck becomes the robust, even sexual, intimacy of stopper and flask. His multipart bottles (p. 17) are like a chorus line, with his former flashy colors now yielding to extravagant gestures. Mount notes that "the title *Scent Bottle* refers to the small and precious vessels that have been made throughout the history of blown glass and also my belief that a finely handcrafted work will always carry the scent of the maker."[8]

DANTE

Dante Marioni's father, Paul Marioni, was a significant figure in the early Studio Glass movement in California, and he has been an important part of the Seattle art community since 1979. Dante, born in 1964, started blowing glass as a teenager. As a twenty-three year old who had already learned Venetian glassblowing from the Italian grandmaster, Lino

Nick Mount, *Scent Bottle*, 1998 (cat. 76)

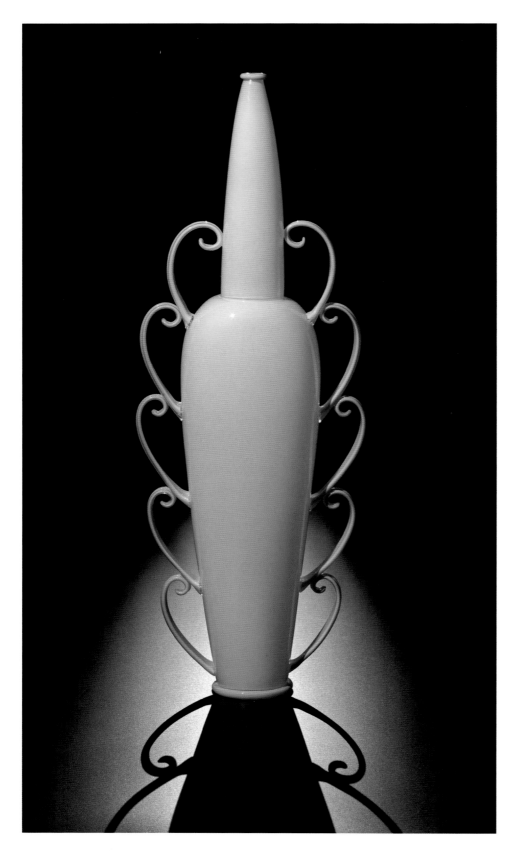

Tagliapietra, Dante worked for Marquis at Noble Effort, Dick's Northwest production studio. Dante was particular—possibly dogmatic—about the techniques of Venetian cane working that he had learned. Marquis good-naturedly made up T-shirts for his crew that asked, "Are you sure Lino done it this way?"

In 1984 the Australian glass artist Tony Hanning, a partner at Mount's Budgeree Glass, spent six months working with Paul Marioni in Seattle. When Dante first visited Australia two years later, Hanning was his host. Klaus Moje brought his class from the Canberra School of Art (later part of the Australian National University, or ANU) when Dante demonstrated glassblowing at Monash University in Melbourne. ANU was just building its hot shop, and Klaus asked Dante to visit the following year. In 1987 Dante was one of the first people to inaugurate that facility.

Marioni has visited Australia about ten times since then. Artists in *Links* frequently cite his 1994 workshops with Dick Marquis at JamFactory and ANU, which Nick Mount had

Dante Marioni, *Vessel with Ten Handles (Homage to Martinuzzi)*, 2001 (cat. 52)

OPPOSITE: Richard Marquis and Dante Marioni, *Three Goblets*, made in Australia, 1994 (cat. 60–62)

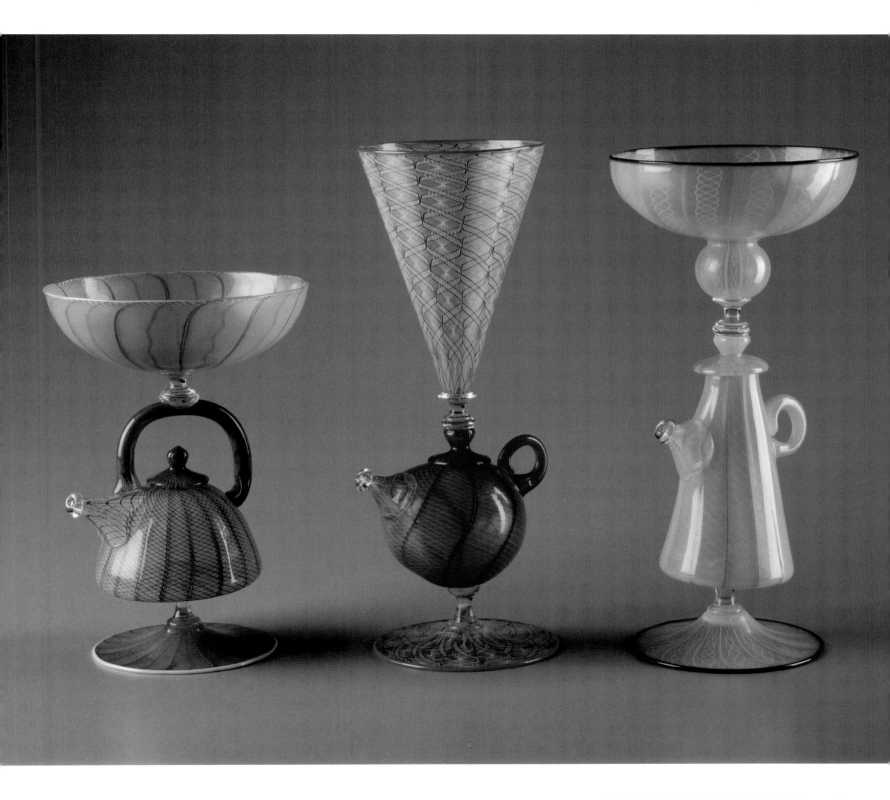

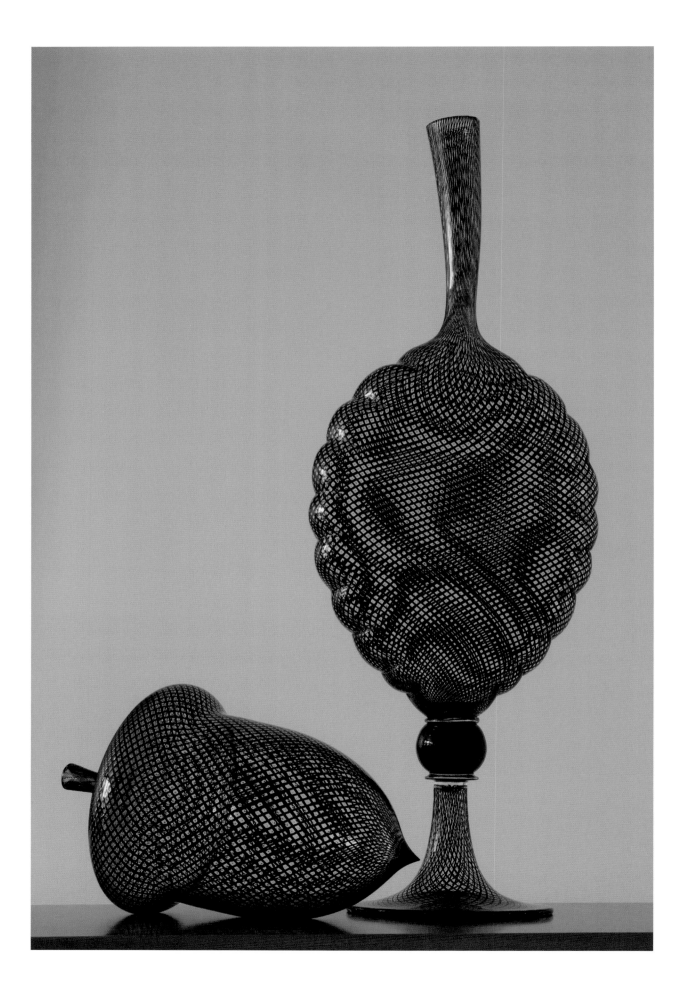

initiated in celebration of the twentieth anniversary of Dick's first visit to Australia. Dick and Dante blew their signature teapot goblets (page 21) before audiences in which artists such as Clare Belfrage were amazed. Others didn't yet appreciate what they were seeing, as the ease with which the Americans worked seemed to belie the complexity of their accomplishments. Since Dick's visit in 1974, he and Dante were still "the two best glassblowers to visit Australia."[9]

The scale and control of Dante's work continues to amaze. His *Vessel with Ten Handles* (page 20), an homage to the squatter ten-handled vases of Venetian master Napoleone Martinuzzi (1892–1977), has the opacity and quirkiness of color that has attracted so many Australian blowers. With *Oak Leaf and Acorn,* he could be recalling a huge, nineteenth-century Venetian covered goblet, with the oak leaf as its stem and the reclining nut as its toppled covered bowl.

JAMFACTORY AND UNIVERSITY

Mount has always reveled in his identification as a working stiff. For him, the line between factory and studio is porous. Budgeree and JamFactory are his natural environments—glassblowing is a group activity in which the notion of craft apprenticeship still holds weight, the ability to attract and negotiate with clients is a necessary social skill, and the notion of craft in the service of function or ceremony is embraced. Nick's work, aided by the managerial skills of Pauline, sustains a family and home. Having sufficient income to support these has been intrinsic to his glassmaking choices, not simply the oppressive distraction cited by many artists. Hot-glass artists are more likely to embrace this model than kiln workers.

Jessica Loughlin says that blown glass and kiln-worked glass may as well be two different mediums.[10] It's not just the costs of furnaces and fuel paid by blowers that make shared hot shops so prevalent. It's not just the huge outlay of time needed to perfect and maintain blowing techniques, one reason why so many in hot glass continue to hone their skills with

Dante Marioni, *Oak Leaf and Acorn*, 2012 (cat. 51)

production work. Those who use kilns rather than furnaces to heat their glass are able to work alone.

The Glass Workshop at the ANU, originally headed by Klaus Moje (Marquis turned down an invitation to apply for the position), has been particularly notable for the development of kiln-formed glass as a medium for art (see Margot Osborne's essay, following). The career goals for graduates in kiln working are generally artistic growth, gallery exhibitions and sales, and an academic career, if necessary. No production work, few or no commissions. The career paths for glassblowers, even from ANU, are generally more varied and usually include production work, at least early in makers' careers. Production work is often seen as essential to develop skills. It also provides an economic cushion for the high costs of running hot shop furnaces. Those who manipulate blown glass when it is cold even manage to work alone for most of the time, since others blow the glass forms that they inscribe.

In the Venetian-centric Northwest community, a blown piece is essentially finished after annealing. Australian Tom Rowney, for example, works this way (page 47). Once the piece has cooled, a bit of grinding of the base is necessary to remove the evidence of the punty

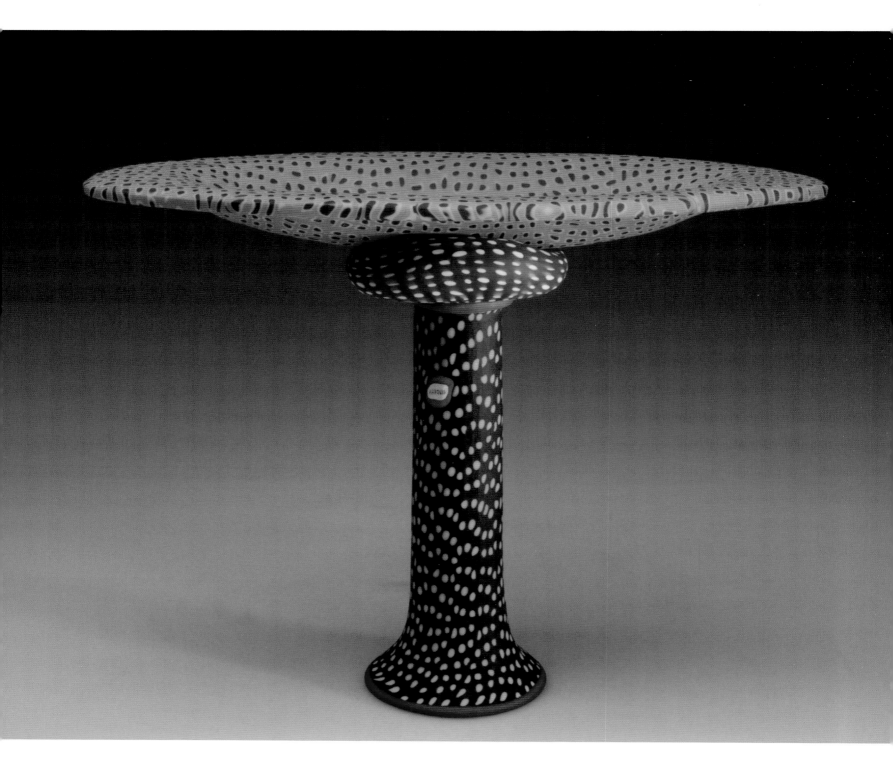

(rod) that once held the hot glass. It is considered a chore. When Carlo Scarpa introduced various cutting techniques to the Venetian vocabulary in about 1940, "traditional masters in Murano must have perceived them as an absolute provocation."[11] Scarpa's techniques have been central to some of Marquis's and Tagliapietra's work from the 1990s, but they are still rare among American glassblowers.

At ANU, where most of the artists in *Links* were trained, the object that emerges from the furnace and then cooled is the beginning, not the end, of the process. Klaus Moje and his successors Stephen Procter and Richard Whiteley agree on this. For them cold working—grinding, carving, etching, engraving, sanding—is essential to modulate the light that emanates from glass, not just to clean up debris. It is a process that is done alone, usually with a grinding wheel. These modifications, exemplified in the work of Procter, Mel Douglas, Ben Edols and Kathy Elliott, and Tim Edwards (who learned cold working from Kathy in 1998) mute a shiny surface. The process for them is considered meditative rather than tedious.

PILCHUCK, THE FUNNEL

Pilchuck Glass School, located north of Seattle, works on a condensed time schedule. This contrasts with both JamFactory, where glassblowers share a facility for years at a time, and ANU, where students are broadly educated for a prolonged stretch of their young lives. Outsiders like Marquis and Marioni show up at those institutions for short workshops, mainly demonstrating their techniques. For Australians living on a distant island continent, this is not enough international exposure. Just as Moje, for example, wanted his glassblowing students to spend time at the Jam after graduation in order to hone their skills, he

Klaus Moje and Scott Chaseling at Pilchuck's "Full Bull[seye]" session, 2000.

OPPOSITE: Richard Marquis, *Marquiscarpa # 29*, 1991 (cat.55)

promoted scholarships for his students to travel to Pilchuck Glass School in order to be exposed to international artists and varying techniques in an intensely focused manner.

Pilchuck is arguably the premiere program of its kind in the world, a Mecca for professionals and amateurs alike in all areas of glass technique. It was founded by Dale Chihuly and patrons John Hauberg and Anne Gould Hauberg in 1971, and focused on hot glass for most of the early years. Moje calls it "the funnel" through which makers from around the world come together, learn new techniques, and produce a stream of invigorated art.[12] Klaus was first at Pilchuck in 1979, and he has been there at least eleven summers since as both instructor and artist-in-residence.

For many artists in *Links,* the connection to Pilchuck is their strongest tie to the Pacific Northwest. At least eighteen of them have attended Pilchuck sessions as instructor, student, or assistant. Those who blow their own glass have been multiple times—for example, Nadège Desgenétez has attended eighteen sessions in various capacities (student, gaffer, staff member, teaching assistant, and instructor); Ben Edols has attended seventeen sessions, three of them as an instructor, and has been both student of and teaching assistant to Dante Marioni more than once. By the 1990s more kiln workers were attending, and, thanks in part to the influence of the Australians, it is an area of continuing growth for the school.

In 1989 Dick Marquis enrolled as a Pilchuck student in Klaus Moje's kiln-working class. He found Moje's technique laborious: "Very Germanic as opposed to Italian."[13] Nevertheless, Dick started his great Marquiscarpa series as a result, and began using Bullseye glass, a product often thought to be unsuited to blowing. With Klaus as initial goad, Marquis began to fuse his murrine into sheets and slump the sheets to make dish-like shapes, which he then ground to a matte surface. He rolled then blew other sheets to make the columnar stands, a technique that he had consistently used since his early training in Italy (page 24). Although Moje's class was the impetus, the technique and aesthetic of the

Clare Belfrage, *Ridge Lines #24,* 2004 (cat.2)

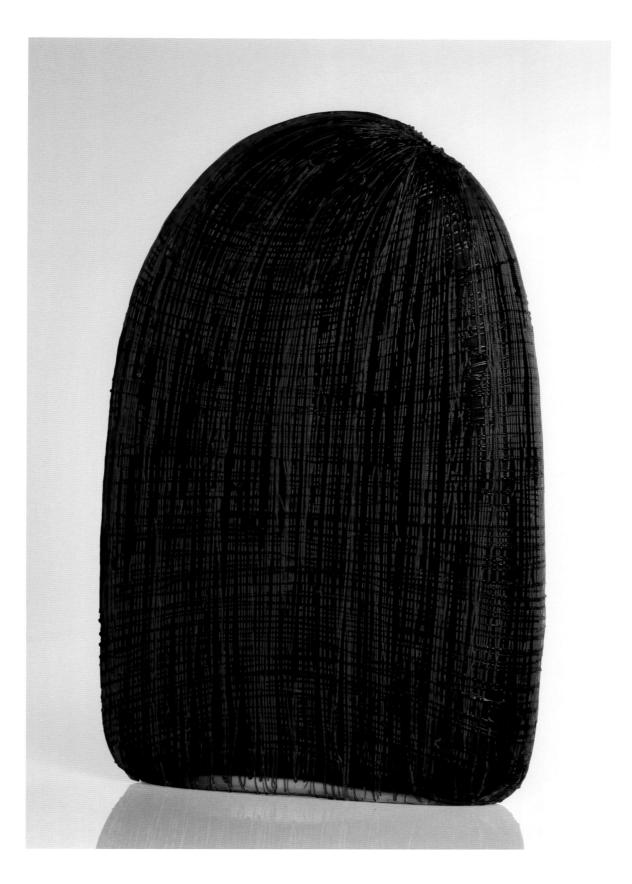

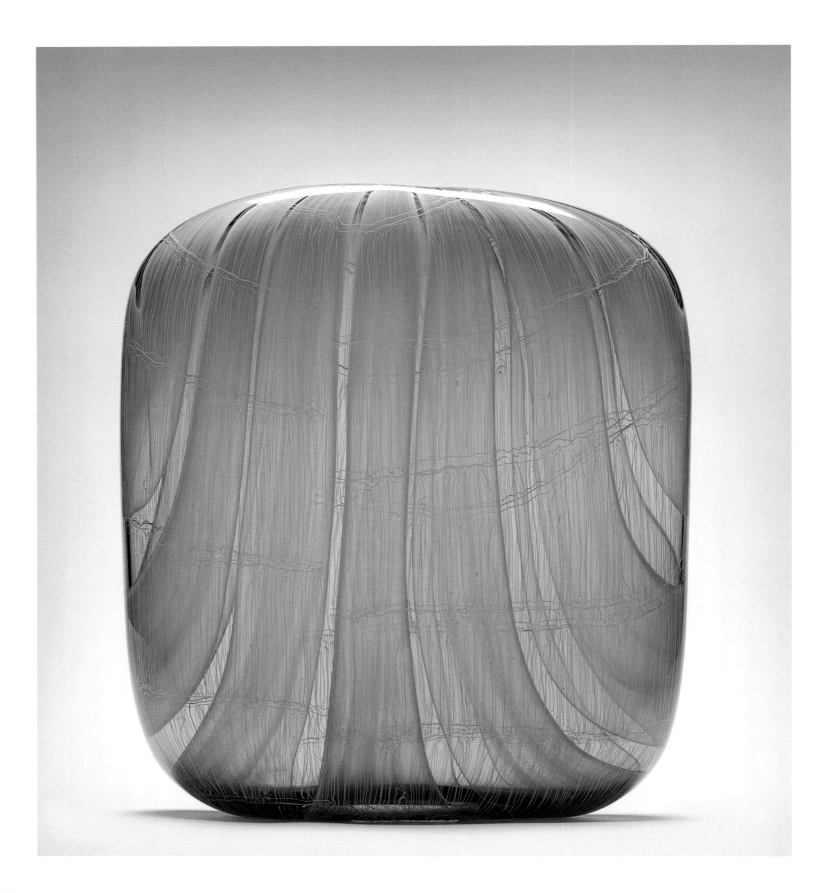

Marquiscarpas is an homage to Carlo Scarpa's mid-century creations for Venini. Unlike Klaus, Dick lightly fused segments of murrine rather than strongly fusing precisely cut pieces of flat glass. He heated his mosaic sheets in a glory hole (an open furnace used by blowers to reheat glass) rather than in a kiln. Dick immediately rolled the sheets while still hot and ground his pieces after, rather than before, slumping and blowing, as Moje did. He hated grinding.[14]

In Marquis's *Elephant in Boat with Wheels* (page 14), the stretching and distortion in the murrine caused by blowing is evident in the elephant. The Moje-like fusion of flat glass elements, simply slumped and geometrically precise, is evident in the boat. The technical finesse combined with lightheartedness and use of found objects is purely Marquis.

THE ARTISTS

The relationships between countries and glassblowers is like a complex branch of a family tree. There are some direct lineages, some distant cousins, and some remarriages. From Dick to Nick to Clare Belfrage is a direct line. Stephen Procter is a distant cousin, thoughtful and restrained, whose place in the tree is protected by the many offspring he shepherded through ANU. Tom Moore is related to Procter through schooling, to Mount through the Jam, and to Marquis by attitude. There are artists such as Scott Chaseling (discussed in the following essay) who have married out, becoming less blowers than fusers. Giles Bettison is in direct lineage to Dick and Dante through fusing and blowing of murrine, yet he is claimed by some kiln workers as their own. When we're caught in the middle of a stranger's family reunion, we don't usually want to know whose aunt by second marriage is also a first cousin once removed. We are delighted that the family is cohesive, supportive, and very interesting.

Clare Belfrage, currently creative director of Canberra Glassworks, completed her undergraduate degree in hot glass at Monash University in Melbourne in 1988. In 1991–92

Clare Belfrage, *Soft Square #21110*, 2010 (cat. 4)

she became a trainee at the Jam and began working for Nick at his Sydenham Road studio. Clare and Gabriella Bisetto, who was also a trainee then (and later followed Clare as production manager at the Jam under Nick), eventually joined with three others to form the Blue Pony Studios (1997–2011) in Adelaide, which provided auxiliary facilities for those blowing at the Jam and others who needed studio space. The artistic exchange and collegiality fostered in South Australia by Nick was compounded by Blue Pony. Even Tom Moore and Jessica Loughlin worked there side by side—"from the sublime to the ridiculous," Clare noted.[15]

Clare saw Dick, Dante, and Lino in New Zealand in 1990, attended Dick Marquis's twentieth-anniversary sessions with Dante at the Jam in 1994, and a subsequent visit by Lino Tagliapietra and Dante in 1996. These visits from abroad led to an explosion of murrine and cane work in Australia. Eventually Clare craved a looser surface than the tight patterning that resulted from these techniques. She started covering her forms with tiny glass rods called stringers, fusing hundreds of them with a torch, one by one, onto hot blown vessels that were held by assistants (page 27). In effect she added not only texture but the element of time to the hot-glass process, which is often dramatically fast. Belfrage was thinking of the growth of lichens on rocks and other natural processes. She was also linking herself to centuries of women's craft practices, particularly textiles, and specifically to her mother's knitting. Despite differences in working temperature, the laying down of lines has similarity to cold working in the meditative act of texturing and the subtle and engrossing variations that handwork bestows on repetition.

The year that Gabriella Bisetto graduated from ANU, 1990, she attended a workshop given by Lino, Dante, and Dick in New Zealand. Belfrage was there also, and the two of them later practiced Venetian cane work at the Jam by blowing scores of spinning tops. Influenced by the color and opacity of Dante's *Whopper* series, Gabriella also started a production line in opaque colors, abandoning the transparent pinks, blues, and iridized glass that was the mode then. As head of the glass workshop at the University of South Australia,

Gabriella Bisetto, *The Shape of Breath #3*, 2007 (cat. 13)

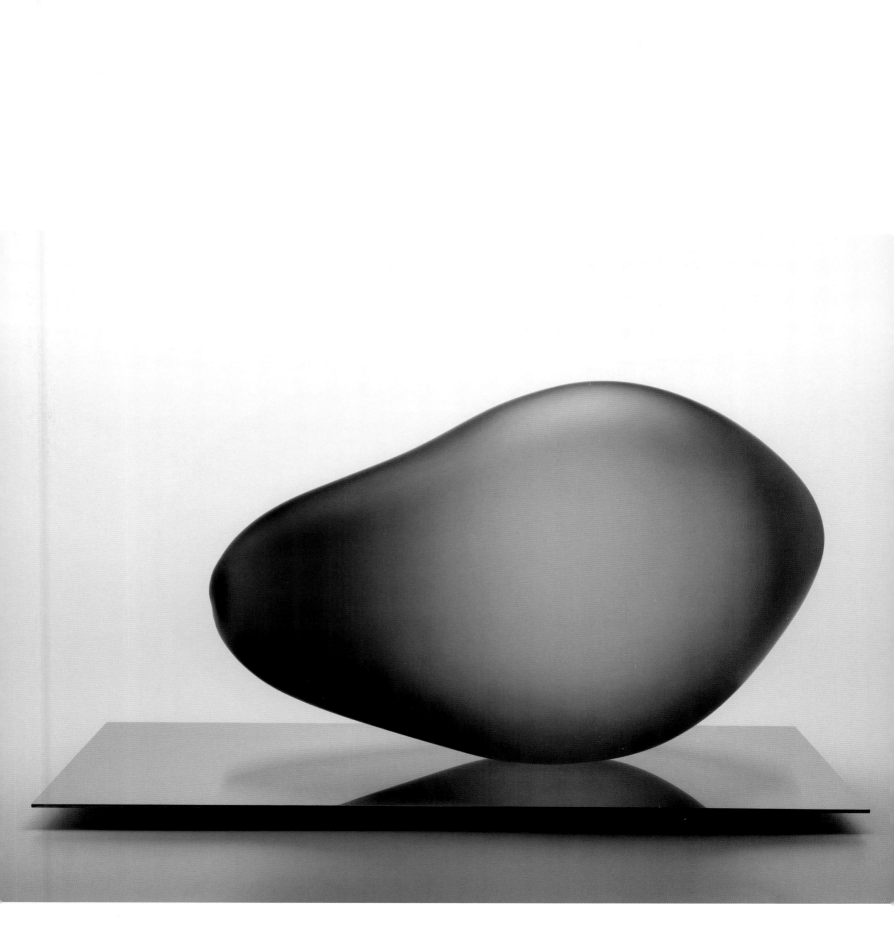

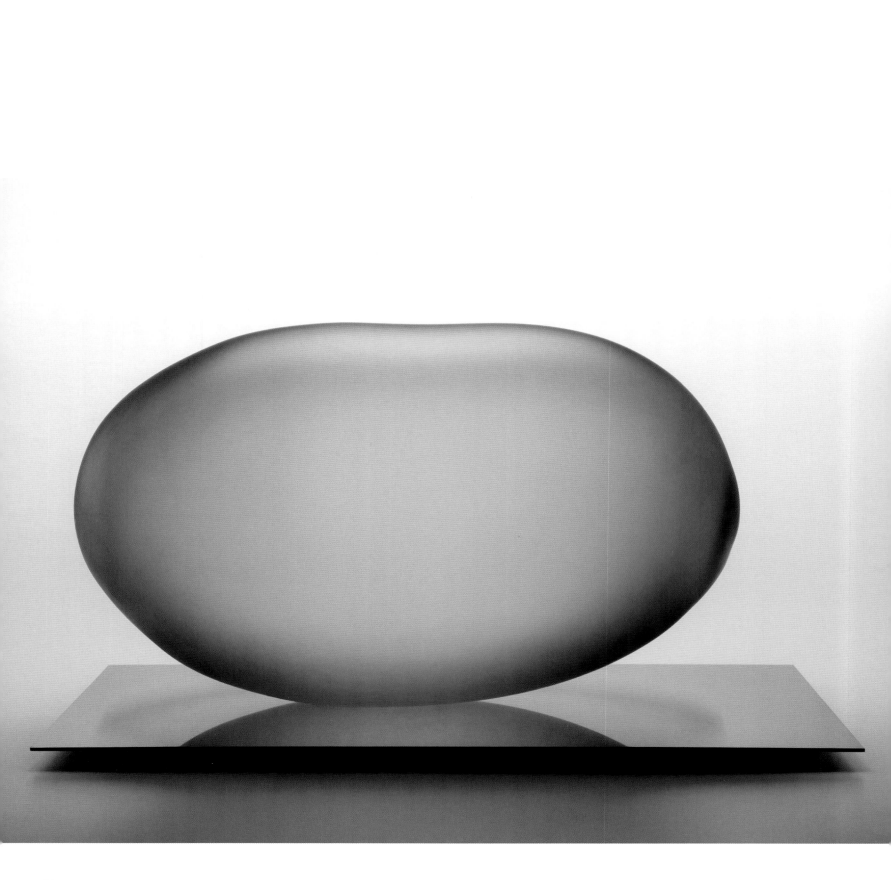

she eventually ended all color and cane work to concentrate on blowing asymmetrical shapes, as she had seen Lino do in New Zealand. "Making asymmetrical forms that are beautiful and graceful is very hard," Bisetto notes. Symmetrical blowing is a sign of technical mastery; controlled blowing off center, unlike dip and drip, is another.

The pieces that make up the series *The Shape of Breath,* which Bisetto blew for her 2007 exhibition *Little Breaths,* were made at the time of her father's death, using a technique she learned from Nick Mount. The objects seem pliant, their gently abraded surfaces, soft. Like pregnant bellies, they suggest ripeness and the potential for movement or growth. Before realizing that art could be a career, the artist had once considered becoming an emergency medical technician and recalled a test in which she had to revive a mannequin. The air she blows into the molten glass is like an act of resuscitation, giving life with her breath.

Despite Tom Moore's strong connections to colleagues at ANU, the Jam (from 1995 to the present), and Blue Pony, he seems to have come from outer space, like a Martian who has invaded a convention of metaphysical poets. Stephen Procter, chief metaphysician and head of ANU's glass workshop during Tom's years there, recognized his student's singular and committed vision, however different from his own. Narrative, surrealism, humor, and commentary seem to be Moore's unique province in hot glass. His colorful and fluid blowing is related to Mount's, but without the references to tools and vessels that rein in Nick's exuberance; his humor and combination of high and low art, if not his glass potatoes, owe something to Marquis, but they eschew Dick's rigorous, nonnarrative formalism.

The eyes in Moore's potatoes are animal, not vegetable. In *Little Known Facts* (page 35), the spooky spud is displayed as a specimen in a glass bell jar, a reflection of museum practice and a wry take on value that is created by an exhibition context. The potato, which is both "alarming and exciting" according to Tom, sprouts a mutant plant/bird hybrid. The bird is the top of a totem-like assemblage of cullet (scrap glass), balloon (a populist relative to Bisetto's inflated forms in *Shape of Breath*), and lumpy vegetable. The poetic sense is absurdist rather than metaphysical. The vitrine itself is sprouting, suggesting that nothing

Gabriella Bisetto. *The Shape of Breath #2,* 2007 (cat. 12)

in Moore's world is wholly inanimate or safe. In *Plant-Powered Island,* the top of a potato becomes the soil of a desert island. The huge bulk of the tuber is submerged, like an aquatic monster, and is self-propelling. This combination of menace and delight is intrinsic to Moore's work. In his art, nature may conquer machines, but it is scarcely benign. The humor is less diversion than a tactic to engage an audience: "Amusing people is a handy way of keeping them interested," he says.[16]

Tim Edwards had a graduate diploma in ceramics from University of Tasmania (1991) when he saw reproductions of Dale Chihuly's work. Attracted to the strong work ethic of the hot shop, Tim likened glassblowing to sheep shearing—"clock on, clock off." Unlike ceramics, glass was immediate, fast, dirty, and glamorous. Yet despite his training in glass with Nick Mount and Tom Moore at the Jam, his aesthetic remained attached to clay, particularly the compressed forms and complex matte surfaces of English makers Hans Coper and Elizabeth Fritsch. "The round was quite boring to me," Tim says. He designed a production line of flattened vases for the Jam in 1999 and began his series of paired, rectangular forms a year later. These works are blown and shaped hot, then carved when cold—the colored surface is cut to reveal the colorless glass underneath. To Tim the glass lathe used for cutting was like a potter's wheel, familiar and meditative. For each diptych there would be six

Tom Moore, *Plant-Powered Island,* 2008 (cat. 72)

OPPOSITE: Tom Moore, *Little Known Facts,* 2004 (cat. 70)

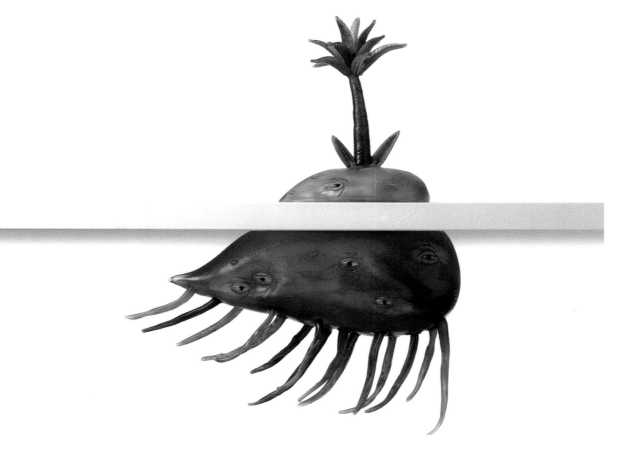

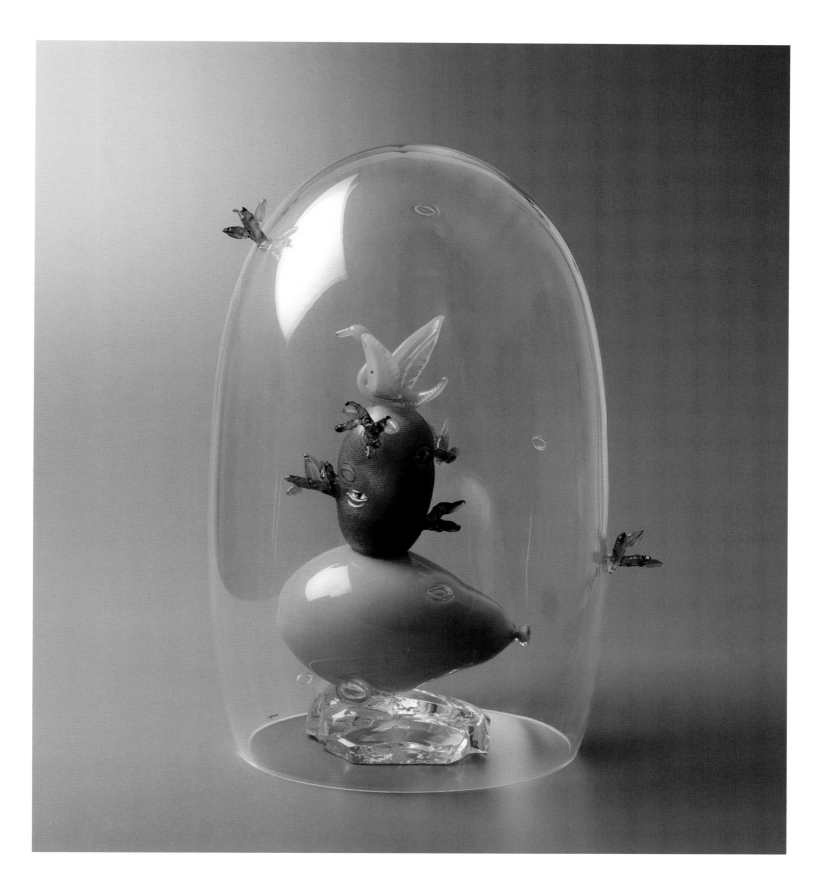

Tom Moore, *Massive Hooligan*, with backdrop, 2007 (cat. 71)

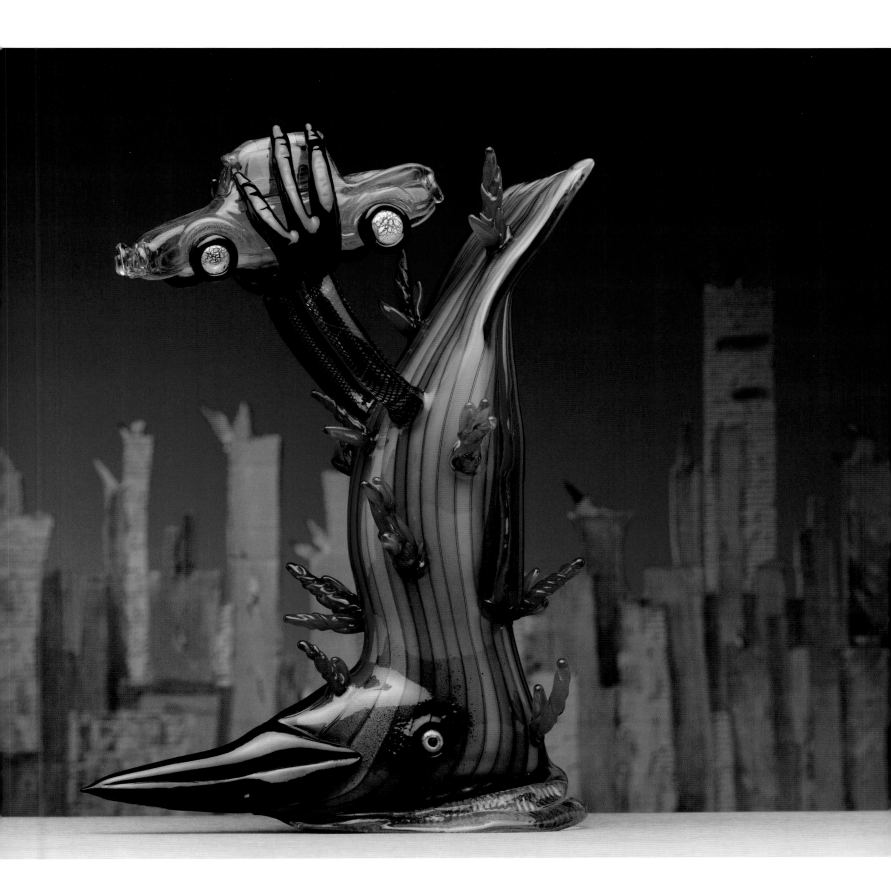

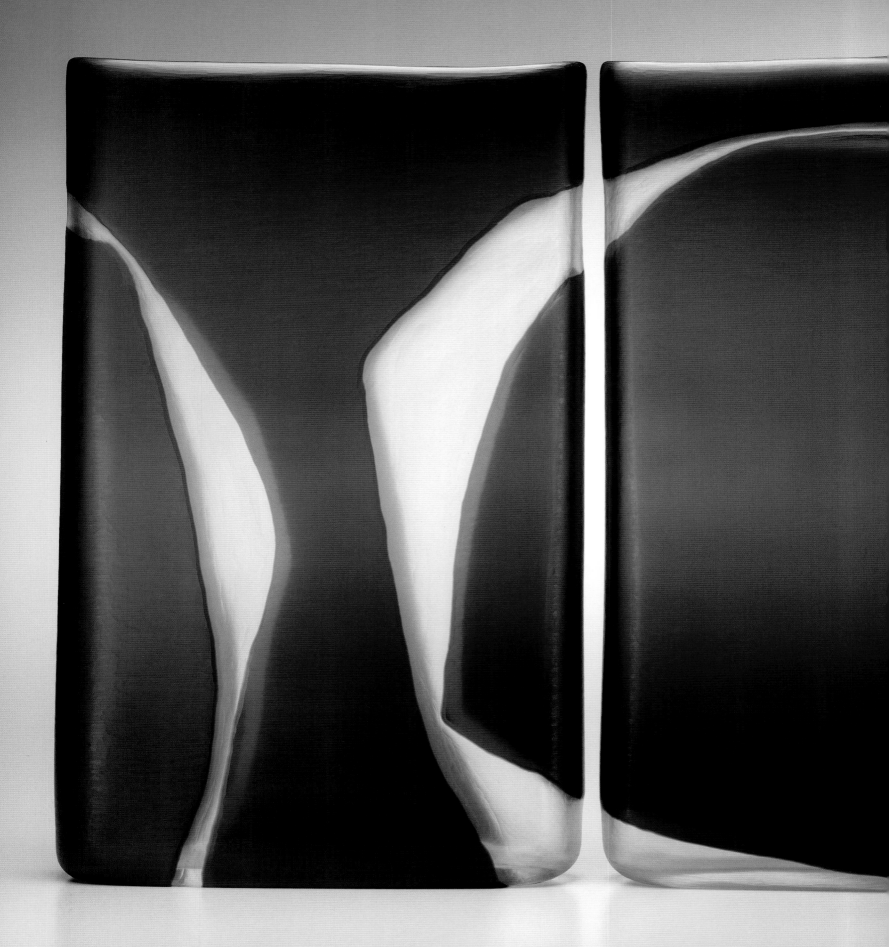

to eight hours of grinding, then ten to twelve hours of stone finishing to further mute the surface.

The first designs were diptychs, each half absolutely requiring the other to succeed. Later pieces hint at landscape, perhaps the overriding inspiration of Australian artists. The carved surface pattern in *Drift* seems hewn from rock. It is full of energy as the white area thins and widens and jumps the void between solids. Listing of paired properties becomes unavoidable—dark and light, positive and negative, matter and air, separate but equal, joined yet apart. The opposite sides of the flattened pieces closely follow the same pattern, slightly offset—substance and shadow.

Ben Edols says, "I definitely consider myself a graduate of Pilchuck just as much as a graduate of the Sydney College of the Arts and Canberra School of Art. I am a product of that environment."[17] Like Dante Marioni, the person he has worked with most during his seventeen sessions at Pilchuck, Ben considers himself a "craftsman first," honoring skill, promoting beauty, and valuing accessibility. Despite his and partner Kathy Elliott's schooling at ANU, the couple

Tim Edwards, *Drift*, 2006 (cat. 36)

Tim Edwards, *Suspension*, 2002 (cat. 35)

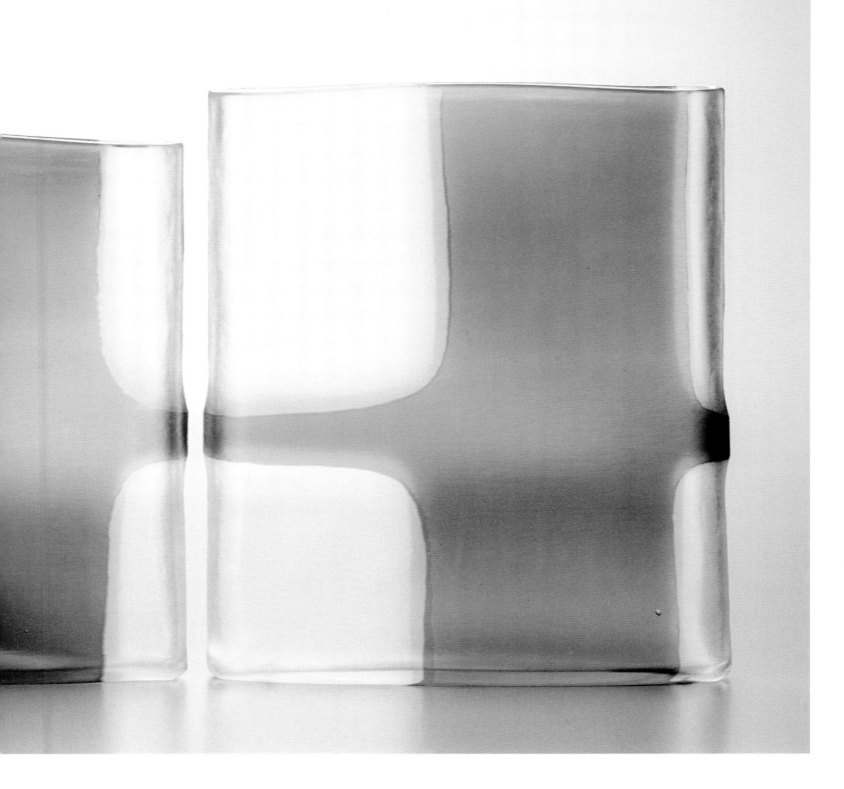

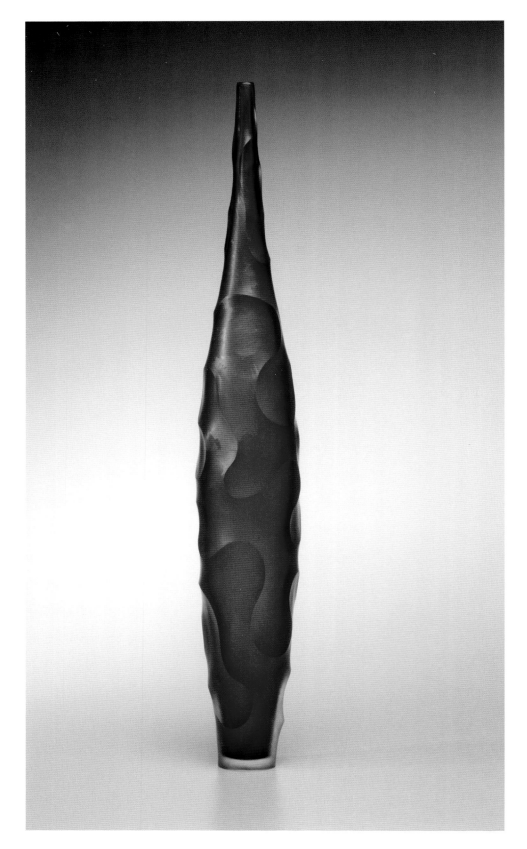

followed the Mount model rather than the academic route. They consider themselves to be "small businesspeople," making a living as studio practitioners. Edols and Elliott employ a team and create limited production lines to support their one-of-a-kind work and anchor a family. Gaffing for others and making commissioned work, particularly corporate awards, help provide financial stability. Kathy does not participate in the production lines, but coldworks unique glass pieces, sometimes refining Ben's rough cuts, which he makes on the lathe wearing Darth Vader–like protective clothing. Kathy generally works alone, using a finer wheel. Carving is "a way of letting light play over matter," she says.

Curled Leaf (pages **44–45**) is a smooth gesture, capturing the drape and twist of molten glass. The leaf would spin out of control in the wind if it weren't for the muscular stem anchoring it to the table. The various gathers

Ben Edols and Kathy Elliott, *Unravelled*, 1997 (cat. 31)

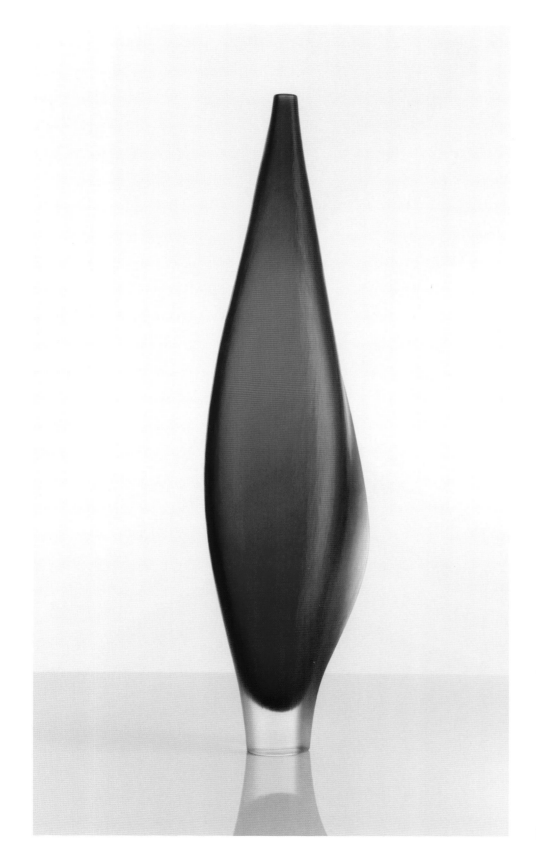

of hot glass include elegant gold and silver leaf and black cane. A hollow blown form is squashed and stretched. A helper on a ladder holds the rod as the glass droops toward the floor. Ben, with a blowtorch, directs the descent into a definitive shape, catching it in flight. The seemingly effortless twist has been unrepeatable so far. Kathy's cold work crisps the contours and gives the leaf a subtle parallel veining, not at all like nature's gum.

As a high school student, Tom Rowney delivered newspapers in the Budgeree Glass neighborhood and liked what he saw through the studio windows. In 1989 he asked Nick Mount if he could work there, and the teenager became part of the crew after school, five days a week for about two years. Budgeree was then a full factory with more than a dozen employees. Nick did most of the freehand blowing. Tom and others blew objects such as lamp shades and cookie jars using molds. This was a

Ben Edols and Kathy Elliott, *Red Stem*, 2010 (cat. 34)

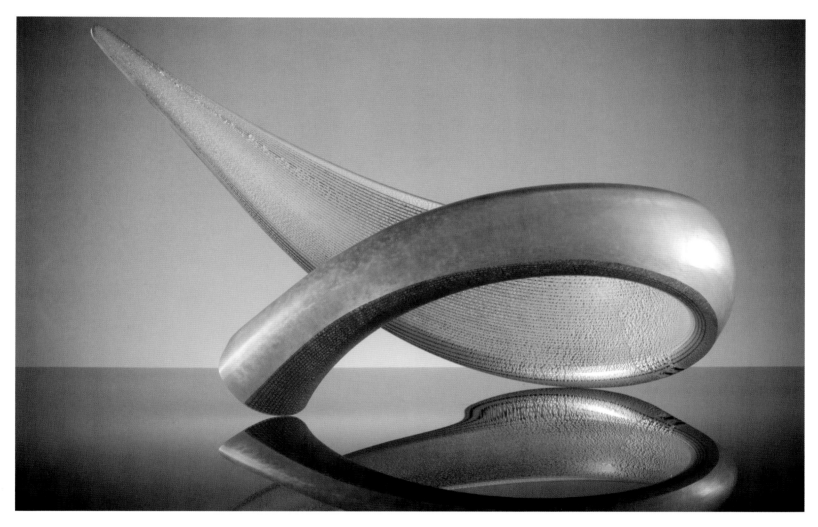

Ben Edols and Kathy Elliott, *Gold Curved Leaf*, 2005 (cat. 32)

"rigorous, incredible introduction" to glass, Rowney says. It is perhaps the closest a young-ster could come to the European apprentice system. When Budgeree precipitously closed in 1991, Nick told Tom to contact Klaus Moje, then head of the glass workshop at Canberra School of Art. Two and a half weeks later Rowney was enrolled as a student. In Tom's sec-ond year at ANU, Stephen Procter replaced Klaus as head of the glass workshop. "Stephen tried to get me to be more thoughtful about my work, but I'm process driven," Rowney re-marks. "I'm gaudy and Venetian, and he was thoughtful and ethereal."

Rowney says that the complicated cane work that he loves came from Dante and Lino "by proxy" via Ben Edols, whom Tom assisted for about seven years starting in 2000. His *Red, black with white incalmo bowl* (page 48) is a technical tour de force that avoids being precious through its majestic scale, strength of contour, and boldness of design. Bowls are blown within bowls. Patterned bands are melded to other patterned bands. A definitive layer of solid red is riveting and defies the laciness of the cane. The inside of the bowl holds secrets. One must be amazed that a blown glass vessel can change personality from inside to out. Technique is not so cheap.

Much of Rowney's income derives from helping others as a gaffer and as the technical manager at Canberra Glassworks, a superlative, government-funded glassmaking facility that opened in 2007. It is at the Glassworks that Mel Douglas carves the beautifully modu-lated forms that Rowney blows for her.

Tom Rowney, *Black and white merletto bowl 2008 #13*, 2008 (cat. 85)

PAGES 48–49: Tom Rowney, *Red, black with white incalmo bowl 2008 #11*, 2008 (cat. 84)

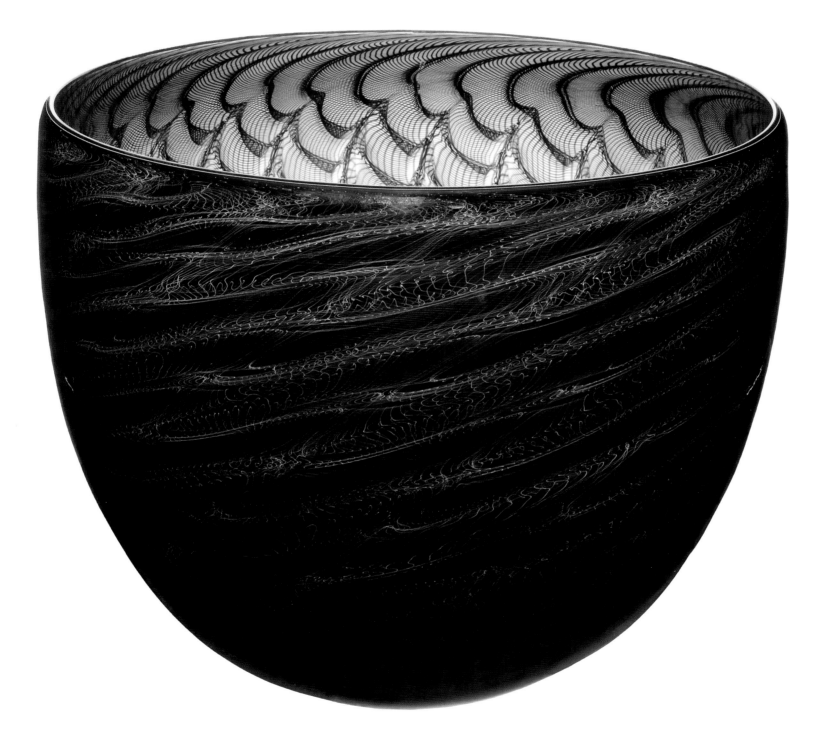

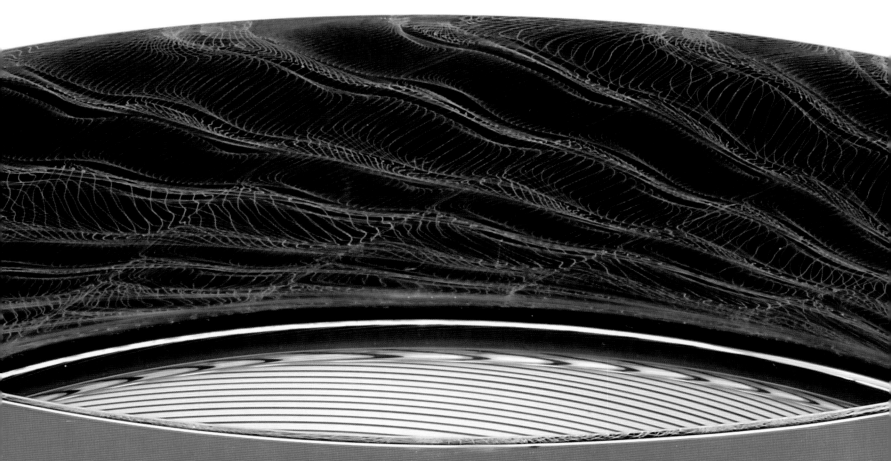

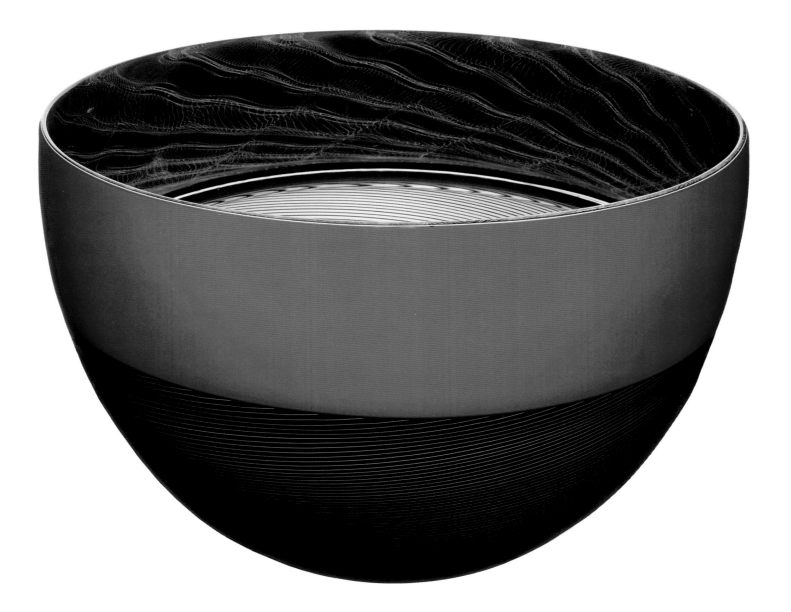

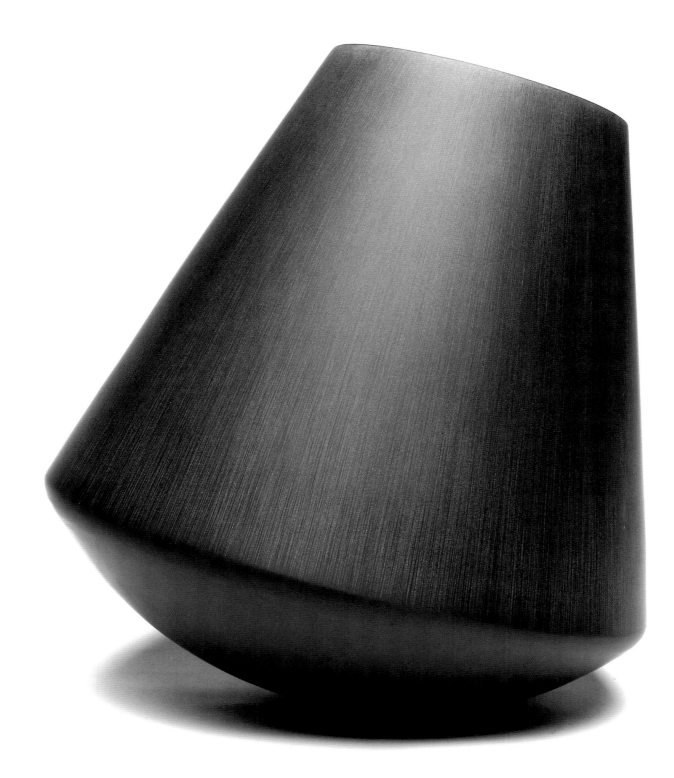

Douglas studied at ANU under Stephen Procter and Jane Bruce, who taught cold working as well as glassblowing. "Everyone cold-worked their surfaces," she says about that period in the late 1990s. Jane taught technique and encouraged exposure to international artists though workshops and travel (to Pilchuck, for example). Procter taught thoughtfulness. "Stephen guided people," Mel recalls. "When he was with you he was very focused. I think about little things he said: 'Be more brave and bold, not tentative. Consider everything—the finish, the lip, the way things balance. Give yourself time. Explore the journey of making the piece. Think about work beforehand.'"

Incline #3 is black on black, like all of Douglas's work, because of the way that black uniquely changes with variations in carving and sanding. The blown form is simple and definitive, much like the shapes she admires in Ellsworth Kelly's abstractions. The exterior surface is sanded to a perfect soft matte, then engraved with a pneumatic hand tool, which is like a pencil rather than a lathe, to follow the contours of the vessel with lines that feather out from the top. The contrasting base and interior, which are neither sanded nor engraved, are shiny black. Asymmetrical blowing causes the form to rest gently on its base. *Incline* tips as if it were offering its contents rather than defending them. In its poise, Douglas wants to project a "sense of silence before something topples over."

Stephen Procter's *Intermedian* (pages 54–55) is a precursor to *Incline* in its asymmetrical blowing, parallel engraving, and restrained demeanor. In *Lines through Light*, a book of his art and words published in 2007, five years after his death, the tenor of his thinking is evident:

> For me the cutting and shaping of a form is like tuning a musical instrument, searching for that particular resonance, the round sound, both out and within. . . . Balance is key to my

Mel Douglas, *Incline #3*, 2010 (cat. 28)

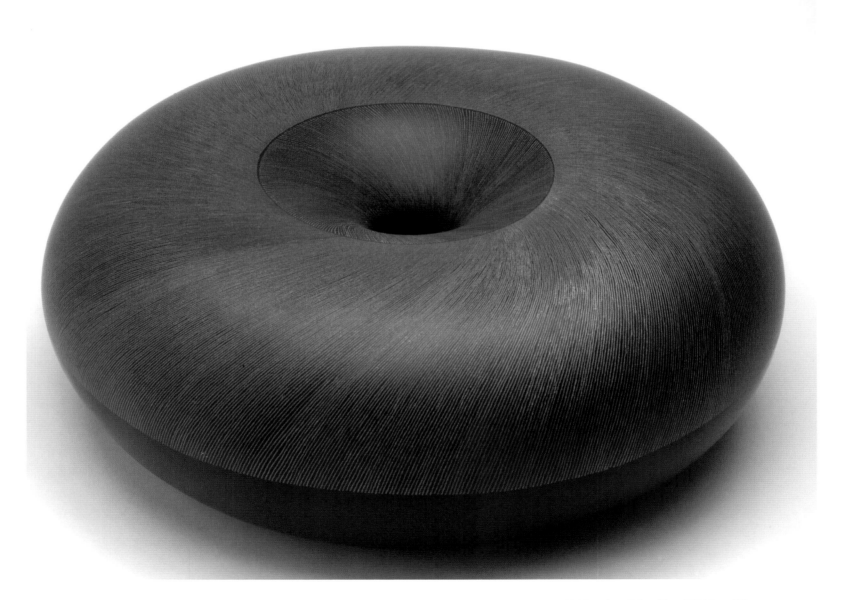

Mel Douglas, *Either Way*, 2004 (cat. 27)

OPPOSITE: Mel Douglas, *Open Field #6*, 2010 (cat. 29)

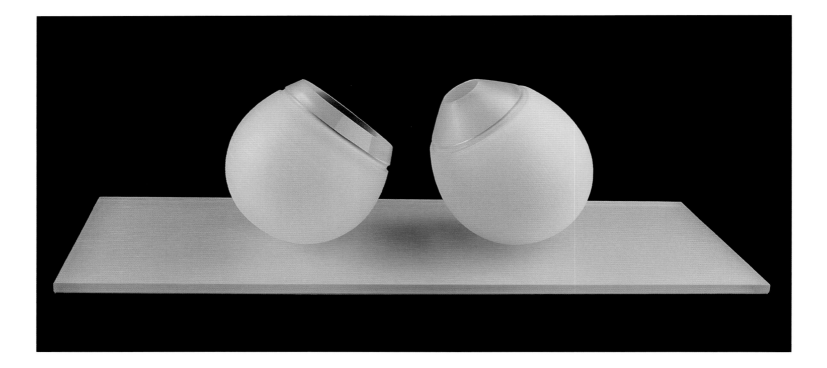

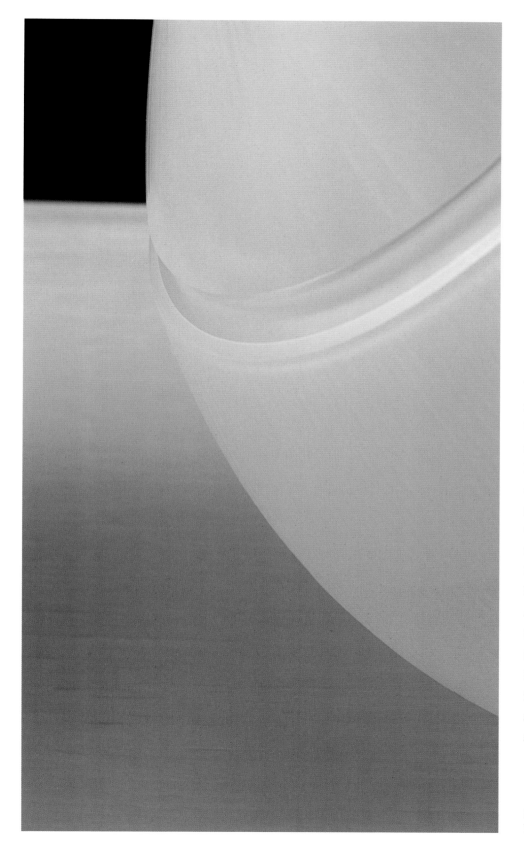

work . . . in the physical sense but also more vitally in the metaphorical sense. The dynamic of balance is constant movement and change . . . where opposites are equal. A state of stillness delicately poised on the edge of movement. . . . In a state of perfect balance there is unity.[18]

Procter was an English glass engraver and blower who had spent a year as an artist-in-residence in the glass program at Illinois State University in 1978–79. After a distinguished career in the United Kingdom, he returned to Illinois in 1991 as a visiting associate professor. A year later he moved to Canberra to head the glass workshop at ANU, in close association with Jane Bruce, his teaching and administrative anchor. Procter's connection to the Pacific Northwest was not great—Dick Marquis and Dante Marioni made an influential visit to ANU in 1994, and the exceptionally important Latitudes workshops with Bullseye Glass (see pages 67–68) occurred under his tenure. Procter's importance to a majority of the artists in *Links*, his encouragement of their different styles, their wide travels, and their international associations makes his inclusion unavoidable.

OPPOSITE AND LEFT: Stephen Procter, *Intermedian*, 1996 (cat. 78)

Nadège Desgenétez is on the current faculty at the ANU glass workshop, where she has taught alongside Richard Whiteley since 2005. She brought to Australia glassblowing skills first learned in her native France and then developed during a decade in Seattle, where she worked on crews for the stellar artists in Northwest glass. Nadège met Lino Tagliapietra in 1993 at the Centre Européen de Recherches et de Formation aux Arts Verriers (CERFAV) in Vannes-Le-Châtel, France. When she first visited Seattle in 1994, lured by its reputation as a center for glassblowing, Lino was there, working on Chihuly's *Piccolo Venetian* series at Benjamin Moore's studio. He mediated her introduction to the Seattle glass scene. Chihuly decided that a passionate French glassblower should go to Pilchuck, and he helped her get a scholarship for the following summer. Nadège took Lino and Checco Ongaro's class in 1995. Her blowing partner was Ben Edols, and Dante and William Morris were gaffers. In 1997 she was a student of Dick and Dante's there. Nadège has returned to Pilchuck many times since as student, gaffer, teaching assistant, and teacher. Her *Chaussette* series was begun in 2001 at Pilchuck with Dante's help (pages 60–61).

Trained as a designer, Nadège initially lacked confidence about making sculpture. Yet homesickness compelled her to the imagery of her mother's striped stockings (*chaussettes*), seen from the vantage point of a little girl hugging her parent's leg. The image is part nostalgia and part wish-fulfillment, the creation of a romanticized past in which the negative has been filtered out. All memories cannot be as lighthearted as the stockings suggest, and

Stephen Procter, *Walking Through*, 2000 (cat.80)

Nadège Desgenétez, *A tree and I: Elbow*, 2011 (cat. 25)

childhood is rarely an endless summer. But in creating the *Chaussettes*, which demand a large and skillful team to produce, Nadège was able to merge her past and her dislocated, glassblower's present. Her series *Landscape of the Body* continues with imagery of fragmentary, jointed limbs. Here the joints relate to the bent silvery trunks of Australian gum (eucalyptus) trees. The muted surface is a result of sanding that she refined observing Australian cold workers and with the help of Masahiro Asaka, a former ANU graduate student from Japan who now lives in Canberra.

> My work is a product of my migrant history. Seattle was my home for close to a decade, and the work I still make today reflects the influence of crucial mentors I worked with on a regular basis. Among them are Dante Marioni, whom I admire for his innate formal sensibility, his unwavering love of glassblowing, and his dedicated and unaffected challenges to an ancient trade. And Dick Marquis, one of the first contemporary artists whose work drew me to the medium, excited me, and inspired me to break my own rules in hot glass.

Nadège Desgenétez, *A tree and I: Knee*, 2011 (cat. 26)

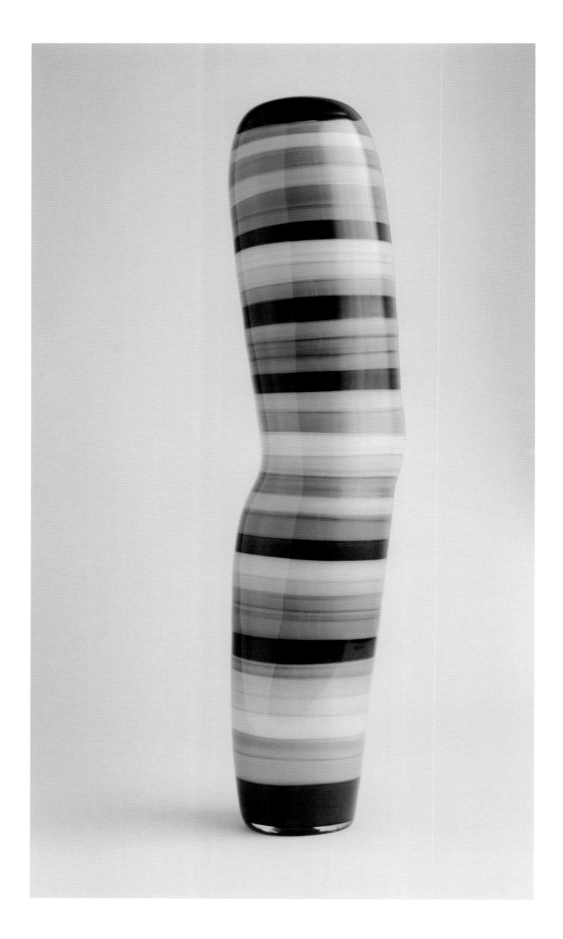

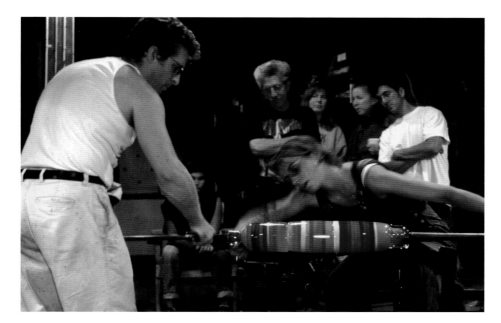

Dante Marioni gaffing for Nadège Desgenétez at Pilchuck, 2001.

OPPOSITE: Nadège Desgenétez, *Chausette (dark purple)*, 2004 (cat. 23)

NOTES

1. See letter from Richard Marquis to Anna Venini (1995) reprinted in *Choosing Craft: The Artist's Viewpoint,* Vicki Halper and Diane Douglas, eds. (Chapel Hill: University of North Carolina Press, 2009), 83–86.

2. Rafaella Del Bourgo, unpublished Australian journal entries, June 4–6, 1974.

3. Richard Marquis, interview with the author, Seattle, June 27, 2012.

4. "Bill Boysen's Australian Tour," in *Blowglass* (Sydney: Australian Council for the Arts and Crown Corning, ca. 1974).

5. Richard Marquis, "What I Did on My Summer Vacation in Australia 31 Years Ago," *Glass Art Society Journal* (2005): 11.

6. *Living Treasures: Masters of Australian Craft* is a program organized by Object: Australian Design Centre (originally the Crafts Council of New South Wales). It has consisted of an influential annual or biennial traveling exhibition and a major publication for each designated artist.

7. Margot Osborne, *Nick Mount: Incandescence* (Adelaide: Wakefield Press, 2002), 84.

8. Email to author, August 11, 2012.

9. Dante Marioni, interview with the author, Seattle, June 5, 2012.

10. All interviews with Australian artists were conducted by the author in Australia in May 2012 unless otherwise noted.

11. Helmut Ricke, "Tradition and Renewal: Venetian Ways and Lino Tagliapietra," in Suzanne K. Frantz, *Lino Tagliapietra in Retrospect: A Modern Renaissance in Italian Glass* (Tacoma: Museum of Glass, 2008).

12. Klaus Moje, interview with the author, Pilchuck, July 3, 2012.

13. Richard Marquis, interview with the author, Whidbey Island, June 27, 2012.

14. Some Australians emphasize differences between Moje's techniques and traditional Venetian practices; they consider the so-called Australian roll-up to be unique. Conversely, artists in the Italian tradition generally think that the differences are trivial, and do not grant special status to the roll-up.

15. Ten of its twelve members trained at the Jam. Members published *Blue Pony* (Adelaide, 2012) to coordinate with an exhibition at JamFactory.

16. See http://mooreismore.com/ for examples of Moore's video productions.

17. Peta Mount, interview with Ben Edols, New South Wales, February 16, 2012.

18. Christine Procter and Itzell Tazzyman, eds., *Stephen Procter: Lines through Light* (RLDI and Christine Procter, 2008), 76, 81.

CONTEMPORARY KILN-FORMED GLASS IN AUSTRALIA: THE CANBERRA/PORTLAND CONNECTION

MARGOT OSBORNE

It is impossible to consider the development of fused and kiln-formed glass in Australia without returning again and again to the central role played by the Canberra School of Art Glass Workshop at the Australian National University (ANU). All the exhibiting artists in *Links* who work with kiln-formed glass have been at one time or another associated with the Canberra glass program as staff or are alumni of its undergraduate or postgraduate programs. It is equally impossible to discuss the recent history of kiln-formed glass in Australia without taking into account the pivotal role the Portland-based Bullseye Glass Company has played in supporting the creative development of emerging Australian glass artists. In particular, this support can be seen in Bullseye's association with the Canberra School of Art Glass Workshop.

This special relationship goes back to the workshop's inception in 1982, when noted German glass artist Klaus Moje arrived in Australia to take up his appointment as founding head, a position he held until he retired in 1992. Shortly before coming to Australia, when Moje was teaching at Pilchuck Glass School in 1979, he met Boyce Lundstrom, one of the cofounders of Bullseye Glass, who was a student in his class. Lundstrom saw that Moje was experiencing technical problems using the glass then available for fusing and invited him back to the Bullseye factory to meet his partner Daniel Schwoerer. Bullseye took up Moje's challenge to develop a range of kiln-compatible colored glass sheets, and two years later sent him the first crate of experimental colored glass. Moje brought the Bullseye glass with him to Australia, and so began the thirty-year process for Moje of continually pushing the technical and creative limits of kiln-compatible colored glass.

For Moje, Bulleye's flat sheets of colored glass opened possibilities not previously available for kiln-formed work. Many more colors could be combined in one composition without the risk of technical incompatibility. The colored sheets could be cut into strips, stacked, fused, and slumped in a mold to form mosaic compositions in Moje's signature plate form. His approach to composition was liberated, shifting from a restrained linear geometry to a painterly polychromic complexity. This approach can be seen in comparing the subdued palette in Moje's work before he started working with Bullseye glass with the multicolored patterns of the double-diamond plate from 1987 (pages 64–65). Moje has often stated that this transformation in palette and style can be attributed in part to his impressions of the high-key colors of the Australian natural environment and to his sense of being in a new world, so different from Europe.[1] Reflecting this, he gave the title *New Horizons* to the first pieces he made with the Bullseye glass in Australia. He exhibited these at the third Ausglass Conference in Adelaide in 1983.[2]

From the outset of his time in Australia, Moje fostered links with Pilchuck and Bullseye. On the one hand, he found stimulus for his own glass practice through regular sessions at Pilchuck as an instructor and in working collaboratively with other studio glass masters, including most notably Dale Chihuly and Dante

Richard Whiteley, *Klaus Moje*, 1990. Made at Pilchuck Glass School print studio.

Klaus Moje, *Untitled* [pre-Bullseye palette], 1978 (cat. 63)

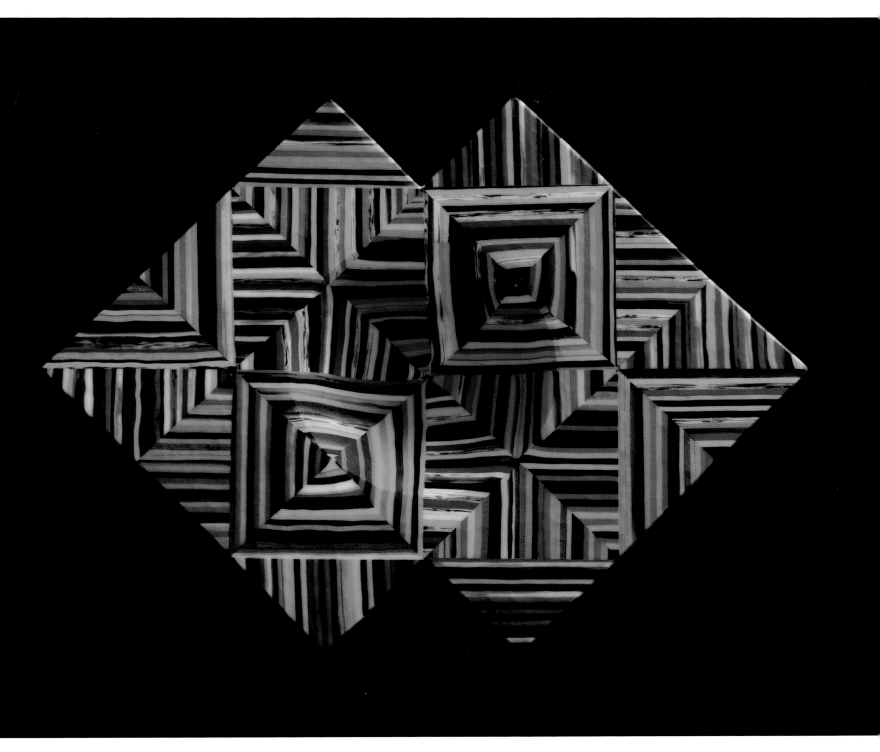

Klaus Moje, *Untitled [Double Diamond]* [post-Bullseye palette], 1987 (cat. 64)

Marioni.[3] On the other hand, he was active in creating professional development opportunities for his students. David Williams, who was head of Canberra School of Art during Moje's tenure, has recounted how Moje successfully argued the case for federal government funding through the Australia Council to enable Australian art school students to attend the annual sessions at Pilchuck Glass School.[4] Meanwhile, shortly after Moje's arrival in Canberra, Bullseye donated two cases of glass to the school, setting in motion a process of student experimentation with fusing the kiln-compatible colored sheets.[5]

This collaboration between Canberra and Portland had two-way benefits. Bullseye Gallery's executive director, Lani McGregor, has acknowledged, "Without the inspiration of seeing Moje transform that fusible glass into works of art and 'infecting' his Canberra students with the skills to do likewise, it is unlikely that Bullseye would have continued on this course."[6] The term "disruptive technology" refers to innovative developments that radically change the existing market and values. Arguably, the Bullseye kiln-compatible glass sheets had that kind of impact in the glass world. Crucially, it was the students, staff, and alumni of the Canberra School of Art who became the vanguard in experimentation with the creative possibilities of this new glass. The astonishing diversity in aesthetic innovation that arose from this experimentation is testament as much to the educational environment in Canberra as it is to the creative possibilities opened by Bullseye's technical innovation.

From the outset at Canberra School of Art's Glass Workshop, Moje inculcated his educational ethos that acquisition of traditional technical skills must go hand in hand with aesthetic development—that acquiring knowledge of the medium was intricately bound up with using it as a means of aesthetic expression. He had brought two lathes with him from Germany, and it was this European emphasis on the then-unfashionable skills of cold working that contributed to Canberra alumni creating highly finished and technically soph–isticated glass works that looked different from what was being made elsewhere. Three decades later, cold working has spread throughout contemporary Australian glass practice, to the extent that using lathes and other cold-working tools to cut, engrave, and abrade the surface is an essential part of the glass artist's technical repertoire and aesthetic

Dante Marioni (seated) gaffing for Klaus Moje (rear) in Portland, assisted by Janusz Pozniak, 1993.

OPPOSITE: Klaus Moje with Dante Marioni, *Orange Vessel*, 1993 (cat. 65)

approach. Australian glass artists have become recognized internationally for their expertise in this field, and several in this exhibition have been guest demonstrators at Pilchuck.

Moje's educational methodology was grounded in an innovative fusion of the European model of technically oriented, skills-based apprenticeship and the American model that favored creative self-expression and studio work. Both models rely on inspirational leadership and mentorship from the studio head, and in this respect the glass workshop has been very fortunate. Moje's founding ethos has been maintained, with modifications, under each of its subsequent heads, Stephen Procter (1993–2000), Jane Bruce (2000–2002), and Richard

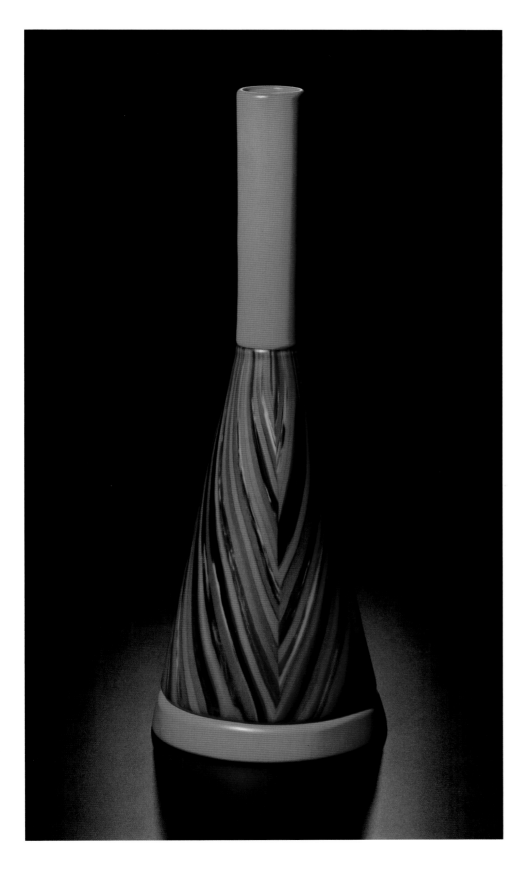

Whiteley (since 2002). Whiteley has stated: "The programs that emerged here established an approach to glass pedagogy which features an interweaving of skills, training, innovative thinking and professionally directed focus. The result was to set contemporary Australian studio glass on a parallel different to other parts of the world."[7]

A decisive moment in the Canberra/Portland connection stems from the 1993 experimental sessions in Portland when Moje and Dante Marioni collaborated to explore possibilities of combining fusing and blowing techniques. Moje brought the fused mosaic sheets with him from Canberra to be blown by Marioni. The resulting series of small vessels were marked M/M/P (Moje/Marioni/Portland), with one included in this exhibition lent by Marioni from his own collection (left).

The following year, Moje's former student Kirstie Rea (who was on the teaching staff of the Canberra School of Art from 1987 to 2003) attended a Pilchuck workshop by Lino Tagliapietra and Rudi Gritsch that explored this new direction of combining blown and kiln-formed glass processes. Rea also undertook a short residency with Bullseye in Portland, where she suggested that Bullseye Glass might be interested in supporting further experimental

workshops in this area at the Canberra School of Art. The company donated the glass for what became known as the *Latitudes* workshops of 1995 and 1997. A key group of emerging and established Australian glass artists working with both blown and kiln-formed glass participated in these sessions. Each workshop resulted in an exhibition. The first *Latitudes* exhibition traveled to Portland to inaugurate the Bullseye Connection Gallery (July 6–31, 1995) and was also shown in Sydney and Canberra. The second exhibition, *Latitudes: Bullseye Glass in Australia*, was curated by Merryn Gates for the ANU Canberra School of Art Gallery. It toured to Seto, Japan, for the 1998 Glass Art Society conference, to Bullseye Connection Gallery in Portland, and to galleries across Australia in 1998 and 1999. Australian glass was starting to establish a presence on the world stage. Artists represented in *Links* who took part in the second Latitudes workshop and exhibition are Moje, Rea, Bruce, Procter, Giles Bettison, and Scott Chaseling. Jessica Loughlin and Mel George were student assistants for the 1997 workshops.

At this time Rea was working with a complex repertoire of techniques, including both fusing and blowing, to create minimalist abstract "shed" forms. These drew on her sense

Kirstie Rea, *Myth or Memory*, 2001 (cat. 81)

OPPOSITE: Kirstie Rea, *Fine Line II*, 2004 (cat. 82)

of connection to the agricultural landscape around Canberra. This has remained a source of inspiration running through Rea's work in the intervening years, while at the same time her approach to glass has matured to show a sophisticated resolution of form and content. This is epitomized in the refined, lathe-cut sculptural form of *Fine Line II* (page 69), with its abstract allusions to the tines of agricultural tools used to furrow the fields. The colored shadows cast by the tines are Rea's quiet homage to the aesthetic influence of American land artist James Turrell and testament to her fascination with anachronistic farm tools as emblems of the fragile yet resilient relationship between humans and the environment.[8] She has stated: "I am in awe of the power and resilience of these landscapes and environments and their ability to heal what happens to them. Objects from these landscapes radiate energy and residual power as they recline near where they once made their mark."[9]

While Rea played a key role initiating and coordinating Latitudes, British-born/American artist and lecturer Jane Bruce was also active in facilitating and participating in the workshops. For Latitudes she created asymmetrical blown, kiln-formed, and lathe-cut vessel forms in which a surface layer of opaque matte-black glass was cut to reveal abstract slashes of colored glass encased in layers within the interior of the vessel. After teaching at

Jane Bruce, *Shift*, 2006 (cat. 14)

OPPOSITE: Klaus Moje with Scott Chaseling and Kirstie Rea, *Niijima 10/99-Bl*, 1999 (cat. 66)

Canberra School of Art Glass Workshop for ten years, including two as its head, Bruce left in 2004 to return to New York. She continued as artistic director of North Lands Creative Glass in Scotland (2002–2007) while establishing her studio in Brooklyn.

Her solo exhibition with Bullseye Gallery, *Contained Abstraction* (2008), marked a return to kiln-formed glass, fabricated to her instructions by Portland's Studio Ramp, run by Mel George and Jeremy Lepisto. There are clear

formal concerns linking the earlier black vessels, in which the austerity is undercut by colorful slashes, and Bruce's restrained use of color and honed forms in the two works in *Links*. In *Shift* there are residual allusions to the vessel in Bruce's abstracted white geometric forms, sculpted in relief against a white ground and defined by shadow outlines of primary color. *Shift* is imbued with a formal ascetic purity that aligns it with earlier developments in modernist painting and sculpture, while at the same time rooting it in the history of the vessel in the decorative arts.

In 1997, at roughly the same time that the Latitudes workshops were taking place, Moje took the next step in developing hybrid fused and blown forms while in Niijima, Japan, as master-in-residence for the Tenth International Glass Art Festival. His experimental forms were inspired by Japanese ikat-dyed textiles from the Edo period, but they did not survive the kiln. It was not until he returned to Canberra and teamed up with Rea and Scott Chaseling that the three were able to resolve the technical issues behind what became known as Moje's *Niijima* series. The key innovation of this series was that the slab of fused, multilayered, patterned glass was reheated until it was soft enough to be picked up on a hot collar and rolled into a cylinder shape, which could then be hot-worked, blown, and shaped.[10] The Australians, in discussion with Bullseye, adopted the term "Great Australian roll-up" for this technique, and launched it to the glass world at the Glass Art Society conference in Seto, Japan, in 1998. Chaseling and Rea subsequently toured internationally over the next few years demonstrating the roll-up technique. Moje's *Niijima 10/99-B1* was acquired for the Corning Museum of Glass as the fourteenth Rakow commission. However, the *Niijima* roll-up forms of 1999/2000 proved to be a short chapter for Moje, as he soon returned to evolving complex and technically demanding fused geometric patterns in both slumped plates and wall panels.[11]

It was left to Scott Chaseling to more fully develop the aesthetic and technical potentials of fused and blown glass. A lot happens in Chaseling's double-sided fused and blown vessels. These large, technically dazzling forms not only fully exploit the unique potential of the roll-up to create different designs on the inner and outer surface of the vessel, but they also reveal the scope offered by fused glass for compositions combining a mix of techniques. For

ABOVE AND OPPOSITE: Scott Chaseling, *Absent Memories* (front, back, and interior detail), 2004 (cat. 17)

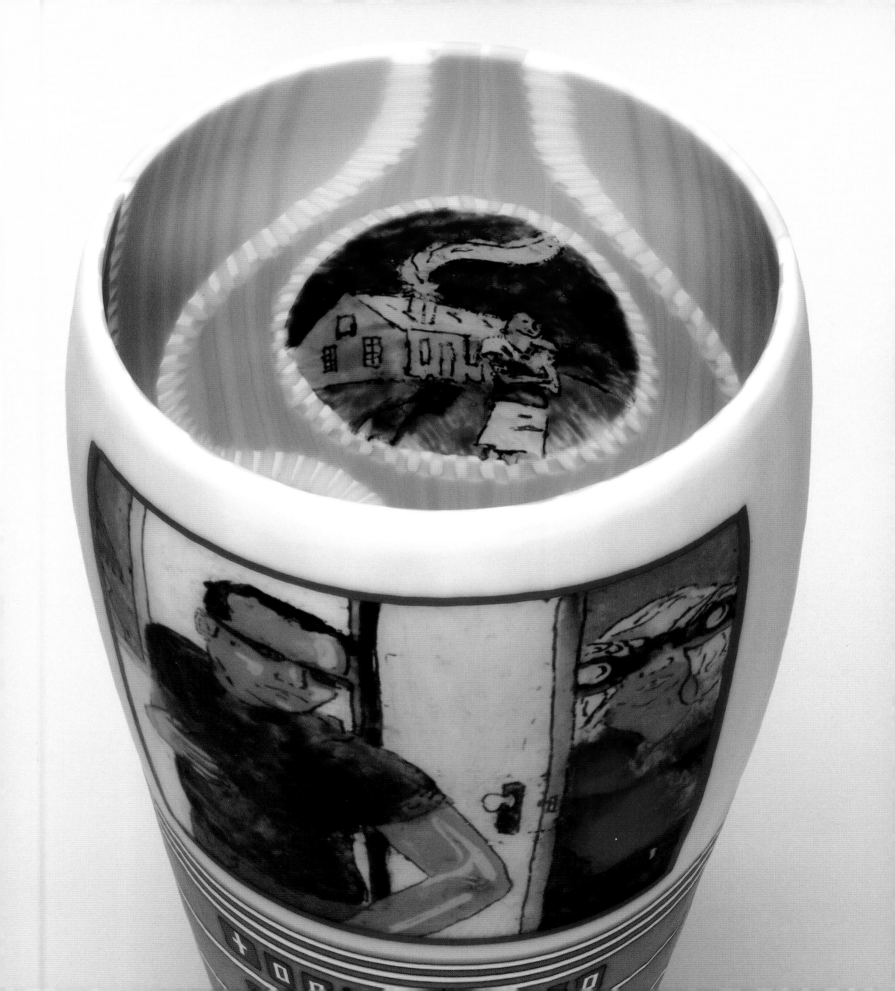

LEFT: Scott Chaseling, *When the Penny Drops* (front), 2001 (cat. 16)
RIGHT: Scott Chaseling, *The Cleansing* (back), 2004 (cat. 18)

Scott Chaseling, *Now or?* (front and back), 2006 (cat. 19)

instance, Chaseling characteristically juxtaposes decorative murrine sections, stripes, and circles with hand-drawn, reverse-painted panels featuring scenes from his life. He creates interplay between enigmatic personal narratives circling the exterior and interior of the vessel. The narrative mood can shift from laconic humor to existential angst, and from domestic bliss to social commentary. For Chaseling, glass has always been more a conceptual than a technical medium. This driving interest led him to move on from the roll-up vessels several years ago. He now works with found materials and low-tech approaches to create conceptual sculptures from recycled glass bottles.

Despite the burst of energy generated by Latitudes, the presence of blown and fused glass utilizing the roll-up technique is barely visible among the current practices of the Australian artists who took part in the workshops. Giles Bettison works across blown and fused glass but uses the hot-glass technique of heating his murrine tiles quickly in the glory hole rather than the roll-up. However, American artist Steve Klein has become an exemplar of this technique. For instance, *Exploration 168* (2012, not illustrated) features a patterned sphere of blown, kiln-formed glass resting on an undulating base.

Steve Klein, *Exploration Lybster 1*, 2004 (cat. 43)

OPPOSITE: Giles Bettison, *Magenta Vessel*, 1995 (cat. 5)

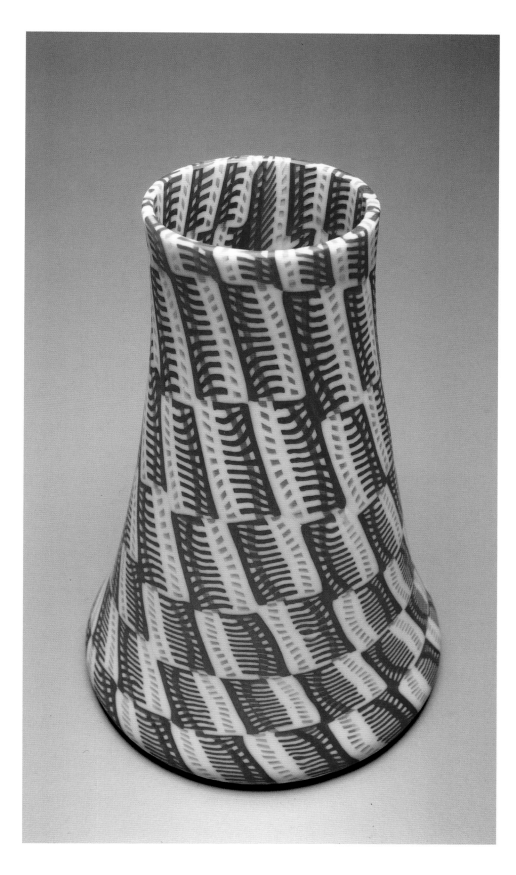

One of the outcomes of the 1997 Latitudes workshops was that Lani McGregor visited Canberra, grew excited by what she saw, and invited four emerging glass artists from Canberra—Giles Bettison, Claudia Borella, Mel George, and Jessica Loughlin—to undertake a residential program at the Bullseye factory in Portland. This took place in January 1998 and culminated in the exhibition *International Young Artists in Glass: Australia* at Bullseye Connection Gallery. Bettison, Borella, and Loughlin were recent graduates of Canberra School of Art, while George was still a student.[12] The residency and exhibition launched their work on the international stage and were also the beginning of the artists' ongoing connection with Bullseye, which represents all four artists through Bullseye Gallery. Over the ensuing years the company has provided technical support toward solving experimental problems and marketing support toward developing the artists' careers.

Each of the four young artists responded to the Bullseye sheet glass in totally original and remarkably diverse ways. There was no sense of "house style." Bettison had already started to develop his innovative adaptation of traditional Venetian murrine using Bullseye glass while he was a student assistant to Rea during the first Latitudes workshop in 1995. Instead of using

traditional glass canes, he cut, stacked, and fused colored sheets of glass, then heated and stretched these stacks into rods in the glassblowing workshop. He crosscut the stretched rods into intricately patterned tiles or lozenges, which he then arranged in flat compositions of murrine patterns. The composition was then heated in a glory hole and picked up on a collar for blowing into simple vessel forms. Bettison has acknowledged that seeing Dick Marquis demonstrate his interpretation of traditional Venetian murrine at the JamFactory in Adelaide in 1993, and again later in Canberra, was one of the powerful sources of inspiration influencing his own interest in murrine glass.[13] After seeing Marquis, Bettison moved from Adelaide to Canberra and enrolled in the glass program at Canberra School of Art in 1994.

The 1998 Portland residency enabled him to produce an impressive body of new work, pushing even further the use of flat sheets for murrine and demonstrating an outstanding virtuosity in his command of color and composition. That year he received the Urban Glass Award for New Talent, and Bullseye started representing his work through its own gallery and internationally through art fairs. Dan Klein has stated that Bettison "more or less reinvented the ancient Venetian tradition of incorporating *murrine* into glass vessel."[14]

The complex rhythmic patterns of Bettison's murrine vessels often reference the organic warp and weft of handwoven textiles, with the stretching of the layered glass creating a striated "bleed" that evokes the diffused dye patterns of Asian ikat weaves. One of his first murrine pieces, and the progenitor of his future fascination with textiles, was *Magenta Vessel* (page 77), which is an homage to the textiles of Bauhaus artist Annie Albers. The simple contrasting colors of this piece are an atypical precursor of the subtle, glowing tonalities and more intricate patterns that Bettison started to develop during the Portland residency. He took traditional, essentially decorative murrine and introduced a whole new world of tonal gradations and rhythmic abstract composition, infused with evocations of landscape, textiles, and the immanent organic patterns that surround us in the natural and material world.

Giles Bettison, *Textile 10 #14*, 2010 (cat. 9)

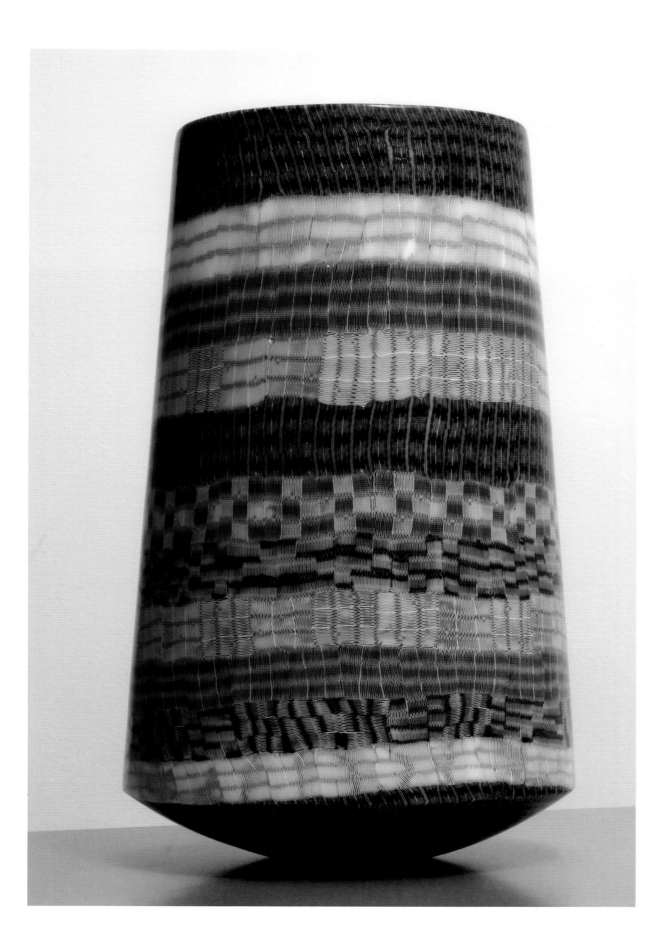

Giles Bettison, *Lace 09 #36*, 2009 (cat. 7)
OPPOSITE: Giles Bettison, *Lace #22*, 2009 (cat. 8)

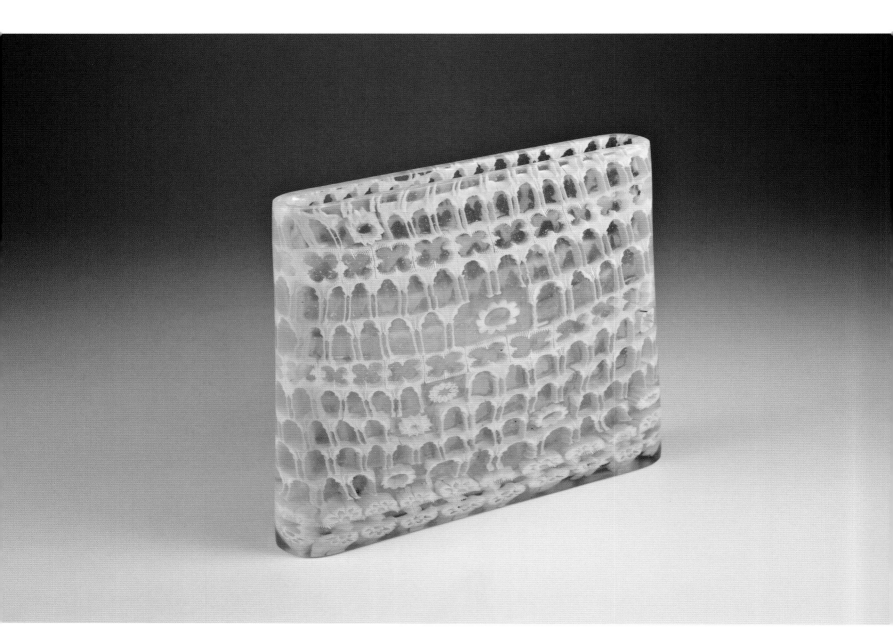

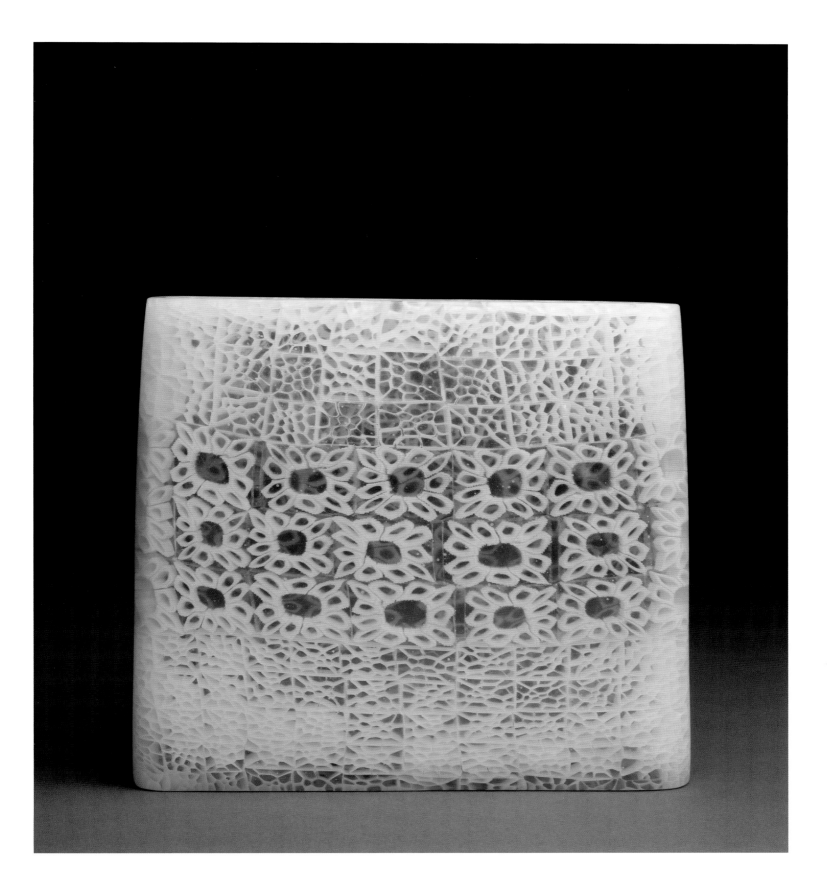

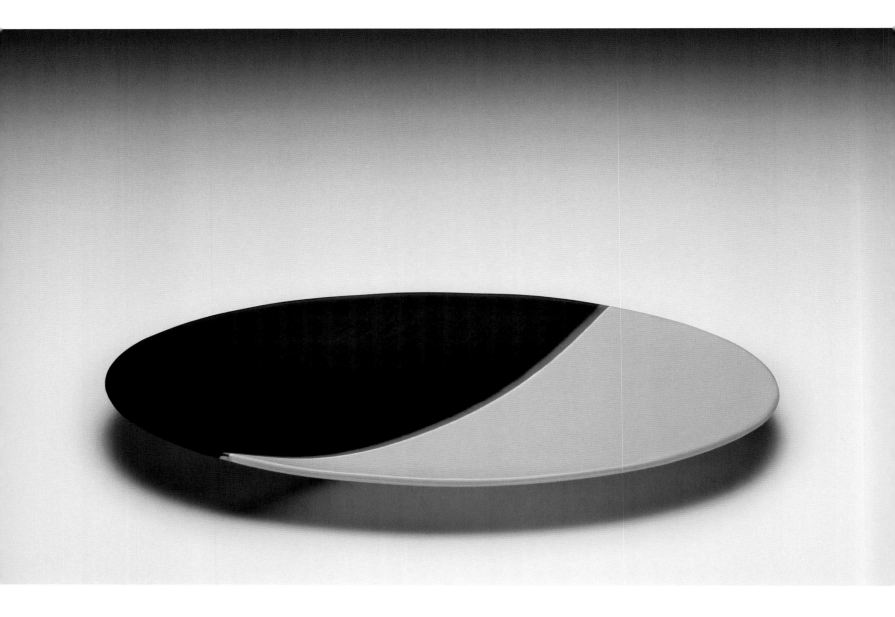

This style would predominate in his work over the next decade, especially in those vessels and panels that referenced aerial vistas of the Australian and American landscapes. The recent vessel *Textile 10 #14* (page 79), with its complex layered design and tapering basket form, is a representative example of Bettison's ongoing fascination with woven textiles and baskets. In contrast, the two *Lace* forms (pages 80–81) are precursors of the latest direction in Bettison's glass practice. While retaining allusions to textiles, in these works he has reduced color to a minimalist palette of white, cream, and clear glass and built up layers of glass to create a sense of transparent depth in which his lacelike fractal patterns are suspended.

Jessica Loughlin was twenty-two and had just graduated from Canberra School of Art with first-class honors when she attended the Bullseye residency in 1998, but she had already won Australia's coveted Ranamok Glass Prize and been a finalist in Young Glass International, Ebeltoft, Denmark. She used the residency to develop her series of large, gently curved *Horizon Line* plates. Each was divided across the center into light and dark hemispheres and inscribed with a pale textural calligraphy. In the Bullseye catalog, Loughlin stated: "I am standing at a central point, bound only by the horizon. There is no activity, confusion or noise, just empty space."[15] The conceptual concern with "the beauty of emptiness,"[16] with the connection of landscape and mind space, and with the medium of fused glass as a refined material embodiment of an existential state of mind, has run throughout Loughlin's work since that time.

Her most recent piece in *Links* is *in close distance* (page 125), a wall panel inspired by the salt lakes of Australia's vast inland desert regions. Loughlin's quiet, understated approach to kiln-formed glass belies the sophisticated technical prowess and constant experimentation that underpins it. The salt lake series was achieved through applying a "slurry" of ground glass mixed with water to the fused glass panel, then waiting for the water to evaporate and leave behind its residual watermark, which is permanently fused with the glass surface in the kiln.

Jessica Loughlin, *Horizontal Line Series #14*, 1997 (cat. 45)

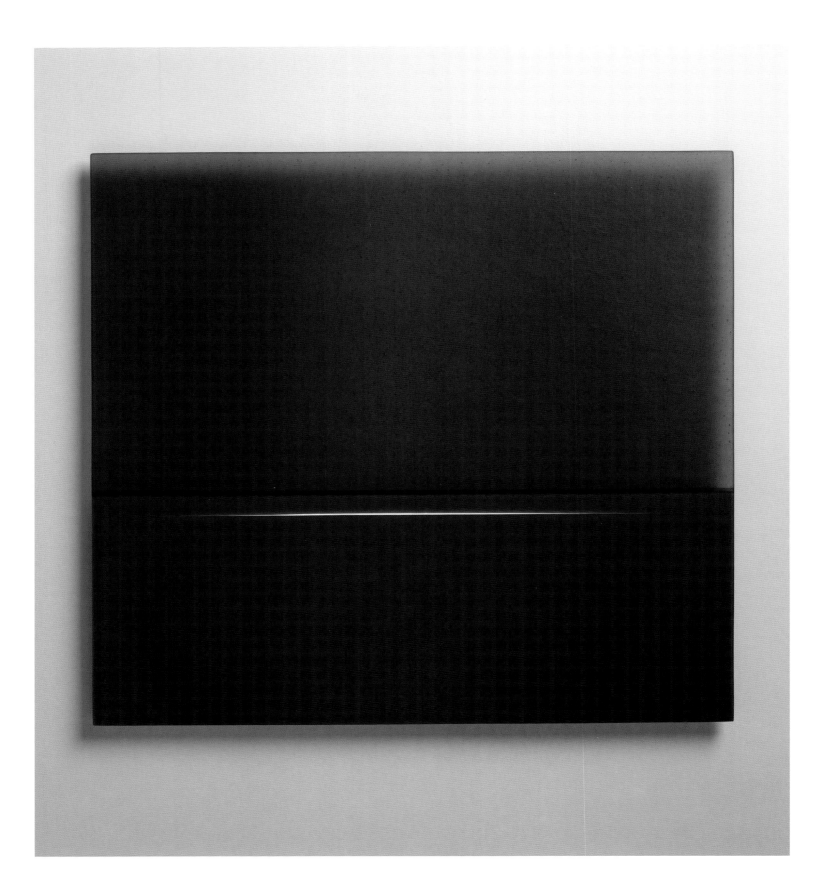

Jessica Loughlin, *quietening 5*, 2004 (cat. 46)

OPPOSITE: Jessica Loughlin, *open space 28*, 2005 (cat. 47)

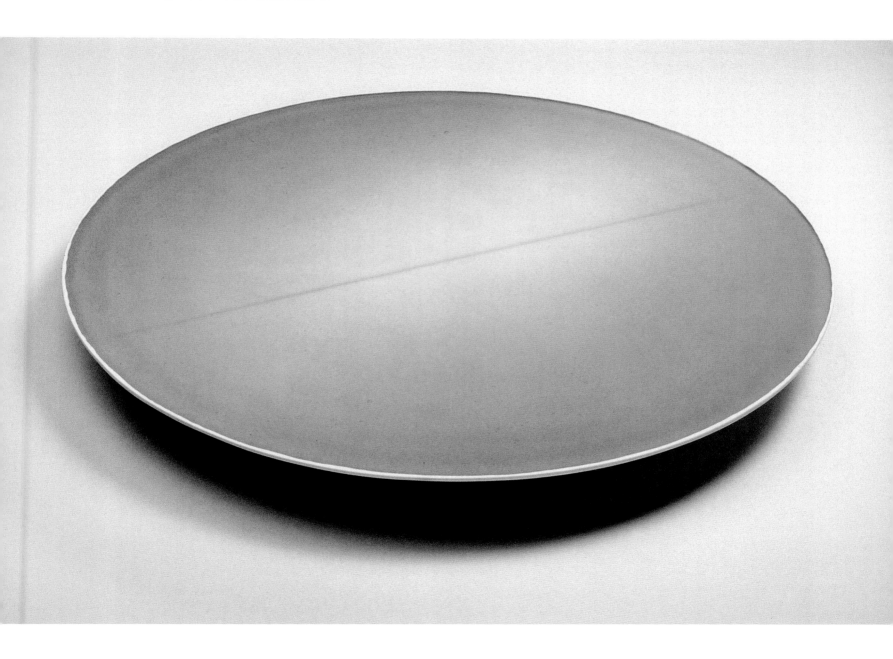

In 2012 she stated, "Over the years my works may appear very different but they are all different expressions of the same core idea, and that is my relationship to vast space and seeing distance and understanding how those wide open spaces affect us."[17]

Since 1998 Loughlin has undertaken three more residencies with Bullseye (1999, 2002, and 2004–2005). She has held three solo exhibitions with Bullseye Gallery and been represented by the gallery at art fairs including SOFA (New York, Chicago, and Santa Fe), Art Miami, ArtMark, and Collect (London).

Mel George, the other artist in *Links* to have taken part in the landmark 1998 residency at Bullseye, has taken a very different path from that of Bettison or Loughlin. After the residency she returned to Australia to complete the final year of her degree, and then returned to Portland to work as an assistant in the Bullseye Research and Education Department for three years. She met her husband, Jeremy Lepisto, while at Bullseye, where he was working as a glass technician. In 2001 the two set up a glass fabrication studio, Studio Ramp LLC, to make their own artwork and create large-scale

Mel George, *Change of Scenery*, 2008 (cat. 40)

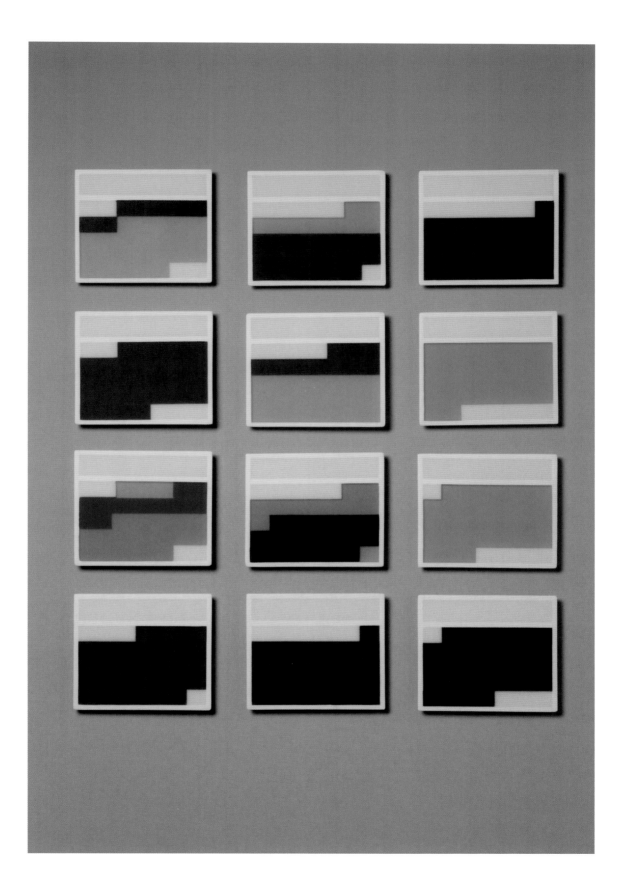

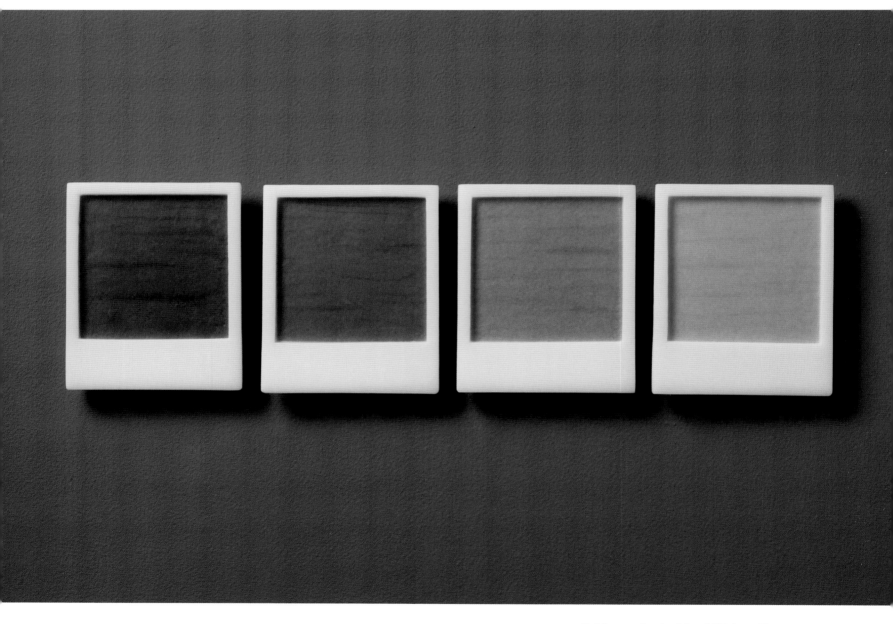

Mel George, *Portland Hue*, 2009 (cat. 42)

Mel George, *Dry Shade*, 2009 (cat. 41)

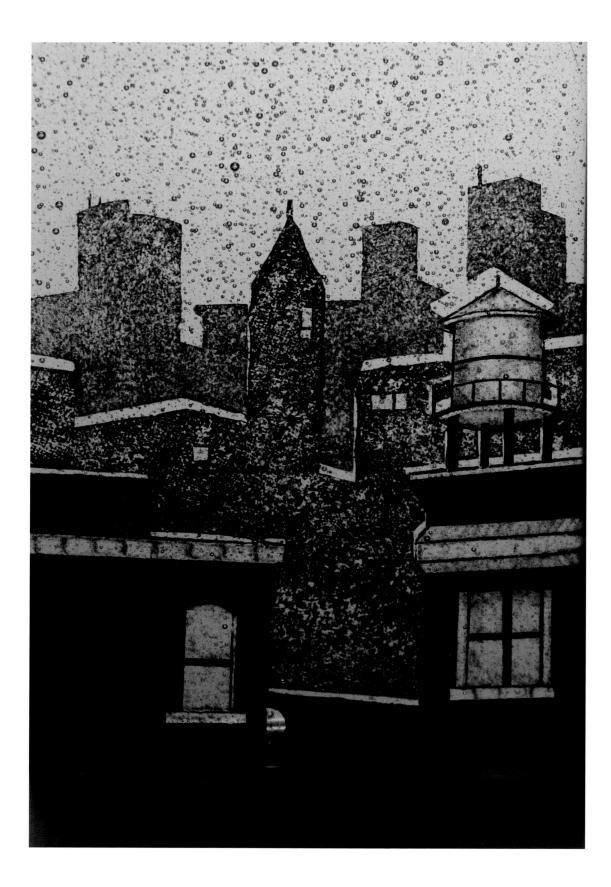

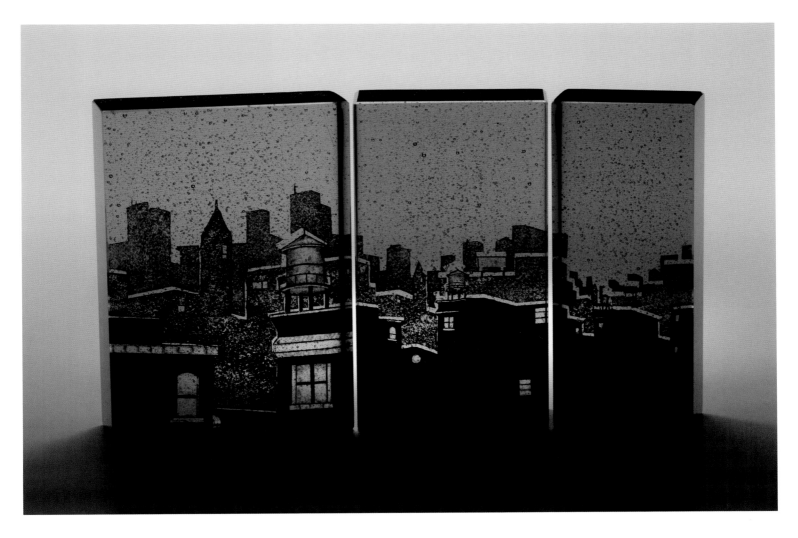

Jeremy Lepisto, *Further from Here*, 2006 (cat. 44)

commissions, other artist's artwork, and architectural projects. They operated Studio Ramp successfully for eight years, before closing the business and moving to Canberra in 2009. George was appointed artistic programs manager at Canberra Glassworks, and Lepisto has undertaken residencies at both Canberra Glassworks and the ANU Glass Workshop while also pursuing a PhD in sculpture at ANU.

In her recent work George has created sequences of small wall panels in modulated monotones. These subtle shades are abstract poetic encapsulations of personal memories, evincing nostalgia for places that have importance to her. A distinctive feature of her approach is blending the Bullseye glass sheet and their fine crystalline powders to create a unique personal palette of subtle tonal nuances. In *Portland Hue* (page 88), a sequence of four panels in muted shades of gray suggest Polaroid images, metaphorical reminders of mood and place for the artist, who has now left that misty "colorscape" behind for the sun-drenched colors of Australia portrayed in *Dry Shade* (page 89).

Lepisto shares with George a sense of place, but where she works abstractly, he creates sculptural works in which images of urban and industrial landscapes are embedded in the layers of glass. Lepisto adapts photographic images with hand drawing and delicate pigmentation using glass powders to emulate the grainy quality of old photographs. These are then placed between layers of uncolored glass before being fused in the kiln. For *Links* he is represented by *Further from Here* (pages 90–91), a triptych featuring a gradually receding perspective of a water tower in the foreground set against an urban skyline.

Richard Whiteley, who has been head of the ANU Canberra School of Art Glass Workshop since 2002, is held in high esteem in Australia and internationally, both as a glass artist and for his leadership role in Australian glass. In this exhibition he is the only artist working with large-scale sculptures, which are cast in the kiln in molds and then extensively finished with a range of cold-worked cutting and polishing techniques. Whiteley originally trained under Moje in the 1980s. In common with both his former mentor and Chaseling, Whiteley originally worked with stained glass. He recalls being an altar boy and "being showered by colors from the stained glass windows."[18] His cast forms are imbued with this ineffable sense of numinous presence, of translucent colored light filtered through the glass. Whiteley has commented that the intensity of light in Australia may seep into the psyche of glass artists here.[19]

Whiteley was initially influenced in his approach to cast glass by his experiences at Pilchuck in 1986, when he took a class from the great Czech masters Stanislav Libenský and Jaroslava Brychtová. Gradually, he has evolved his distinctive language. The formal aesthetic of famed Japanese architect Tadao Ando, particularly the way his structures create a powerful aura through an interplay between positive and negative space, between monumental form and voids saturated with light, has been another persistent influence on Whiteley. He characteristically creates an inner and an outer dimension to his cast forms, mediated by the aperture or void. In his most recent sculptures the aperture is carved to create an illusion

Richard Whiteley, *Solid Light*, 2005 (cat. 91)

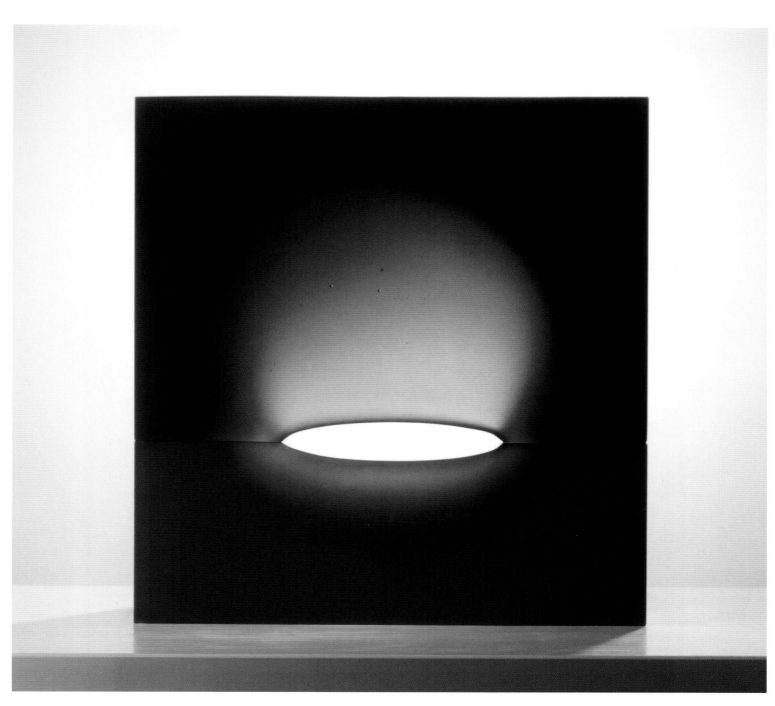

OPPOSITE AND ABOVE: Richard Whiteley, *Orb*, 2008 (cat. 92)

that the cold, hard glass has a strange, pliable sensuality, imbued with fleshly overtones. Tina Oldknow has written of his work: "Whiteley's training in stained glass is reflected in his ability to modulate light and colour within the architectonic structures of his sculptures, which are monumental and complex in their layering, folding and wrapping."[20]

Among the group of younger artists who have emerged from the Canberra glass program over the past decade under Whiteley, there is a noticeable focus on creating works where kiln-formed wall panels and freestanding forms become the equivalent of a canvas for abstract and figurative composition.

There is apparent, too, a suggestion of gender difference, with female artists working with quiet tonal monotones and restrained, minimalist forms and, significantly, seeking resonance between inner and outer worlds.[21] Loughlin was the first to use glass as a means of embodying inner states in her mindscape/landscape series.

While completing an honors year at Canberra School of Art in 2006, Cobi Cockburn evolved her own glass language using technically complex fused, kiln-formed, hot- and cold-worked processes. She created graceful vessel-shaped forms, drawing on the shape of indigenous bark and fiber receptacles, cradles, and canoes (page 99). Organic basketry patterns of layered and sliced sheet glass in muted natural tones were evocative of woven forms and reflected the colors of the dry grasslands around Canberra. She met with instant recognition, winning the Lino Tagliapietra Glass Prize at *Talente* in Munich in 2007 and receiving her first exhibition, *Whispers,* at Sydney's Sabbia Gallery. The following year she held her first American solo exhibition at Bullseye Gallery and traveled to Portland as a teacher and speaker at the annual Glass Art Society conference. In 2009 Cockburn was jointly awarded the prestigious Tom Malone Prize.

Her most recent exhibition, *"esse:" being in the abstract…*, in 2011 at Sabbia Gallery, presented a suite of nine abstract panels, in each of which a horizon is defined in quiet tonal gradations of gray-green and white. Cockburn stated: "Expressing a deep sense of presence with an undeniable sense of absence, sometimes holding opposing forces in a fine balance,

Cobi Cockburn, *Quiescent,* 2010 (cat. 22)

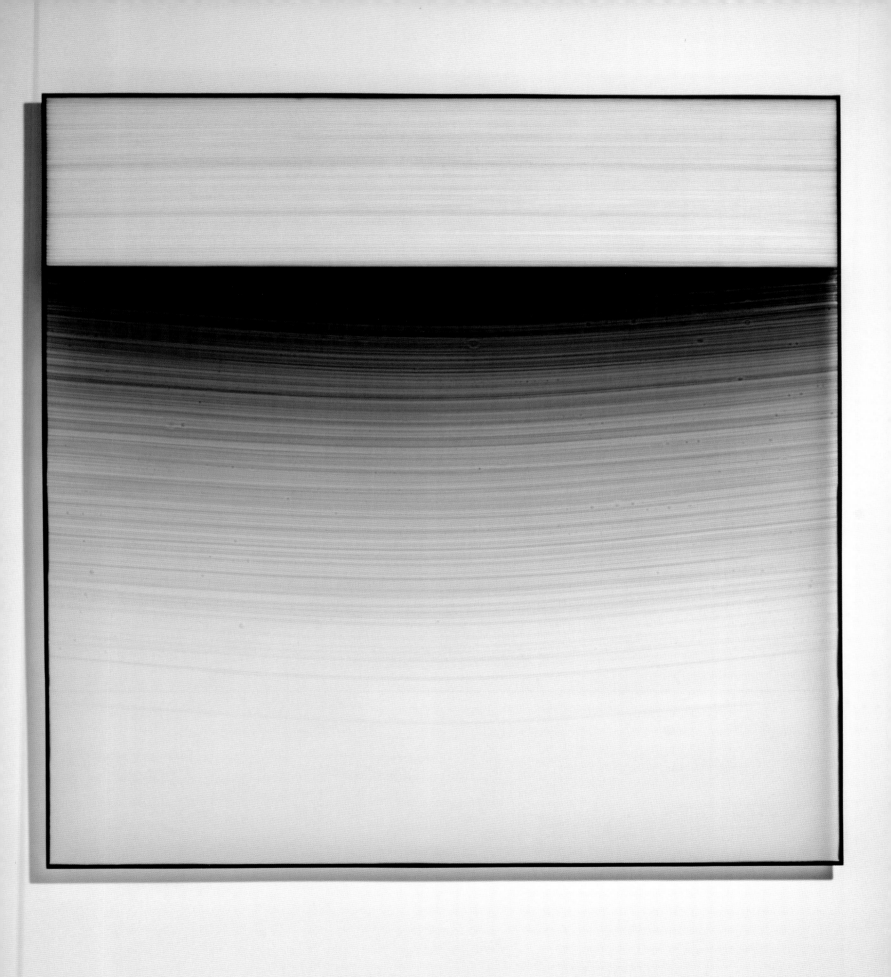

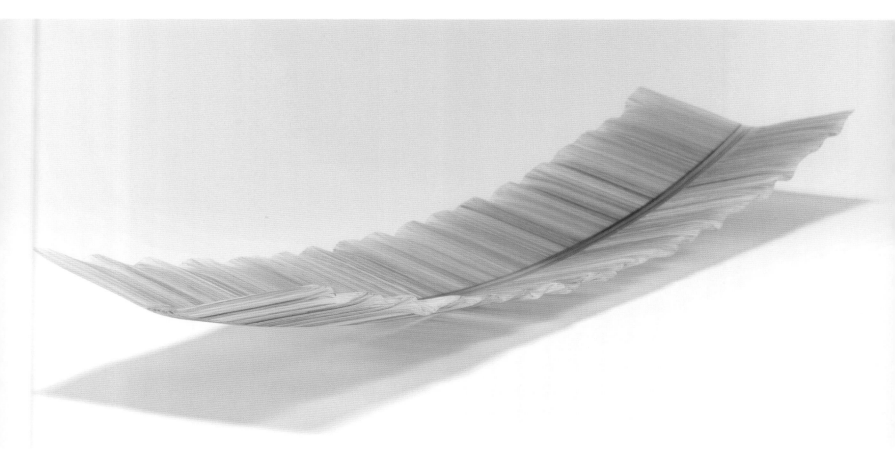

Cobi Cockburn, *Presence*, 2008 (cat. 21)

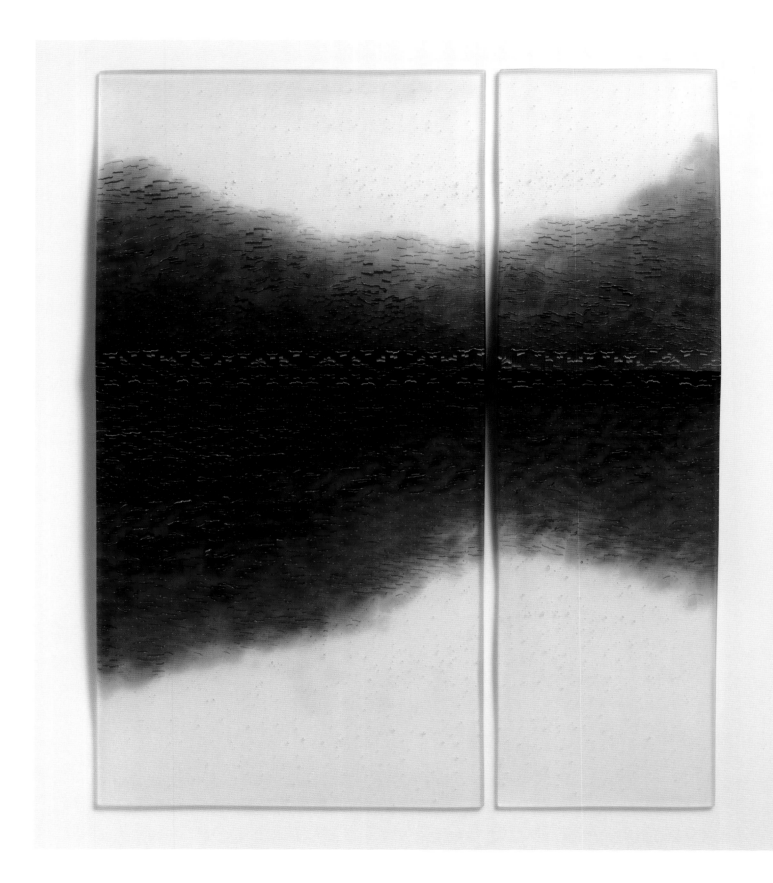

these works explore my realities. They acknowledge elements I not only see, but feel."[22] This entire suite was acquired by the Art Gallery of Western Australia, Perth.

In her kiln-formed and cold-worked panel *Quiescent* (page 97), in the collection of the National Gallery of Australia, Cockburn continues her approach to glass as a medium in which to encapsulate ineffable emotions and embody a state of mind that is beyond words. She states: "My work is an expression beyond language. Its stillness resolves the inner turmoil and calms the questioning, and the longer I contemplate its depths the more I see."[23]

Another instance of quietude and contemplation can be found in the emotional resonance of the murrine panels of Janice Vitkovsky. She originally worked with blown glass while in the JamFactory's two-year design associate program, traveling to Pilchuck Glass School on a JamFactory scholarship and being selected to exhibit at the *Talente* emerging artist expo in Munich. Vitkovsky had already started to experiment with murrine when she became inspired by Giles Bettison's unique approach and persuaded him to take her on as an assistant in a mentor relationship. Assisted by an Australia Council grant, she worked under Bettison in his New York studio in 2003–2004, before moving to Canberra to undertake a postgraduate year at the ANU Canberra School of Art Glass Workshop.

With this excellent pedigree as a foundation, Vitkovsky has spent her time since graduating working in her Adelaide studio on the painstaking development of a continuing series of murrine wall panels. These have been exhibited in Australia and internationally through Bullseye Gallery. Vitkovsky has evolved her own aesthetic language, vastly different from the approach of her former mentor Bettison. Instead of the multi-hued mosaics associated with murrine, she creates monochromatic, seemingly fluid tonal diffusions of aquatic blue-greens or saturated blood reds through the clear glass panel. Vitkovsky is interested in a synesthesia of visual and emotional frequencies to express inner states through color and pattern. She composes rhythmic shifts in tonal density to generate movement within the glass so that the intricate patterns flicker in response to the wandering gaze of the observer.

Janice Vitkovsky, *Saturation II*, 2010 (cat. 90)

PAGES 102–3: Janice Vitkovsky, *Transition*, 2008 (cat. 88)

Brenden Scott French, *Cargo–Future's Pass* (side A), 2010 (cat. 38)

The full palette, painterly impact of Brenden Scott French's abstract wall panels creates a complete contrast to the group of muted and restrained works by women artists. Like Vitkovsky, French completed the two-year design associate program at the JamFactory's glass studio and for several years focused on blown glass, being awarded the Lino Tagliapietra Scholarship to attend Pilchuck in 2001. In 2007 he had residencies at the ANU Glass Workshop and at Canberra Glassworks and was awarded the Stephen Procter Fellowship to attend the North Lands glass school in Scotland. During this year of intense research and stimulus French's focus gradually shifted to working with kiln-formed glass.

Like Loughlin and Cockburn, French draws inspiration from the landscape, but instead of the arid natural landscape of Central Australia, he is attracted to the lush tropical colors of Queensland (where he grew up) and the cultivated hills and valleys near Adelaide (where he now lives), with their patchwork plantings of vines, olives, and vegetables. There is an element of abstract expressionist improvisation in his approach to color and composition as he incorporates the occasional chance events that are part of the kiln-forming process. He has said that he wants to avoid being precious, to be spontaneous and to allow the material to have its voice.

In the approaches of each of these artists, the extreme discipline and painstakingly slow making processes impose a rigor and contained intensity that undercut any tendency toward self-indulgence or overstatement. A disciplined harnessing of technique and perception can be seen in the approach of American artist April Surgent, who spent four years at ANU, obtaining her BFA with honors in 2004, before moving back to establish a studio in Seattle. In

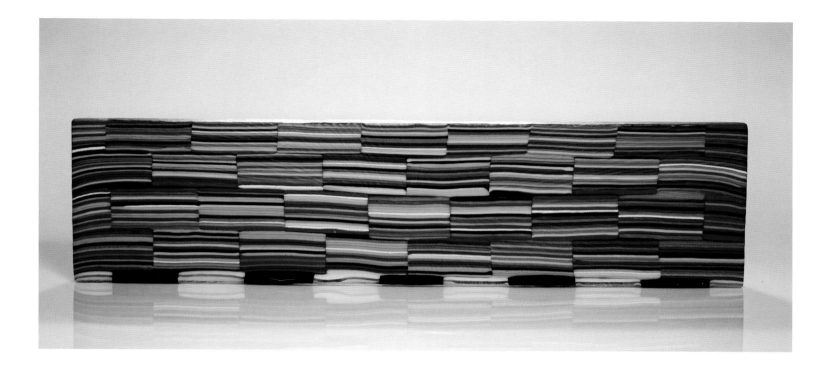

Canberra she first started to engrave layered sheets of glass to reveal the underlying colors and to work in a figurative mode. She has since achieved international recognition for her hand-carved relief drawings in glass. These are based on preliminary digital photographs of the urban environment translated into glass using the ancient technique of cameo engraving, to which she was introduced by esteemed Czech master Jiří Harcuba in a workshop at Pilchuck in 2003 (page 108). Since then the two have worked together many times, most recently at the Corning Museum of Glass in 2012. Surgent uses the traditional technique for contemporary ends, creating evocative impressions of the urban landscape, depicted in gray-green-black tones reminiscent of the half-tone images of silver gelatin photography. For Surgent these are the equivalent of personal diary records of transient moments and fast-changing landscapes. In 2010 she received the Urban Glass New Talent Award. That year she was honored also with a solo exhibition at Bellevue Arts Museum, Bellevue, Washington.

Meanwhile, Klaus Moje, the man who started it all, and who is widely regarded as the father of kiln-formed glass in Australia, has reached the pinnacle of acclaim throughout the glass world and achieved the highest honors of his profession, including lifetime achievement awards from Urban Glass and from the Glass Art Society. Dan Klein remarked that Moje is "one of the finest glass artists of our time."[24] In 2008 Moje completed his most ambitious project to date, a suite of monumental panels, *The Portland Panels: Choreographed Geometry*. The panels were fabricated for Moje by Bullseye Glass, which provided a team of eight to work under his supervision during the many months of development and five weeks of actual production needed to create the panels.

Brenden Scott French, *Cargo–Future's Pass* (side B), 2010 (cat. 38)

PAGES 106–7: Brenden Scott French, *Open Sky*, 2011 (cat. 39)

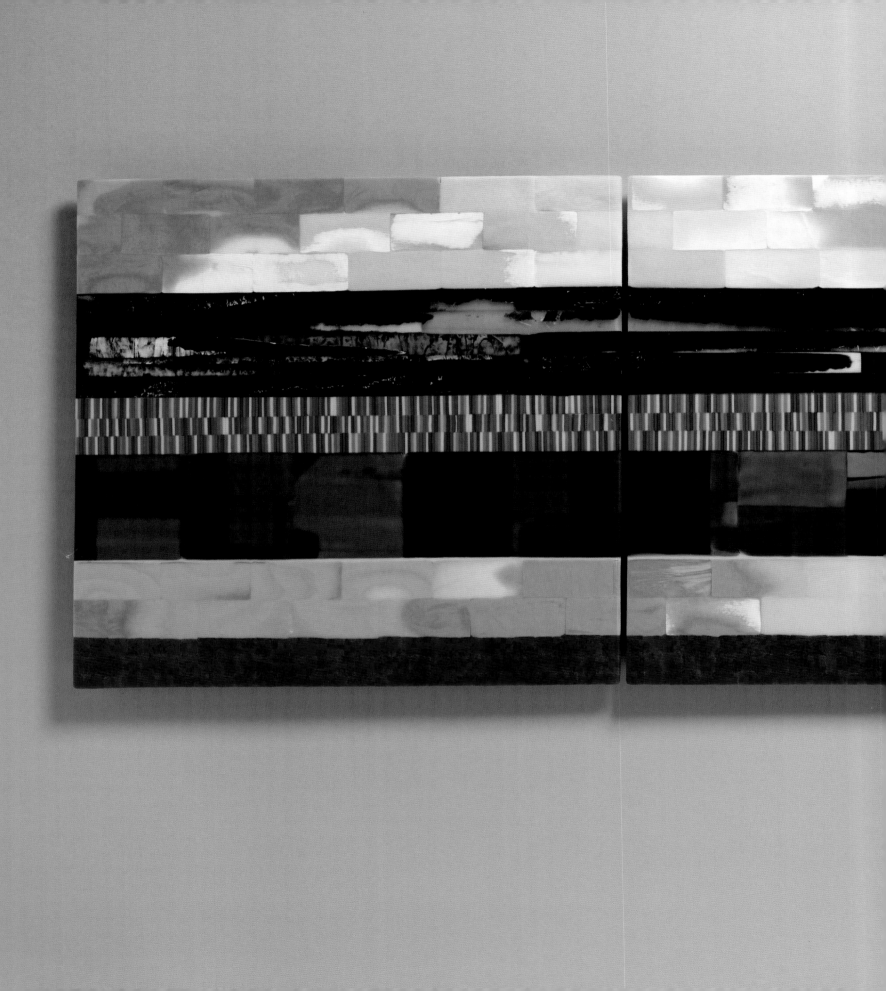

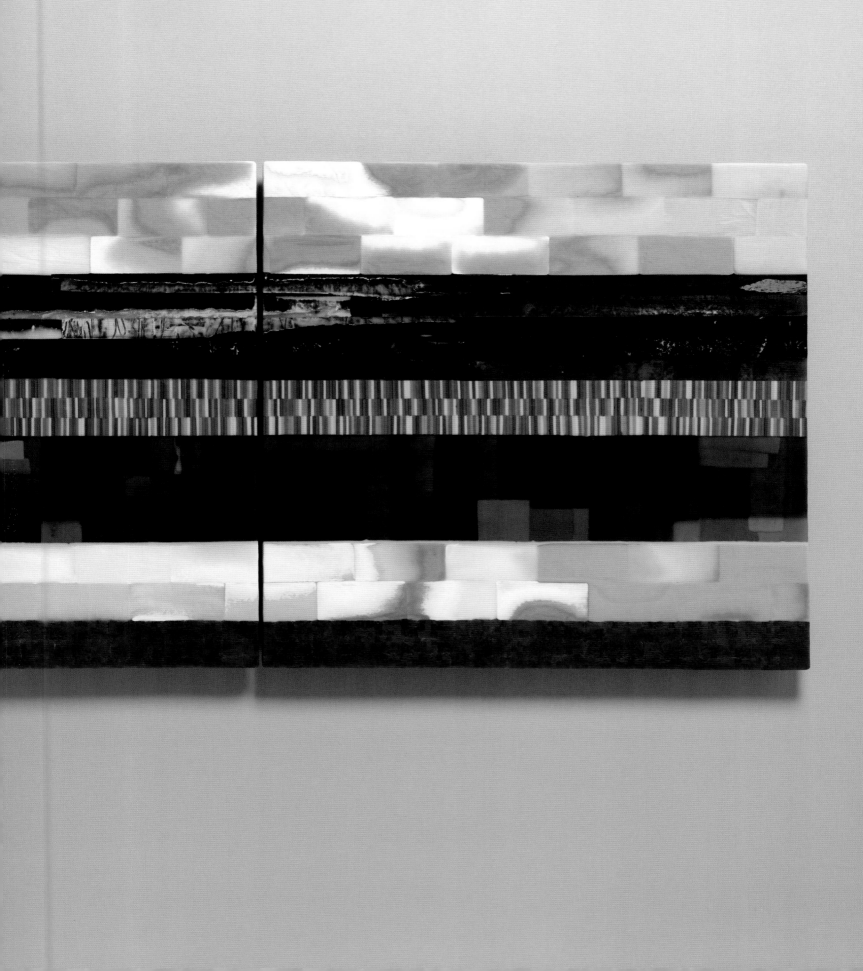

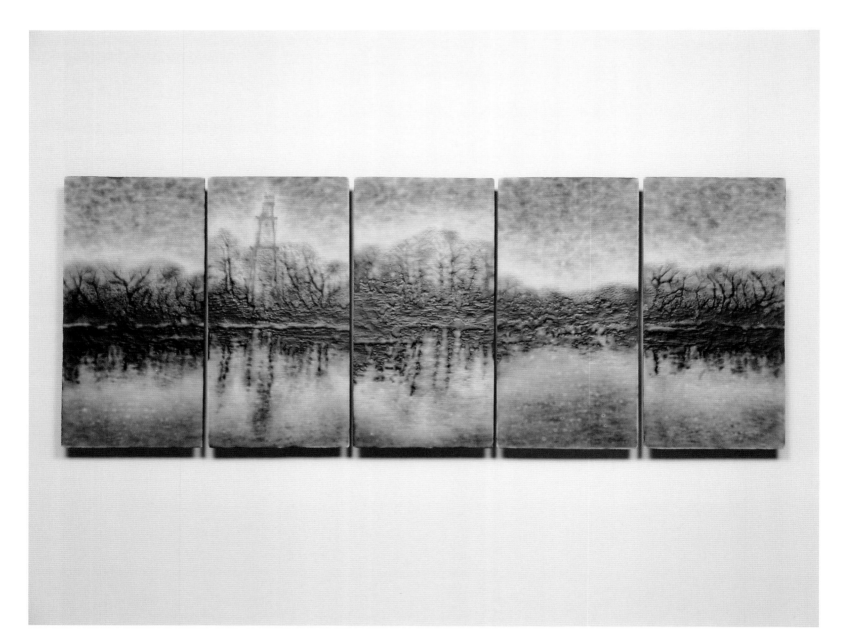

Describing the effect of *The Portland Panels*, I wrote in 2008:

The grand scale enables a dynamic interplay between the three design elements. Firstly there is the dominant design of overlapping diagonal bands generating an illusion of three-dimensional form. Within each band there is the astounding intricacy of poly-chromatic strips to lure the intimate gaze. The third element is the background composed of even finer linear strips in grey and black with mottled flecks of white. . . . The rhythmic choreography of overlapping forms hovers between order and disorder, between a tenuous, unstable equilibrium and impending collapse.[25]

The Portland Panels were exhibited as part of the retrospective exhibition *Klaus Moje,* mounted by Portland Art Museum in 2008. The exhibition was later presented at New York's Museum of Arts and Design as the first single-artist exhibition at the museum.

In the past decade artists working with kiln-formed glass in Australia have moved to a new stage of assured understanding of their medium, beyond the technical challenges and breakthroughs of the 1990s. Now the focus is fully on kiln-formed glass as a formal and aesthetic language. Artists who took part in the Latitudes workshops and Bullseye residencies have now achieved consummate mastery, while they continue to push technical possibilities to find new ways to embody their ideas. The latest generation of artists to emerge have an astonishing level of technical and aesthetic accomplishment. The Canberra/Portland connection continues to generate innovative approaches to kiln-formed glass.

April Surgent, *I'll Think of You from There*, 2007 (cat. 87)

NOTES

1. Dan Klein, "Material Understanding and Chromatic Splendor: The Art of Klaus Moje," in *Klaus Moje* by Bruce Guenther and Dan Klein (Portland: Portland Art Museum, 2008), 46.

2. Megan Botteri, *Klaus Moje: Glass* (Sydney: Craftsman House, 2006), 57.

3. Moje attended nine sessions as an instructor from 1979 to 2004 and was Pilchuck artist-in-residence in 2000.

4. Botteri, 65.

5. Jo Litson, "Fused Together: Education and Industry: Canberra School of Art Glass Workshop and the Bullseye Connection," *Object* 42 (June 2003): 51.

6. Ibid.

7. Richard Whiteley, "Along a Different Parallel: Australian Directions in Glass Education," in *Australian Glass Today* by Margot Osborne (Adelaide: Wakefield Press, 2005), 20.

8. Mark Bayly, "Shadow-field: The Synthesis of Light and Shade in the Art of Kirstie Rea," in *The Colour of Air, The Scent of Light: Works by Kirstie Rea* (Canberra, 2004).

9. Kirstie Rea artist statement, *The Colour of Art, The Scent of Light*.

Klaus Moje at Bullseye Glass beside *The Portland Panels*, 2007.

OPPOSITE: Klaus Moje, *The Portland Panels Choreographed Geometry* (detail), 2007 (cat. 69)

10. Moje's cylindrical *Niijima* vessels are shaped but not actually blown, but the potential was there and this was subsequently explored by others, most notably by Scott Chaseling.
11. Moje has continued to demonstrate the roll-up technique in international glass master classes and workshops.
12. Claudia Borella now lives in New Zealand and is therefore not part of the *Links* exhibition.
13. Record of interview with Peta Mount, Adelaide, January 30, 2012.
14. Dan Klein, *Artists in Glass: Late Twentieth Century Masters in Glass* (London: Mitchell Beazley, 2001), 28.
15. *International Young Artists in Glass* (Portland, OR: Bullseye Glass Company, 1998), 21.
16. Artist statement for exhibition *Landscape: Mindspace*, Bullseye Gallery, 2002, and accompanying publication *Jessica Loughlin at Bullseye Glass* (Portland: Bullseye Glass Company, 2002), 4.
17. Email to author July 2012.
18. Interview with the author September 2004.
19. Ibid.
20. Tina Oldknow, "The Quest for Form," in *Richard Whiteley*, exhibition catalog (Canberra, 2009), 5.
21. I am not suggesting that concern with resonance between inner and outer worlds is an exclusively female preoccupation in glass. In 2010 I curated an exhibition on this theme, *Mind and Matter: Meditations on Immateriality* for JamFactory Contemporary Craft and Design, Adelaide, and Object, Sydney. Three of the eight artists (all Canberra Glass Workshop alumni) were male, namely Richard Whiteley, Brian Corr, and Masahiro Asaka. Female artists were Jessica Loughlin, Janice Vitkovsky, Mel Douglas, Gabriella Bisetto, and Deb Jones.
22. Artist statement, Cobi Cockburn, *'esse', being in the abstract…* (Sydney: Sabbia Gallery, 2011).
23. Email to author August 2012.
24. Klein, *Artists in Glass*, 146.
25. Margot Osborne, "The Glass Art of Klaus Moje: Disciplined Emotion," *Neues Glas/ New Glass*, no. 4 (2008): 23.

AUSTRALIAN GLASS THROUGH A FACTORY LENS

LANI McGREGOR

Like all histories, that of Bullseye Glass Company is woven of fact and fiction, but punctuated with key dates and events to which its keepers ascribe special importance. Unlike the typically slow evolution of manufacturing methods, products, and markets, it is sometimes a single encounter—a collision of time, place, and personalities—that defines the future of an organization.

IN THE BEGINNING: SUMMER 1979

Pilchuck Glass School's 1979 summer session is one such moment. It was there and then that Boyce Lundstrom, one of Bullseye's three founders, first met the German artist Klaus Moje, who would soon initiate the glass workshop at Canberra School of Art, and where the Portland, Oregon factory became inextricably linked to Australia in the decades ahead, as Moje, Bullseye, and Australia carved out a singular place for kiln forming in the world of contemporary studio glass.

Pilchuck 1979 was in some ways Bullseye's "Little Toledo"—a moment when a handful of artists, similarly curious about one aspect of glass forming (in this instance fusing), collided in the heady and passionate atmosphere that characterized the arts and society at large in post-1960s America.

But as significant as Pilchuck 1979 has come to be in Bullseye's short history, it was and continues to be in many ways as peripheral to fusing as fusing has been to blowing in the Pacific Northwest and elsewhere. Pilchuck's campus epicenter is its dramatically pitch-roofed hot shop, where furnaces and gaffers dance, glow, and dazzle in ways that a well-prepped kiln shelf and a precisely programmed controller can never engage. At Pilchuck, the kiln studio is literally an uphill climb, and while it has improved over the years, it has yet to catch up to its flashy cousin and the cheering audiences down the hill.

While they share a material, the two major methods of working glass are worlds apart. Blown (or hot) glass centers on a furnace, a glory hole, a marvering table, and a gaffer's bench. At its finest the method involves a team of skilled workers moving with exquisitely timed, dancer-like moves.

Fusing, or kiln forming, is by contrast typically a solo act, its essential tool an electric—sometimes gas-fired—chamber into which room-temperature, premade glass in the form of sheets or chunks, grains or powders, is placed and heated.[1] Molds may or may not be used. The process is rarely an intentionally spontaneous one. Executing well-made kiln glass requires acute skills of anticipation: knowing how the material will behave at specific temperatures for specific periods of time while inaccessible to the hands of the maker.

Blowing can be great theater. Kiln forming more closely resembles a science experiment. Except for the occasional "creative disaster," the end product of kiln forming is more interesting to view than its making.

The more low-key persona of fusing or kiln glass in the Seattle/Pilchuck community has occasionally collided with Portland's second city "we-try-harder" posture. Often overlooked by travelers jetting between the West Coast hot spots of Seattle and San Francisco, Portland's attitude toward blown glass in general can

Bullseye Glass founders (from left) Ray Ahlgren, Dan Schwoerer, and Boyce Lundstrom, late 1970s.

be tinged with the feisty yip of the underdog or the bellicose chest-thumping of a lesser city-state.

Another Bullseye cofounder and current owner/CEO, Dan Schwoerer, frequently recounts the advice he received from studio glass pioneer Harvey Littleton on telling his former professor at University of Wisconsin, Madison, that he was moving to Portland. "Portland? Why would you go *there*"? Schwoerer recalls Littleton chiding. "Go to Seattle. Or San Francisco. Forget Portland!" In a 60s knee-jerk response to authority, Schwoerer promptly booked his ticket to "Stumptown."

OUTSIDE THE BUBBLE

For Klaus Moje in 1979, Dale Chihuly's invitation to visit Pilchuck was eagerly received. Moje regularly describes his first visit to the campus as one of awe at the energy, enthusiasm, and sense of exploration unrivaled by anything he had experienced in his more formal glass training in the German Glashfachschulen of Hadamar and Rheinbach. He had been invited by Chihuly after Pilchuck's cofounder had seen the unusual fused and carved-glass forms that Moje was making in his Hamburg studio. Moje's appreciation for what Chihuly had done in creating the Pilchuck Glass School is central to the admiration that the two masters have shared for almost forty years.

As keen as Moje's enthusiasm might have been, that summer in Pilchuck the Italians and the Swedes owned center stage. They easily mesmerized an audience of young Americans who had rarely seen hot glass handled with such skill. That Lino Tagliapietra arrived at Pilchuck the same year as Moje—while of historic significance for blowing—did little to help the position of kiln glass in America. The theatricality of the hot-glass process, especially as demonstrated by Venetian masters, easily captured the attention that the less exuberant and more solitary methods of kiln forming could not hope to match.

While the hot shop reverberated with flame and applause, Moje searched in vain for a simple kiln and tools to cut the colored glass rods that he had been generously provided in order to continue the work he had begun in Germany. Moje had trained as a glass carver, and the basis of his fusing work had long been the cutting of colored glass bars that were assembled on kiln shelves and subsequently melted together into flat panels in a kiln, slumped into molds on a second firing, and finally ground at their surfaces—with only occasional success, for reasons discussed later.

Although he speaks fondly of that summer, Moje admits "What I got out of Pilchuck was not worth very much. . . no work could really be done to a finished state."[2] Without a kiln, and with only a small band saw from which the diamond blade had quickly been pilfered, Moje's first Pilchuck session was doomed. The odd work that resulted was never of a standard that Moje could accept.

What he *did* get out of Pilchuck that summer—in addition to an appreciation for a particularly American brand of exuberance— was an encounter with Boyce Lundstrom, the notorious zealot of fusing, who had left his partners Dan Schwoerer and Ray Ahlgren down south in Portland, tending their five-year-old sheet glass factory. Ironically, Lundstrom had gone to Pilchuck not to learn about the fusing methods that he, Ahlgren, and Schwoerer

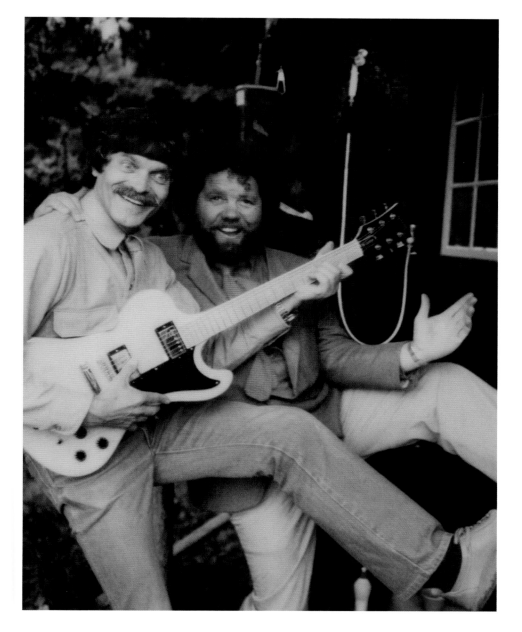

had been exploring in recent years, but to take a blowing class.

Moje regularly and affectionately characterizes the Bullseye Boys in that era as arrogant and naïve American hippies who were eager to show him what they could do to solve his fusing problems. Lundstrom, far from the least arrogant, invited Moje to Bullseye's factory immediately after their Pilchuck summer.

Surprisingly—and fortunately for recent glass history—the German artist, although dubious, humored the Bullseye partners and accepted the invitation.

TWO HUNDRED MILES SOUTH AND A WORLD AWAY

Pilchuck in 1979 was little more than a camp of tents, cabins, and tree houses surrounding a temple to the gods of blowing, and Bullseye Glass Company was at least as funky.

Started in 1974 by three recent graduates from American university glass programs, Bullseye barely merited the title "business." Schwoerer and his then–studio partner Ray Ahlgren had come out of Harvey Littleton's

Klaus Moje (left) and Dale Chihuly at Pilchuck, 1979.

program at Madison, where Schwoerer in the late 1960s had worked as Littleton's assistant, mixing batch ("Without a respirator!" Schwoerer likes to relate with horror-tinged nostalgia), feeding his professor's horses, even fixing Littleton's washing machine. Originally from Los Angeles, Lundstrom had studied with Dr. Robert Fritz at San Jose State, graduating in 1967 with training in glass and ceramics and with a West Coast style of brash salesmanship that helped him convince a couple of Wisconsin blowers to follow him over the nearest business cliff.

In many ways the Bullseye factory was—and continues to be—run as much as a graduate program as a factory. Shortly after setting up a shop in 1974 to roll sheet glass for the reawakening stained-glass trade, the partners began to investigate ways to eliminate the lead line (the definitive element of stained glass) and to melt glasses together through fusing—a glassworking method for which there was absolutely no market at the time.

A wooden shack nestled among weeds alongside the railroad tracks in a southeast Portland neighborhood known as Garlic Gulch would soon become home to Bullseye's Fusing Ranch.

While three blocks away the factory continued to hand roll lopsided sheets of colored glass made with recycled bottle cullet, Lundstrom, often wearing a cowboy hat and wooden clogs and carrying a leather man-purse, preached the gospel of fusing to a small coterie of artistic disciples. Ruth Brockmann, Richard LaLonde, Gil Reynolds, and David Ruth experimented with new methods and materials, tested shelf primers and overglazes, and eventually went out across the United States teaching what they'd discovered at Bullseye about compatibility, annealing, devitrification, volume control, and the various intricacies that are central to fusing but less so to blowing.

In the years immediately following Moje's visit to the factory (1979–1983), the partners devoted so much of the company's resources to the investigation of fusing that they brought it to the edge of bankruptcy. The culmination of the greatest body of original research in contemporary fusing practice was ambitiously titled *Glass Fusing Book One* (1983). The book that years later Richard Whiteley, current head of the glass program at Australian National University, would recall had been the "bible" for students in the 1980s and 1990s would long outlive the Lundstrom/Schwoerer partnership.[3]

A COMMON PROBLEM, A SIMPLE SOLUTION

The difficulties that Moje had encountered in melting together color bars from the German Hessen Glaswerke were the same as those that the Bullseye partners had already discovered in their own early experiments: colored glasses that do not expand and contract similarly once melted together exhibit strain between their interfaces that results in stress sufficient to break the pieces apart—immediately or eventually—once cooled to room temperature.

Compatibility, the central technical obstacle to fusing, is a lesser problem in blowing for two primary reasons. First, the interface of the color layer with the base clear glass is typically thin enough to create little strain. Second, the most common shape in blowing, a sphere, is by its nature a very strong form.

Compatibility in the kiln—where broad interfaces of distinct colors are often fused together—had long hindered the creation

of larger kiln-formed objects in glass. Glass jewelry parts, buttons, tiles, and small vessels have been the end products of the kiln-forming process since roughly 2500 BC. Without a palette of rigorously tested and readily available compatible glasses, they might have remained the primary oeuvre of this lesser-known glassworking method.

Bullseye's solution was a simple if not an immediately obvious one. By fusing glass chips from a range of glass sheets against a standardized base of clear test glass (that would itself be held to the same standard over decades of subsequent production) and using polarized lenses to measure the stress at the interfaces between the individual chips and the base clear, it was possible to identify an entire palette of colors that—if compatible with the base glass—would be compatible with each other. The rest was defining the tolerance of allowable stress, measuring for it, adjusting formulas and melts, measuring again, and keeping meticulous records.

While the testing method is simple, its integration into manufacturing is less so. Making compatible glass depends on a variety of factors: a chemical formula and a melt cycle (the length of time at a particular temperature in the furnace) are the primary determinants, but even the age of a furnace and the barometric pressure can impact the resulting glass. With so many variables, the only assurance of compatibility is testing once the glass is produced. In the case of an incompatible glass, adjustments can be made to the subsequent run, but an incompatible glass cannot be made compatible once formed. Hence the necessity for extreme precision in material measurements and temperature controls—and the crippling cost of even minor errors.

Compatibility is also relative: larger works require tighter tolerances than smaller ones. Hence, glasses deemed incompatible by the standards set in factory testing may still be fired together without great risk of breakage in small jewelry pieces. It is the scale, the often extreme firing cycles, and the intricacy of kiln work that has challenged Bullseye and many of the Australians with whom the factory has worked.

TECHNICAL DEVELOPMENT MEETS ARTISTIC INSPIRATION

Bullseye had previously committed an inordinate amount of work to exploring glass fusing—inordinate, given the size and resources of the small factory and the overwhelming lack of interest shown by its stained-glass dealers at the time. Now the meeting with Moje would prove to be the inspiration needed to continue the efforts when economic realities argued to the contrary.

Moje's fused works, even when realized in a vessel format, alluded to territory largely foreign to the interests of the American blowing community, which was beginning its love affair with the *façon de Venise* as introduced to Pilchuck by Tagliapietra and deftly adapted by the young Dante Marioni, among others. Moje's roots in post-Bauhaus Germany and his coming-of-age studio work in the 1960s ensured that his aesthetic development would, as Portland Art Museum's Bruce Guenther emphasized in the artist's 2008 retrospective, be more strongly influenced by the color theories of Josef Albers and the visual language of Op Art.[4]

Among the myths that cluster about the Moje/Bullseye relationship is one that ascribes

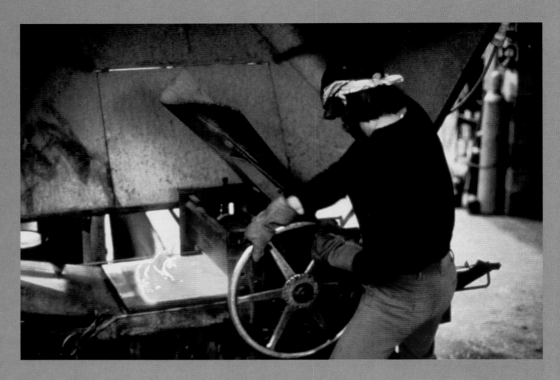

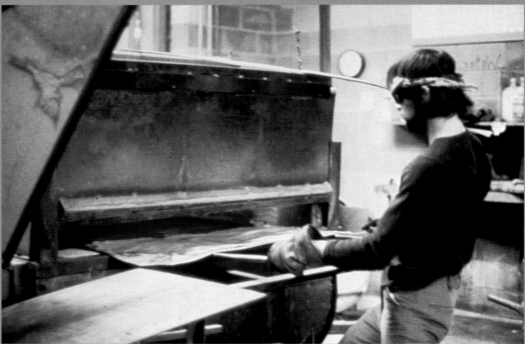

TOP: Sheet glass being hand rolled at Bullseye Glass factory, ca. 1976.

BOTTOM: Sheet glass being loaded into annealer at Bullseye, ca. 1976.

OPPOSITE: Sheet glass moving from roller to annealer at Bullseye, 2006.

to the artist the technical expertise behind the development of compatible glass. What Moje gave to Bullseye—and continues to give—has never been the technical insight to solve material problems. It was and continues to be something far more valuable: aesthetic inspiration. This was exactly the impetus that a factory run by art school graduates needed: a maker who would turn their material into something often more dangerously alluring than profit: a new art-making material and process.

AUSTRALIAN INFLUENCES ON BULLSEYE AND AMERICAN KILN GLASS

Over the last three decades Moje and many of his progeny and successors at the program at Canberra have helped to drive the direction of material and method that has come to define kiln glass at Bullseye and by extension across the United States and abroad. Often the spur has been a technical problem such as the aforementioned compatibility hurdle. Equally often the factory has responded to an individual artist's aesthetic preference, be that for a specific color, form, or density. Occasionally, the incentive is the direct collaboration behind a residency at the factory or an exhibition at the company's Portland gallery. Sometimes it has been process oriented.

Since the original development of Bullseye's compatibility testing program, more recent kiln working by Moje and other Australians has demanded standards previously beyond the factory's testing protocols. Whether firing to higher temperatures with longer soak times—such as Moje's recent more fluid compositions—the multiple glory hole reheats of previously fused murrine in Giles Bettison's pick-up method, or roll-up works such as Scott Chaseling and Kirstie Rea's innovations, the demands on a glass for kiln forming have become increasingly exacting.

In response, the factory instituted triple-fire tests for hot colors that are typically susceptible to changing their chemistry after extreme heat work.[5] Moje himself helped provide the solution when he brought the young Austrian Rudi Gritsch, head of the kiln-glass program at the Glasfachschule in Kramsach, Austria, to Bullseye after Gritsch attended Moje's Pilchuck workshop in 1990.[6]

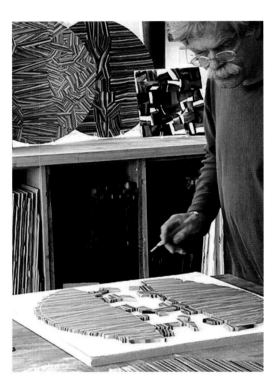

Klaus Moje assembling glass for fusing at his studio in Wapengo, Australia, 2004.

OPPOSITE: Cobi Cockburn, *Quiescent* (detail), 2010 (see p. 97, cat. 22)

At the opposite chromatic extreme from the overheated hot colors is the range of whites and neutrals that Australian artists have directly and indirectly inspired the factory to develop, which would not otherwise have likely appeared in the US market for fusible glass. Minimalists such as Jessica Loughlin and Cobi Cockburn are the unnamed muses of hues like Bullseye's White, Translucent White, White Opaque, Lacy White, Opaline Striker, Cloud, White Streaky, and Vanilla.

Likewise, the factory's development of some of its palest tints for casting were explicitly requested by Richard Whiteley as his works increased in thickness (page 123). Contrary to what the layman often thinks, consistency between glass batches increases in difficulty as tints lighten, making the ever-increasing scale of Whiteley's works an ongoing, albeit welcome, headache.

The recent evolution of much Australian kiln glass to a wall-panel format has driven Bullseye's researchers to study aspects of the process outside the realm of glass manufacturer and to undertake testing on adhesives and mounting systems. The increasing body of Australian kiln glass designed for wall display has come to characterize Bullseye's appearances at national and international art fairs and has presaged the appearance of more two-dimensional wall works in kiln glass by American artists.

Whiteley—and many of the other Australian kiln formers—have more than paid back Bullseye and its users by sharing much of the most advanced technical information in the field of contemporary kiln glass. Whiteley, Moje, Jane Bruce, Loughlin, Bettison, and Rea, among others, have been invaluable fixtures in the teaching and lecture circuits of Pilchuck Glass School, The Corning Museum of Glass, Bullseye, Glass Art Society, and various other programs within the Pacific Northwest and across North America.

The varied technical encounters between Bullseye and the Australians have helped to shape not only the factory's products, but those of the numerous other American manufacturers that eventually followed Bullseye's lead in making compatible glasses for kiln formers once the market had grown to a significant size.

Without artists pushing a material into new territory, a manufacturer can only milk the profits of the inevitable "product life cycle"—a cycle often shortened by its very

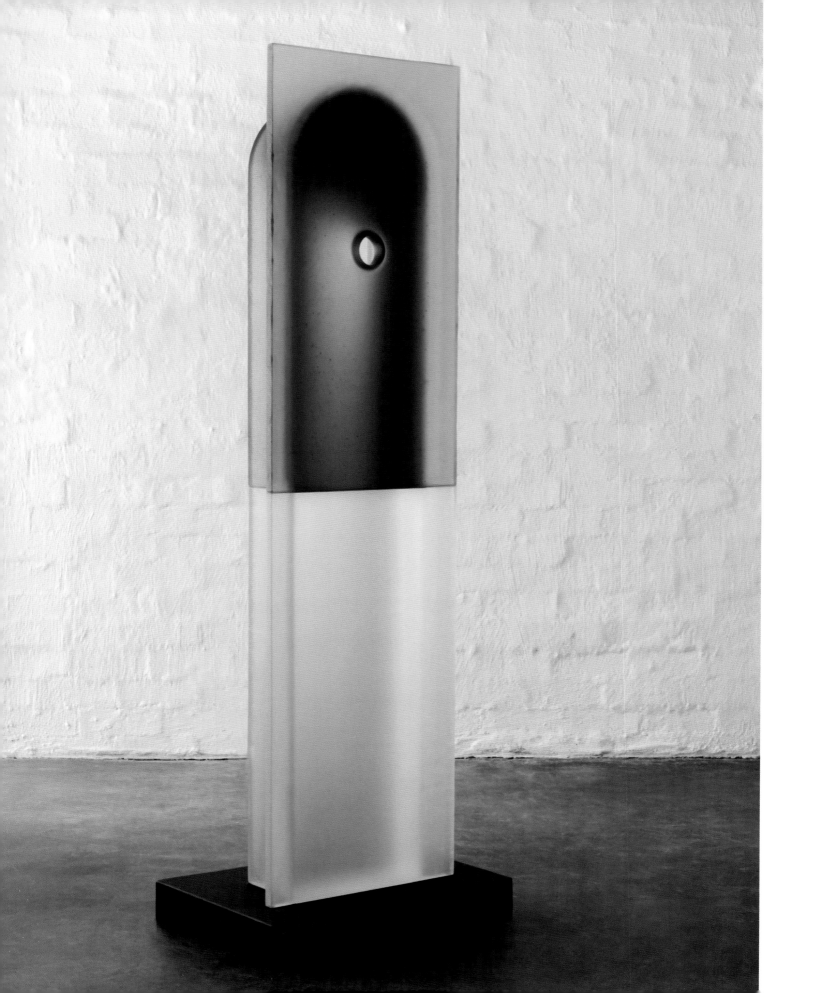

success. The artists who have come out of Canberra especially have consistently pushed the limits of what is done with glass in a kiln and encouraged Bullseye to engage ever more exciting and sometimes perilous after-lives.

THE DUCKBILL PLATYPUS OF CONTEMPORARY GLASS

Of all the methods to have evolved from Bullseye's interaction with the Australians, none captures the innovative and eccentric spirit of this odd coupling as well as the "roll-up."

Occasionally conflated with Giles Bettison's signature murrine pick-up method, whose Venetian roots trace back through American Richard Marquis, the roll up, probably the most Australian of all glassmaking hybrids, is one that has oddly wandered off to America since its Australian parents largely abandoned it still in its infancy.

The "Great Australian roll-up" has often been misunderstood in America. Developed originally as a way to marry fusing and blowing—to combine the thoughtful, painterly precision of kiln work to a third and vertical dimension of hot glass without the cost or constraint of the furnace—the roll-up was the brain child of Moje and his students Scott Chaseling and Kirstie Rea.

After refining the method during their 2000 Bullseye residency and sharing it with an American audience, Chaseling and Rea eventually moved on in their own work, leaving the method to an American audience that frequently misunderstood both a central point of the process—it doesn't require furnace glass—and a major corollary—it is the kiln-centric preparation that makes or breaks the end result.

Among the few Americans who "got it" are Californian Johnathon Schmuck, who worked at Canberra on Moje's early roll-up team, and Steve Klein (page 76), who learned the method from Chaseling and Rea in the Bullseye workshop. Still further removed, but taking the method to a remarkable new place, is artist Marc Petrovic, whose much applauded "Avian roll-ups" have recently hatched years and miles away from their land of origin.

Richard Whiteley, *Arch*, 2012 (cat. 94)

That the Great Australian roll-up has achieved more prominence in the States than in Oz is hardly a rare cultural phenomenon. Few prophets get much attention in their homeland.

THE VIEW FROM HERE

Thirty-three years have passed since a fledgling Oregon glass factory hit the radar of a German artist struggling to fuse glass in the woods of Western Washington. The former tree farm has grown to become the acknowledged annual summer hot spot for the world's most luminous and most aspiring in contemporary glass.

The German/Australian artist has retired—albeit only from his "day job"—to devote full time to his art and to his position as the acknowledged "Papa" of kiln glass, not only in Australia but around the world.

Bullseye's hippie-built favela of factory sheds and smokestacks has disappeared beneath an architecturally impressive corporate façade, while still clinging to and occasionally achieving its dream of campus life.

It's 2012 and deep in the factory studios, the icon of Venetian-style blowing, Lino Tagliapietra, is loading kiln shelves with sheet glass, frits, and murrine. "This fusing stuff— it's not so easy as we used to think," he confides to a Bullseye technician after building his sixtieth fused panel—all without the audience to which blowers are accustomed.

I suspect that like many who have looked up the hill from Pilchuck's pulsating hot shop, Tagliapietra, on his many visits to the campus, may have glimpsed the Australians working alone, creating in their quietly elegant ways in the kiln studio, and noticed the strength in their method and the beauty in their vision.

Bullseye has been fortunate to have shared their journey.

Jessica Loughlin, *in close distance*, 2009 (cat. 49)

NOTES

1. Kiln forming, kiln working, or—less precisely—fusing is the broadest category used to designate glass shaped primarily within a kiln. (Blowing and hot casting also employ a kiln, but as an end process for the annealing—the controlled cooling—of the previously formed glass.) Subcategories of kiln forming, sometimes called kiln glass, include *kiln casting*, which requires a mold or other supporting structure for glass thicker than 6 millimeters; *slumping*, usually a secondary firing process, in which a previously flat panel of glass is draped into or over a mold; and *pâte de verre*, a kiln-casting process in which the primary glass form is precrushed glass particles, may or may not involve a mold, and (in its more recent versions) employs relatively lower firing temperatures than full-fused or kiln-cast works. Rarely is kiln glass or kiln forming called "warm glass" by professional artists working in the field, a term found offensive by many.

2. Interview with the author at Bullseye Glass Company, Portland, Oregon, April 1, 2012.

3. Lundstrom sold his shares in Bullseye to Schwoerer in 1985. Ahlgren had left in 1980.

4. Bruce Guenther, "A Fused Ground," in *Klaus Moje* (Portland, OR: Portland Art Museum, 2008), 9–13.

5. Certain glass compositions behind the range of hot colors—reds, yellows, oranges, and pinks—are prone to change their internal chemistry on multiple or high-heat firings. The metal oxides involved are usually cadmium, selenium, sulfur, and gold.

6. Gritsch eventually returned to Bullseye as its first head of kiln-glass research in the early 1990s.

Klaus Moje, *Untitled #10*, 2005 (cat. 68)

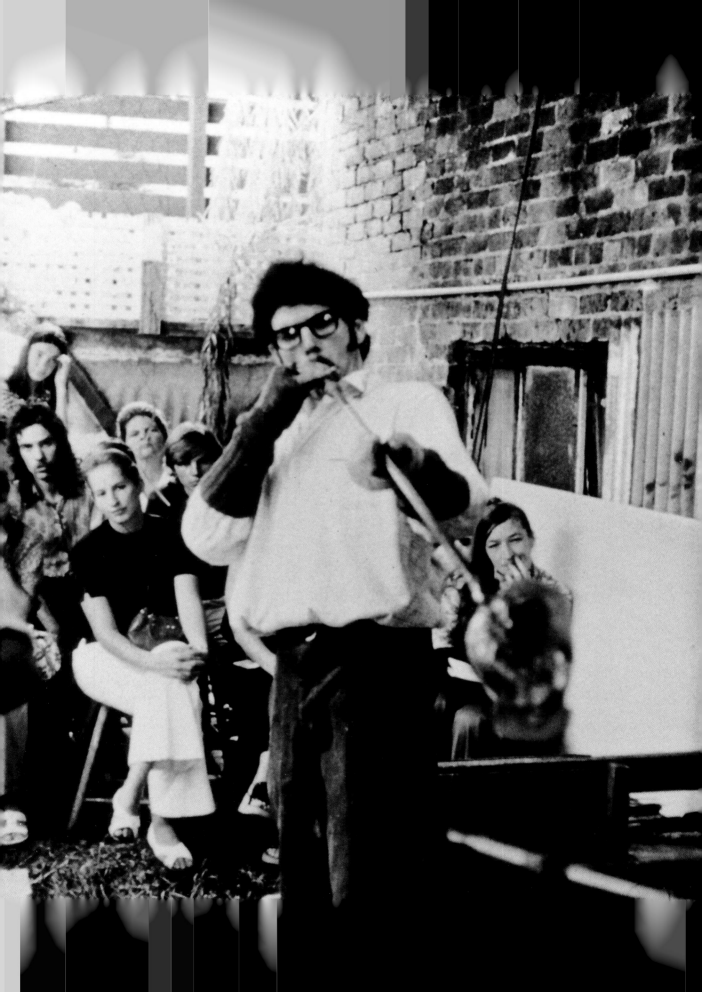

LINKS AND MORE LINKS:
AN AUSTRALIAN BACKGROUND, 1970s–1990s

GRACE COCHRANE

Joining, stretching, breaking, rearranging, fusing, scratching, polishing, falling off, attaching, accumulating—"links" are usually components of some form of chain.

And so it is with this exhibition. *Links: Australian Glass and the Pacific Northwest* gives an insight not only into the work of this particular group of people, but also into the particular set of circumstances that has brought them together. The detailed consideration of relationships between these Australian glass artists and their colleagues in the Pacific Northwest of the United States provides a compelling example of the value of personal and professional connections that can successfully cross considerable time and distance. Many events have contributed to the development of this story—from Dick Marquis's visits to Australia in the 1970s and Klaus Moje's arrival at the Canberra School of Art in 1982, to the growing connections between centers such as the Bullseye Glass Company, Pilchuck Glass School, and JamFactory Contemporary Craft and Design, and the two-way migration between both countries that has followed into the 2000s. At the same time, these developments are underpinned by a wider history of other, often related, connections that also provide a context for the exhibition. This essay is intended to provide a summary of that wider background; of more links in the chain.

STUDIO GLASS: EARLY DEVELOPMENTS

Glassmaking had been carried out in hot-glass industries and lead-lighting workshops in Australia since the nineteenth century. But by the early 1970s, while some commercial flat-glass studios remained, eventually only the Philips lighting company's Leonora Glass Works, near Newcastle in New South Wales, still operated as a hot-glass factory. The important Crown Crystal Glass company in Sydney, part of Australian Consolidated Industries (ACI), had ceased hand production in 1968 when it merged with Corning, USA, to become known as Crown Corning. In the quickly developing crafts world of the 1970s, many Australians were glad to adopt the example of working in glass as an individual maker. However, they also needed to make links with industry and European traditions where they could, in order to learn some of the processes.

While stained or flat-glass was equally part of the contemporary crafts movement, this essay will focus on those who chose glassblowing, kiln forming, casting, and cold working, although a number of those included in *Links*, in fact, started their careers working with flat-glass processes. Earlier, experiments with kiln working had been made in the 1960s by painter and stained-glass artist William Gleeson in Melbourne, while into the 1970s, glass artists such as David Wright and Cedar Prest (later chair of the Crafts Board) incorporated cast components into their windows, and many from this field were to make "autonomous panels" for exhibition. In Sydney, also in the 1960s, designer Douglas Annand had used glass in a number of innovative ways, including molding, engraving, and laminating layers of sheet glass for sculptures (page 130).

Hot glass as a studio activity was introduced to Australia through the efforts of individual artists from many different backgrounds. Some, such as Stephen Skillitzi in Sydney and Regina Jaugietis in Adelaide, had experimented with glass casting in the 1960s while studying ceramics. After further study overseas, and

Stephen Skillitzi demonstrating glassblowing in a studio beside the Potters Society Gallery, Woolloomooloo, Sydney, 1972.

seeing Czech glass at Expo 67 in Montreal, Skillitzi took part in Dale Chihuly's first class at Haystack Mountain School of Crafts in 1968 before returning to Australia in 1970. From 1972 he gave impressive public demonstrations from a studio in the Potters Society Gallery in Sydney and in many other places, stimulating considerable interest in glassblowing. American Ron Street set up a studio in Perth as an artist-in-residence in 1973, after similarly studying at universities in the United States and being aware of the work of Harvey Littleton and Dominick Labino.

In about 1970 English-trained Richard Clements started lampworking in the new Argyle Arts Centre in the Rocks, in Sydney, before establishing his continuing practice in Tasmania. Around that time, Peter Minson, a third-generation glassworker in his father's scientific glass-apparatus factory from 1956, set up his own studio in Sydney to experiment with lampworking, and later studied at Orrefors and Kosta Boda in Sweden before continuing his long career in this field. Skilled Leonora Glass Works employees Jimmy Wittman (who had also worked at Crown Crystal and Anna Venetian glassworks), Paul Haworth, and Julio Santos started to blow glass independently in about 1972. Santos had trained as a glassblower in Portugal from the age of twelve and had worked in Germany in the 1960s before migrating to Australia. He eventually became master blower at Leonora in 1968 with special expertise in cane-work inclusions, which he continues to use today.

After it closed hand production in 1968, ACI's Crown Crystal glassworks remained an important resource for those few early studio workers through the expertise of past employees and as a source of small items of discarded equipment, before they were shipped to a surviving partner company in New Zealand. Its records were also crucial to John Croucher's research into the development of Gaffer Glass in New Zealand in the 1990s, which was to be widely used by glassblowers, and later casters, everywhere. Until its closure in 1982, Leonora Glass Works had also been essential as a source of glass (not only as cullett but also

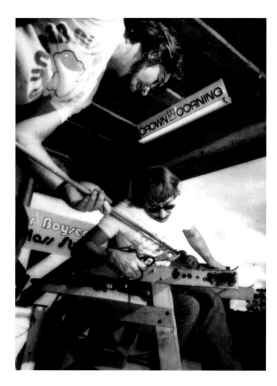

TOP: Bill Boysen (seated) and Peter Docherty in the Blowglass studio, 1974.

BOTTOM: Douglas Annand (right) making a freestanding, laminated glass sculptures for Knox House, Sydney, 1966, photograph and sculpture now in Powerhouse Museum collection.

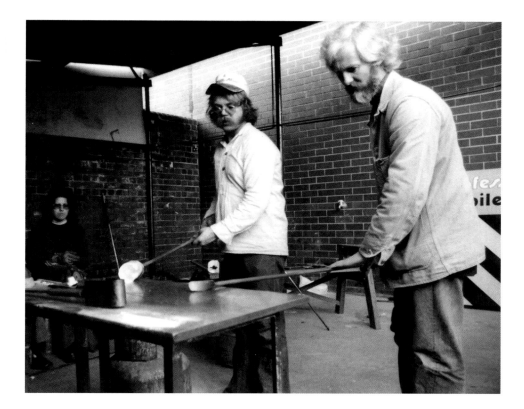

from recycled broken lights) and had assisted designers such as Douglas Annand from the 1960s. It also encouraged Denis O'Connor through offering a scholarship from art school, Goran Wärff periodically as a designer, and Maureen Cahill in return for advice on color. Experimenting with designing in industry, Les Blakebrough worked with Julio Santos and others at Leonora from 1976.

After her arrival in Australia from the UK in 1956, Anne Dybka worked as a decorator for the Crown Crystal Glass Company. She developed an interest in glass engraving, joined the English Guild of Glass Engravers, and set up her own influential studio in the Rocks in Sydney in the late 1970s. Similarly specializing in glass engraving, Alasdair and Rish Gordon arrived in Perth in 1980 from Scotland and established a studio that also launched the later careers of son and daughter Kevin and Eileen Gordon.

ACCESS AND EXCELLENCE: STATE PATRONAGE

During the 1970s, national and state governments were interested in increasing assistance for the arts and set up bodies to devise and administer grant programs for artists and their support organizations. The formation by 1971 of the Crafts Council of Australia and related state organizations ensured a strong lobby for a Crafts Board in the re-formed national funding body, the Australian (now Australia) Council for the Arts, in 1973. As well as providing studio development and travel opportunities for those in all crafts fields, the Crafts Board

made efforts to support and tour local exhibitions and also import those that could provide notable examples of work being made elsewhere. It also encouraged and subsidized visits from international experts.

The Crafts Board's comprehensive Crafts Enquiry of 1975 revealed very little studio or manufacturing glass production throughout Australia and identified it as an area of need. Even before the report was published, through projects organized by the Crafts Council of Australia, the board brought in two key visitors in 1974 for the purpose of teaching skills and promoting interest in glassmaking. In an unprecedented collaborative venture, the Crown Corning company assisted the Crafts Board in providing a mobile glass furnace for a four-month visit by American glassblower Bill Boysen. Through this "Blowglass" project, Boysen demonstrated and taught glassblowing in a number of city and regional locations in Victoria, the ACT (Australian Capital Territory), New South Wales, and Queensland (page 142-43). Boysen was assisted at various times on his tour by Denis O'Connor, an art student who had received a scholarship from Leonora, and Peter Docherty, who had worked at ACI's Crown Crystal works.

The second visitor in 1974 was Richard Marquis, who came from the United States for

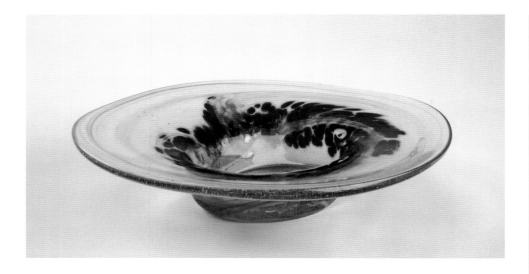

LEFT: Sam Herman, *Dish*, 1978.
RIGHT: Warren Langley, *Druid site XXXIII*, 1986.

two months. With assistance from promising Gippsland Institute student Nick Mount, he worked mainly in art schools in Colleges or Institutes of Advanced Education in Tasmania, Victoria, and Western Australia. He built glass workshops or advised on their establishment and used the Blowglass furnace at the School of Art in Hobart, Tasmania. Marquis returned to Hobart for twelve months in 1976 as an artist-in-residence at the school to work with potter Les Blakebrough and set up a glass studio that continued until 1982.

Influenced by crafts workshops overseas, such as those at Kilkenny in Ireland and in Scandinavia, the South Australian government established the Jam Factory Workshops in Adelaide in 1973 with production and training facilities in a number of different crafts areas. American-trained Sam Herman came to the Jam Factory from the UK in 1974 as a consultant and then returned to set up a hot-glass workshop and train apprentices, the first being Peter Goss, Rob Knottenbelt, Tom Persson, and John Walsh. In 1976, Czechoslovakian-trained Stanislav Melis was persuaded to come to Adelaide from Sydney, where he had lived since 1968, to work in and later run this workshop when Herman's contract concluded in 1978. Now known as JamFactory Contemporary Craft and Design, this center has maintained a constant commitment to training, production, and exhibitions, providing studio spaces for artists and artists-in-residence. It has also provided employment for many glass artists, and there is now the opportunity for independent artists to rent the facilities instead of duplicating hot-shop facilities in personal studios.

In Melbourne, the Victorian state government acquired the old Metropolitan Meat Market building in 1977, and when this opened as the Meat Market Craft Centre in 1978 (operating until 1998), among its many facilities was a flat-glass studio, run initially by Graeme Stone. A hot-glass studio followed, managed at first by Richard Morrell and then by Pauline Delaney from about 1989. In 1986 Tony Hanning hired Morrell's space for a few days and, having met Dante Marioni in the United States, invited him on a first visit to make forms for his own cameo glass. As a "warm-up" exercise, Marioni blew fluted goblets and asked Hanning what else he wanted. When Hanning said he wanted a goblet that would take a can of beer, he had to run across to the pub at 10 a.m. to get a few cans for Marioni to sample. The goblet made has exactly the right capacity.

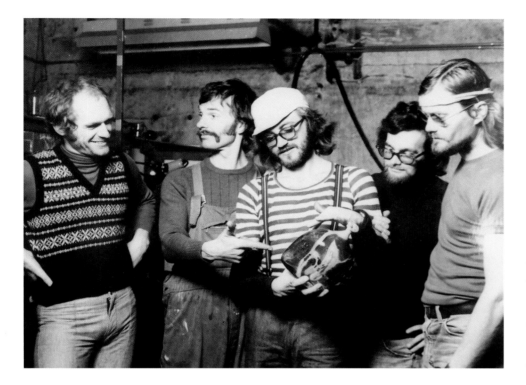

JamFactory's first hot-glass workshop trainees with Stanislav Melis, later workshop foreman, 1976. From left, Rob Knottenbelt, Peter Goss, Stanislav Melis, Tom Persson, and John Walsh.

INS AND OUTS: INFLUENCES FROM ELSEWHERE

At this time, a number of people sought experience overseas, some with their travel supported by the Crafts Board. Gerry King graduated in ceramics in South Australia in 1966 and studied glass in the United States, Europe, and Canada in 1974. He set up a studio in Adelaide in 1975 and now maintains extensive international exhibition and workshop connections. Glen Whiting, from Western Australia, was awarded a Churchill Fellowship in 1974 to study glass forming in the United States. Con Rhee, who had graduated in science in Australia, studied at Haystack and ran a glass studio in Nova Scotia before returning to Tasmania in the 1970s. After working with Marquis there in 1976, he established a workshop, significantly from about 1979 developing his own glass from Tasmanian pure quartz sand, using a Marquis formula for a modified Venini clear glass batch mixture. Rob Knottenbelt, one of the first Jam Factory trainees, also went overseas to study and then set up Britannia Creek Glass in Victoria in 1984, not only making production glass, but with an increasing interest in sculptural forms, using water-jet cutting processes.

Many different paths were followed and connections made. Warren Langley gained a science degree in the early 1970s and spent the next few years learning to work with glass. He traveled in 1977–78 to study in the Pilchuck summer program and at the Brierly Hill Technical College in the UK, returning to set up a studio in the early 1980s in Sydney. Here he made kiln-formed sculptural works and also ran his business, Ozone, producing textured glass panels for architecture. He now carries out commissions internationally for his

"light and landscape" glass installations, including *Breathe* at the Museum of Glass in Tacoma, Washington (2004–2007). In 1976 Neil Roberts became interested in glass after seeing Stephen Skillitzi blowing glass in Adelaide and later Peter Docherty and Denis O'Connor working in the mobile Blowglass workshop in regional New South Wales. He joined the Jam Factory, where he worked until the end of 1979, and later studied at Orrefors in Sweden. In the 1980s, Roberts moved toward making installations using glass, including *Flood Plane* on Lake Burley-Griffin in Canberra. This temporary commission, for the Floriade Festival in 1990, used 150 meters of an aerial agricultural spray watering system surmounted and lit by a line of words in blue neon.

The first visiting international exhibition of glass was an edited version of *American Glass Now*, which had originated at Toledo Museum of Art and Museum of Contemporary Craft, Portland, Oregon, with thirty contemporary works by ten American glass artists selected for the Crafts Board by Denis Colsey in 1975. The exhibition toured to all state capital cities and Alice Springs over the next two years. The works were purchased by the Crafts Board and later given to what is now known as the National Art Glass Collection, established in

KEUR

PREST

LANGLEY

ZIMMER

KNOTTENBELT

BLAKEBROUGH

DYBKA

SHERLOCK

MOUNT

SANDO

RUTHVEN

ATKINS

BLAKEBROUGH

RHEE

WITH CARE

To AUS - GLASS SHOW
JAM FACTORY GALLERY
APRIL 29 - MAY 20
1979.

PREST

LANGLEY

WALSH

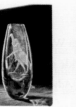
O'CONNOR

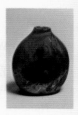
HEIBL

PERSSON

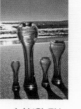
LANGLEY

KNOTTENBELT

SANTOS

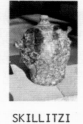
MELIS

SKILLITZI

KING

WRIGHT

HEIBL

PREST

WRIGHT

HEIBL

The Jam Factory Workshops Inc.
169 Payneham Road, St. Peters, Phone 42 5661
Shop and gallery open 10 a.m. - 5 p.m. weekdays
2-5 p.m. Saturdays and Sundays

With Care, front and back covers of the catalog for the first Ausglass
exhibition, held at the Jam Factory gallery, Adelaide, 1979.

The fifty-four artists whose work was represented came from England, Japan, Holland, Czechoslovakia, France, West Germany, Italy, and the United States. While causing some controversy, such an emphasis on sculptural works and installations encouraged a swing away from production glass, and Australian glass exhibitions were to show a marked change from that time.

The influence of both the forms and ideas in *International Directions in Glass Art* and the new processes being used was evident in the second national exhibition at the third Ausglass conference in Adelaide in 1983. Here, a large number of experimental and sculptural works were shown, using techniques such as assemblage, slumping, and fusing. While studio glass had been largely founded in the making of vessel forms, as in all crafts fields there had been a noticable shift to making "art-craft" for a specific collectors' marketplace. At the same time, the Crafts Board's 1984 exhibition, *Craftworks in Australian Architecture*, included a number of glass artists, such as Warren Langley, whose installation for the Joint Coal Board combined kiln-formed glass slabs, fused and float glass, and neon tubing.

In the 1980s some prestigious exhibiting possibilities also developed in Japan. One of the first exhibitions, which included the work of twelve Australians, was *The Beauty of Contemporary Glass: Australia, Canada, the United States and Japan*, organized by the National Museum of Modern Art in Kyoto in 1981. As well, Australians were included in the Hokkaido Museum of Modern Art's triennial *World Glass Now* surveys of glass art from 1982, with Brian Hirst winning the major prize associated with the exhibition in 1994. Since that time, Australians have participated in similar events in other places, such as those in Munich, Corning, Tampa, and Kanazawa. In 1984, Jenny and Klaus Zimmer organized an exhibition of forty-five Australians and ten New Zealanders in *Glass from Australia and New Zealand*, for the Hessisches Landesmuseum in Darmstadt, Germany. Other touring glass survey exhibitions included *At the Edge: Australian Glass Art*, which went from the Brisbane City Gallery to Galerie Handwerk in Munich in 2002.

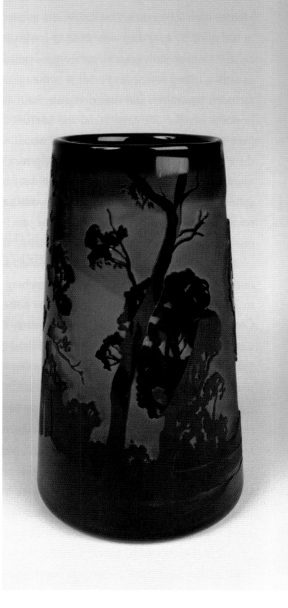

Tony Hanning, *Blue vase (Treescape)*, 1981

Alongside visitors from Europe, the UK, Asia, and New Zealand, Americans who came to Australia in these years included Paul Marioni, Richard Meitner, Richard Marquis, Dante Marioni, Lino Tagliapietra, Ginny Ruffner, Susanne Frantz, Tina Oldknow, Lani McGregor, and Daniel Schwoerer. They came to speak at conferences, sometimes giving workshops and demonstrations in schools and studios. Dale Chihuly, influential for the scope and scale of his work and for his example of working in teams, spoke at the 1993 Ausglass conference in Canberra, which coincided with his touring exhibition *Chihuly in Australia: Glass and Works on Paper*. He also visited Sydney as part of the Sydney Festival in 1998 to install *Red Spears* in the gardens of Government House, as well as a chandelier in the Sydney Opera House, and to give a workshop at Sydney College of the Arts. In 1999, the exhibition *Chihuly: Masterworks in Glass* was shown at the National Gallery of Australia in Canberra and at the JamFactory gallery in 2000.

The summer programs at Pilchuck Glass School outside Seattle, which Chihuly cofounded, had become a major focus for professional development. This was largely a result of the influence of Klaus Moje, as he had taught regularly at Pilchuck. He encouraged Australians not only to study there, but also to work as assistants, and in many instances these initiatives were further supported in the 1980s by the Crafts Board. Many have continued their connections and are encouraging new generations to make their own links. At the same time, Australians became involved in other centers, including Haystack, Wheaton Arts, Corning, and Urban Glass in the United States, at Stourbridge in the UK, and in workshops in Scandinavia, Italy, the Czech Republic, and Japan.

Over these decades within Australia, state and national art museums exhibited glass within their exhibition programs and acquired works, in recent years sometimes supported by taxation incentives through the Australian Government's Cultural Gifts program. As well as the exposure and sales provided through state crafts centers, a number of dealer galleries focused specifically on glass or made it a major part of their exhibition schedules. These included the Glass Artists Gallery, Raglan Gallery, Quadrivium, and later Sabbia Gallery in Sydney; Beaver Galleries in Canberra; Narek Galleries in Tanja; and Makers Mark, Distelfink Gallery, and later Axia and Kirra Galleries in Melbourne. They not only supported collectors at home but encouraged international connections in the form of visiting collectors and collectors' groups, and some participated in a number of international events. With initial encouragement from Craft Australia and supported by Austrade, from 1991 a number of commercial galleries such as Glass Artists, Raglan, and Beaver galleries attended the CINAFE (later SOFA), fairs in Chicago and New York, while some also took work to the Collect event in London.

Further encouraging both new work and informed audiences, from 1995 the annual touring Ranamok Glass Prize, at first known as the RFC (Resource Finance Corporation) Glass Prize, founded by Andy Plummer and Maureen Cahill, has provided an important annual opportunity to introduce new work, as has the Art Gallery of Western Australia's Tom Malone Prize, from 2003. In 1998 David Thomas and Max Bourke set up the Thomas Foundation to provide support for education, the arts, and conservation, and many glass artists have been recipients of scholarships and other grants. Scholarships in memory of colleagues include the Ausglass Vicki Torr Memorial Scholarship and Prize and the ANU's Stephen Procter Fellowship residency.

Into the 2000s, as well as pursuing their art practices, many makers maintain a professional

commitment to undertaking commissioned work, as well as design and production for such as lighting, tableware, containers, and awards. This is not only to ensure the sustainability of their overall businesses, but also because, they argue, each area informs the other: that skills and ideas, production and one-off works, are interconnected. Throughout this period a considerable number of artists—including Warren Langley, Matthew Curtis, Elizabeth Kelly, Barbara Jane Cowie, Sergio Redegalli, and others—also chose to extend their work into commissions for architectural spaces. In turn, Dante Marioni was commissioned to make lighting for Stefano Manfredi's Balla restaurant in Sydney in 2011.

Individual studios remain a key resource for follow-up experience after study in the education programs of the ANU School of Art in Canberra, the University of South Australia in Adelaide, Sydney College of the Arts, and, until recently, Monash University in Melbourne. Complementing JamFactory, a most significant development within the past decade has been the establishment by the ACT government of Canberra Glassworks. The result of lobbying by Moje, the ANU glass workshop, and other local cultural bodies, this facility opened in 2007 in a redeveloped industrial building. With studios for all glass processes, as well as demonstration and exhibition spaces, it provides further opportunities for employment, education, exhibition, and access to its facilities.

During these years of development, the Australian exhibitors in *Links: Australian Glass and the Pacific Northwest* have not only benefitted from their connections with this part of the United States, but have also grown out of, and are contributing to, the always evolving narrative of studio glass—making still more links in the chain.

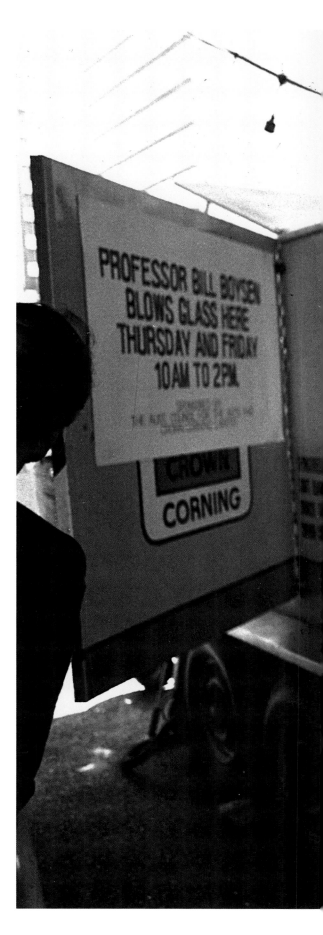

The Blowglass mobile glass furnace used by Bill Boysen and at times by Richard Marquis in 1974.

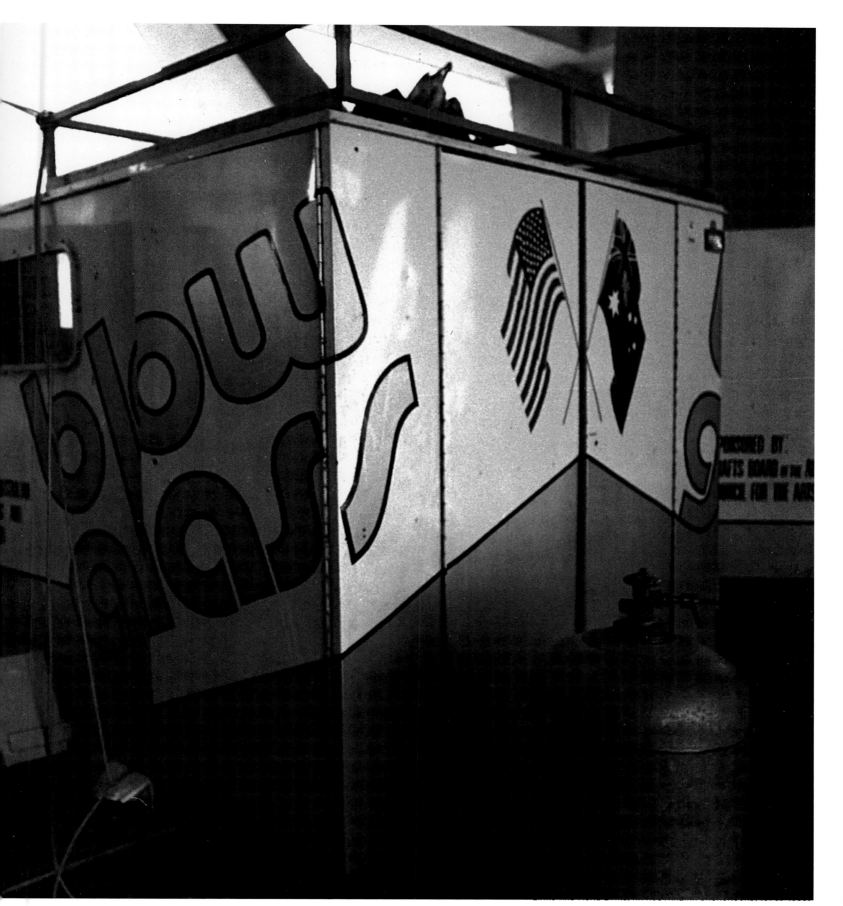

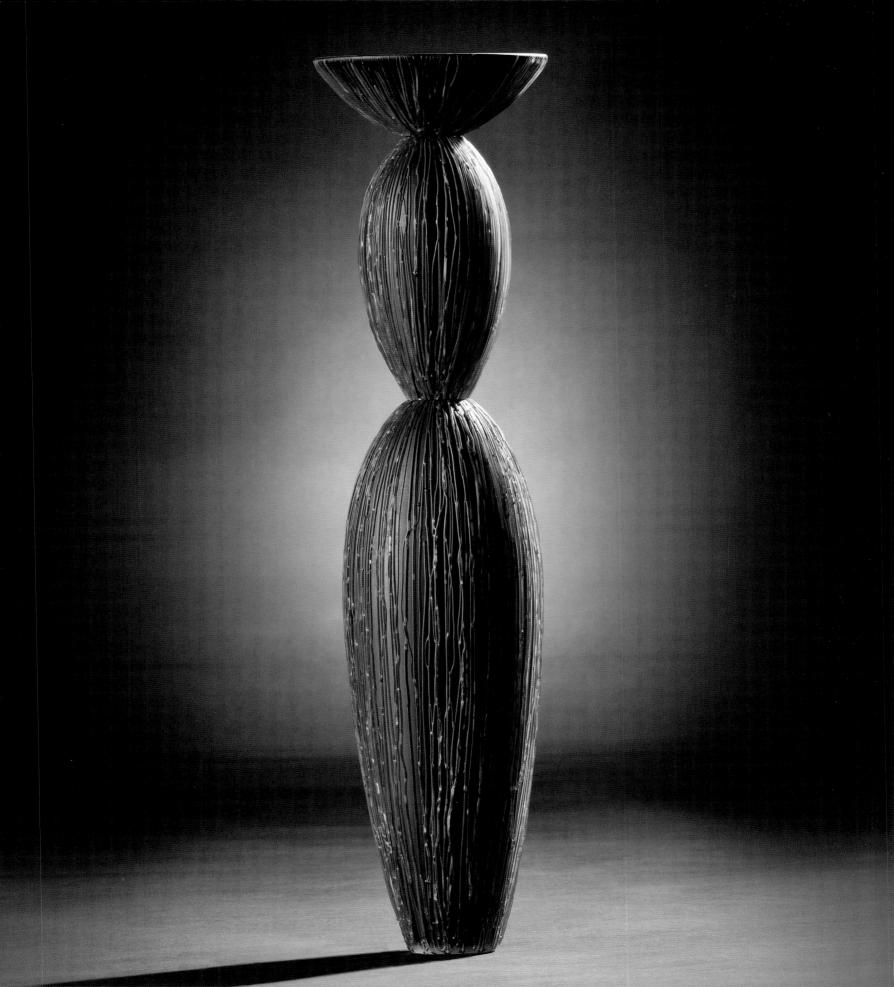

CATALOG OF THE EXHIBITION

May 2013–January 2014
Organized by Museum of Glass, Tacoma
Viola A. Chihuly and North Galleries

Abbreviations:
ACT, Australian Capital Territory (Canberra)
NSW, New South Wales (Sydney)
QLD, Queensland (Brisbane)
SA, South Australia (Adelaide)
VIC, Victoria (Melbourne)

Page numbers refer to illustrations. Dimensions are
height x width x depth. Photo courtesy of the artist
unless otherwise noted.

CLARE BELFRAGE

Born 1966 in Melbourne; lives in Kingston
Canberra, ACT.

1 (pg. 144)
Line Drawing (Gold on Black), 2000
Blown glass with cane drawing, acid-etched and
cold-laminated
21 1/4 x 5 5/16 in. (54 x 13.5 cm)
Courtesy of the artist
Photo by Rob Little

2 (pg. 27)
Ridge Lines #24, 2004
Blown glass with cane drawing, acid-etched
15 3/4 x 8 11/16 x 3 9/16 in. (40 x 22 x 9 cm)
State Art Collection, Art Gallery of Western
Australia, Perth, purchased through the Tom
Malone Prize, Art Gallery of Western Australia
Foundation
Photo courtesy of Art Gallery of Western Australia

3 (jacket)
Passage #40, 2007
Blown glass with cane drawing, acid-etched
15 x 14 x 3 in. (38.1 x 35.6 x 7.6 cm)
Courtesy of Foster/White Gallery, Seattle
Photo by Roger Schreiber, courtesy of
Foster/White Gallery

4 (pg. 28)
Soft Square #21110, 2010
Blown glass with cane drawing
14 9/16 x 12 5/8 x 2 3/4 in. (37 x 32 x 7 cm)
Courtesy of the artist
Photo by Rob Little

GILES BETTISON

Born 1966 in North Adelaide, SA;
lives in Adelaide, SA.

5 (pg. 77)
Magenta Vessel, 1995
Fused, blown, and cold-worked glass murrine
10 1/4 x 7 in. (26 x 17.8 cm)
Collection of Powerhouse Museum, Sydney,
Australia (98/142/2), gift of Bullseye Glass Co.,
1998
Photo courtesy of Powerhouse Museum

6 (pg. 145)
Apparently Random #2, 2003
Fused, hot-worked, blown and
cold-worked glass murrine
10 x 10 3/4 x 2 1/8 in. (25.4 x 27.3 x 5.4 cm)
Courtesy of the artist and Bullseye Gallery,
Portland, Oregon
Photo courtesy of Bullseye Gallery

Giles Bettison, *Apparently Random #2,* 2003 cat 6

7 (pg. 80)
Lace 09 #36, 2009
Fused, hot-worked, blown and
cold-worked glass murrine
8 3/4 x 10 1/2 x 1 3/4 in. (22.2 x 26.7 x 4.4 cm)
Courtesy of the artist and Bullseye Gallery,
Portland, Oregon
Photo by M. Endo, courtesy of Bullseye Gallery

8 (pg. 81)
Lace #22, 2009
Fused, hot-worked, blown and
cold-worked glass murrine
8 1/4 x 9 5/8 x 1 3/4 in. (21 x 24.4 x 4.4 cm)
Collection of Jane Sauer Gallery,
Santa Fe, New Mexico
Photo by Addison Doty, courtesy
of Jane Sauer Gallery

9 (pg. 79)
Textile 10, #14, 2010
Fused, hot-worked, blown and
cold-worked glass murrine
14 x 8 1/2 x 8 in. (35.6 x 21.6 x 20.3 cm)
David Kaplan - Glenn Ostergaard Glass Collection
Photo by David Glomb

GABRIELLA BISETTO

Born 1968 in Griffith, NSW; lives in Kensington, SA.
Unisanet.unisa.edu.au/staff/homepage.
asp?name=gabriella.bisetto

10 (not illustrated)
Exchange #8, 2012
Hot-sculpted glass, cut, polished, and laminated
3 $^{1}/_{8}$ x 5 $^{1}/_{2}$ x 1 $^{3}/_{8}$ in. (8 x 14 x 3.5 cm)
Collection of the artist

11 (pg.146)
Exchange #9, 2012
Hot-sculpted glass, cut, polished, and laminated
4 $^{3}/_{4}$ x 2 $^{3}/_{8}$ x 1 $^{9}/_{16}$ in. (12 x 6 x 4 cm)
Collection of the artist
Photo by Michael Kluvanek

12 (pg. 32)
The Shape of Breath #2, 2007
Blown glass, hand-finished, stainless-steel base
11 $^{3}/_{4}$ x 22 $^{1}/_{2}$ x 12 $^{1}/_{2}$ in. (29.8 x 57.2 x 31.8 cm)
Collection of the artist
Photo by Grant Hancock

13 (pg. 31)
The Shape of Breath #3, 2007
Blown glass, hand-finished, stainless-steel base
13 x 21 $^{1}/_{2}$ x 12 in. (33 x 54.6 x 30.5 cm)
Collection of Jaycen Fletcher and Peter Reeve
Photo by Grant Hancock

Gabriella Bisetto, *Exchange #9,* 2012 (cat. 11)

RIGHT: Jane Bruce, *Sea House,* 2007 (cat. 15)

FAR RIGHT: Cobi Cockburn, *Hollows,* 2007 (cat. 20)

JANE BRUCE

Born 1947 in Buckinghamshire, England;
lives in New York. JaneBruce.com

14 (pg. 70)
Shift, 2006
Kiln-formed and painted glass
11 x 25 ⁵/₈ x 3 ³/₄ in. (27.9 x 65.1 x 9.5 cm)
Private collection
Photo by S. Barell, courtesy of Bullseye Gallery

15 (pg. 147)
Sea House, 2007
Kiln-formed glass
11 ¹/₄ x 7 x 2 in. (28.6 x 17.8 x 5.1 cm)

Courtesy of Bullseye Gallery, Portland, Oregon
Photo by P. Leonard, courtesy of Bullseye Gallery

SCOTT CHASELING

Born 1962 in Tamworth, NSW; lives in Canberra,
ACT. ScottChaseling.tumblr.com

16 (pg. 74)
When the Penny Drops, 2001
Painted, fused, and blown glass
13 ¹/₂ x 6 ³/₄ in. (34.3 x 17.1 cm)
Collection of Pam Biallas
Photo by Duncan Price

17 (pgs. 72–73)
Absent Memories, 2004
Painted, fused, and blown glass
23 ³/₄ x 19 ³/₄ in. (60.3 x 50.2 cm)
Collection of National Gallery of Australia,
Canberra (2004.135)
Photo courtesy of National Gallery of Australia

18 (pg. 74)
The Cleansing, 2004
Painted, fused, and blown glass
20 ¹/₁₆ x 9 ⁷/₁₆ x 9 ⁷/₁₆ in. (51 x 24 x 24 cm)
Collection of Canberra Museum and Gallery,
Canberra, Australia (2005.18)
Photo by Rob Little, courtesy of Canberra Museum
and Gallery

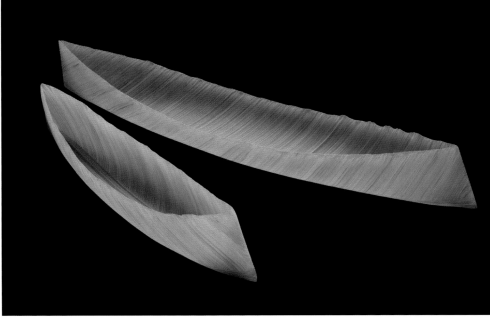

19 (pg. 75)
Now or?, 2006
Painted, fused, and blown glass
19 $^{1}/_{4}$ x 9 $^{7}/_{16}$ in. (48.9 x 24 cm)
Collection of Queensland Art Gallery,
Queensland, Australia, purchased from
Queensland Art Gallery Foundation Grant
(2006.064)
Photo courtesy of Queensland Art Gallery,
Queensland, Australia

COBI COCKBURN

Born 1979 in Sydney, NSW; lives in
Gerringong, NSW.

20 (pg. 147)
Hollows, 2007
Cold and hot-formed glass
a: 5 x 29 $^{1}/_{8}$ x 4 $^{1}/_{2}$ in. (12.7 x 74 x 11.4 cm)
b: 4 $^{1}/_{2}$ x 21 $^{3}/_{4}$ x 3 $^{1}/_{2}$ in. (11.4 x 55.2 x 8.9 cm)
Lent by The Corning Museum of Glass,
Corning, New York, gift of Lani McGregor
and Daniel Schwoerer (2010.6.11)
Photo courtesy of The Corning Museum of Glass

21 (pg. 98, 99)
Presence, 2008
Cold and hot-formed glass
8 x 35 $^{1}/_{4}$ in. (20.3 x 89.5 cm)
David Kaplan - Glenn Ostergaard Glass Collection

22 (pg. 97, 121)
Quiescent, 2010
Cold and hot-formed glass
44 $^{1}/_{2}$ x 44 $^{1}/_{2}$ x 1 $^{15}/_{16}$ in. (113 x 113 x 5 cm)
Collection of National Gallery of Australia,
Canberra, gift of Sandy and Phillip Benjamin
(2010.932)

NADÈGE DESGENÉTEZ

Born 1973 in Caen, France; lives in Canberra, ACT.
soa.anu.edu.au/staff/nadege-desgenetez

23 (pg. 60)
Chaussette (dark purple), 2004
Blown glass, incalmo technique
24 $^{1}/_{2}$ x 8 $^{3}/_{4}$ x 4 $^{1}/_{2}$ in. (62.2 x 22.2 x 11.4 cm)
Collection of Carnegie Museum of Art, Pittsburg,
Pennsylvania, Helen Johnston Acquisition Fund
(2005.7)

24 (pg. 148)
Chaussette (yellow), 2006
Blown glass, incalmo technique
22 x 5 in. (55.9 x 12.7 cm)
Collection of Traver Gallery, Seattle, Washington

25 (pg. 58)
Landscape of the Body Series; A tree and I: Elbow, 2011
Blown glass, mirrored, cold worked, hand sanded
With stand: 51 $^{3}/_{4}$ x 17 $^{3}/_{4}$ x 10 $^{3}/_{4}$ in.
(131.4 x 45.1 x 27.3 cm)
Glass, approx.: 21 x 8 $^{1}/_{4}$ x 7 $^{3}/_{4}$ in.
(53.3 x 21 x 19.7 cm)
Collection of the artist

26 (pg. 59)
Landscape of the Body Series; A tree and I: Knee, 2011
Blown glass, mirrored, cold worked, hand sanded
With stand: 57 x 19 $^{3}/_{4}$ x 11 $^{3}/_{4}$ in.
(144.8 x 50.2 x 29.8 cm)
Glass, approx: 21 x 8 $^{1}/_{4}$ x 7 $^{3}/_{4}$ in.
(53.3 x 21 x 19.7 cm)
Collection of the artist

Nadège Desgenétez, *Chaussette (yellow)*, 2006
(cat. 24)

OPPOSITE: Mel Douglas, *High Tide*, 2011 (cat. 30)

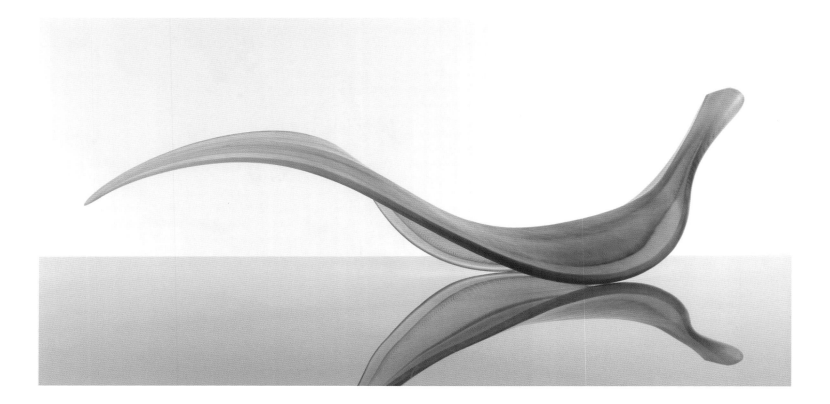

MEL DOUGLAS

Born 1978 in Burnie, Tasmania;
lives in O'Conner, ACT.

27 (pg. 52)
Either Way, 2004
Blown, cold-worked, and engraved glass
6 x 15 ³/₄ x 15 ³/₄ in. (15.2 x 40 x 40 cm)
Collection of Julius Friedman
Photo by Stuart Hay

28 (pg. 50)
Incline #3, 2010
Blown, cold-worked, and engraved glass
15 x 13 ¹/₂ x 13 in. (38.1 x 34.3 x 33 cm)
David Kaplan - Glenn Ostergaard Glass Collection
Photo by Stuart Hay

29 (pg. 53)
Open Field #6, 2010
Kiln-formed, cold-worked, and engraved glass
31 ¹/₂ x 31 ³/₄ x ³/₄ in. (80 x 80.6 x 1.9 cm)
Courtesy of the artist and Bullseye Gallery,
Portland, Oregon

Photo by Stuart Hay, courtesy of the artist and
Bullseye Gallery

30 (pg. 149)
High Tide, 2011
Blown, cold-worked, and engraved glass
10 ⁵/₈ x 16 ⁹/₁₆ x 16 ⁹/₁₆ in. (27 x 42 x 42 cm)
Collection of Andy and Deidre Plummer
Photo by Stuart Hay

BEN EDOLS AND KATHY ELLIOTT

Edols: Born 1967 in Sydney, NSW.
Elliott: Born 1964 in Sydney, NSW.
live in Brookvale, NSW. EdolsElliott.com

31 (pg. 42)
Unravelled, 1997
Blown and wheel-cut glass
29 ¹⁵/₁₆ x 4 ⁵/₁₆ in. (76 x 11 cm)
Collection of Powerhouse Museum, Sydney,
Australia (97/320/1), purchased 1997
Photo by Penelope Clay, courtesy of
Powerhouse Museum

32 (pgs. 44, 45)
Gold Curled Leaf, 2005
Hot-formed and wheel-cut glass
12 ⁵/₈ x 14 ³/₁₆ x 8 ¹¹/₁₆ in. (32 x 36 x 22 cm)
Courtesy of the artists
Photo by Greg Piper

33 (pg. 150)
Reclining Capillary Leaf, 2009
Hot-formed and wheel-cut glass
7 ¹/₂ x 40 x 8 ¹/₂ in. (19.1 x 101.6 x 21.6 cm)
Courtesy of the artists
Photo by Greg Piper

34 (pg. 43)
Red Stem, 2010
Blown and wheel-cut glass
29 ¹/₂ x 6 ¹¹/₁₆ x 3 ¹⁵/₁₆ in. (75 x 17 x 10 cm)
Courtesy of the artists
Photo by Greg Piper

Ben Edols and Kathy Elliott, *Reclining Capillary
Leaf*, 2009 (cat. 33)

TIM EDWARDS

Born 1967 in Millicent, SA; lives in Ainslie, Canberra, ACT.

35 (pgs. 40-41)
Suspension, 2002
Blown and wheel-cut glass
11 ³/₄ x 21 ¹/₄ x 2 in. (29.8 x 54 x 5.1 cm)
Collection of Andy and Deirdre Plummer
Photo by Grant Hancock

36 (pgs. 38–39)
Drift, 2006
Blown and wheel-cut glass
Overall: 18 ¹/₁₆ x 24 ¹/₈ x 3 ¹/₈ in. (45.8 x 61.3 x 8 cm)
Lent by The Corning Museum of Glass, Corning,
New York, The 21st Rakow Commission
(2006.6.11)
Photo courtesy of The Corning Museum of Glass

BRENDEN SCOTT FRENCH

Born 1969 in Toowoomba, QLD; lives in
Adelaide, SA.

37 (pg. 151)
Cargo—Two Parcel Lament, 2009
Kiln-formed glass
9 ¹/₁₆ x 45 ¹¹/₁₆ x 1 ⁹/₁₆ in. (23 x 116 x 4 cm)
David Kaplan - Glenn Ostergaard Glass Collection
Photo by Grant Hancock

38 (pgs. 104–5)
Cargo—Future's Pass, 2010
Kiln-formed glass
8 ¹/₄ x 32 ¹/₂ x 1 ¹/₂ in. (21 x 82.6 x 3.8 cm)
Collection of Andy and Deirdre Plummer
Photo by Christian Mushenko

39 (pgs. 106–7)
Open Sky, 2011
Kiln-formed glass
23 ¹/₄ x 71 ³/₄ x 2 in. (59.1 x 182.2 x 5.1 cm)
Collection of Lani McGregor and Daniel Schwoerer
Photo by Grant Hancock

MEL GEORGE

Born 1975 in Canberra, ACT; lives in
Queanbeyan, ACT.

40 (pgs. 86, 87)
Change of Scenery, 2008
Kiln-formed glass
25 ³/₄ x 22 x ¹/₂ in. (65.4 x 55.9 x 1.3 cm)
Collection of Lani McGregor and Daniel Schwoerer
Photo by Paul Foster, courtesy of Bullseye Gallery
and the artist

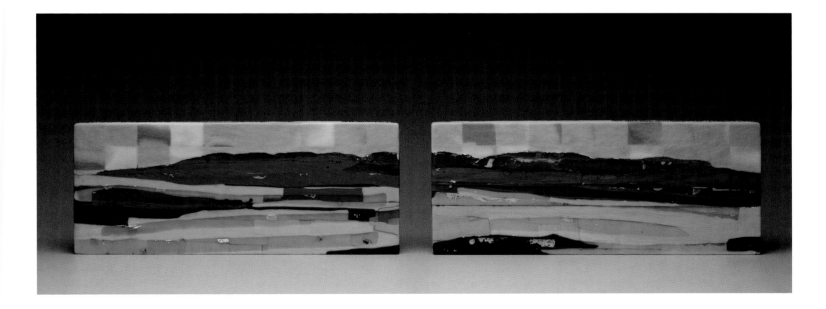

41 (pg. 89)
Dry Shade, 2009
Kiln-formed glass
15 $^1/_4$ x 4 $^1/_4$ x $^1/_2$ in. (38.7 x 10.8 x 1.3 cm)
Private collection
Photo by Paul Foster, courtesy of the artist

42 (pg. 88)
Portland Hue, 2009
Kiln-formed glass
15 $^1/_4$ x 4 $^1/_2$ x $^1/_2$ in. (38.7 x 11.4 x 1.3 cm)
Collection of the Estate of J. Michael Carroll
Photo by Paul Foster

STEVE KLEIN

Born 1946 in Los Angeles; lives in Long Beach,
California, and La Conner, Washington.

43 (pg. 76)
Exploration, Lybster I, 2004
Kiln-formed and blown glass
5 $^1/_2$ x 19 x 18 $^3/_4$ in. (14 x 48.3 x 47.6 cm)
Collection of Museum of Arts and Design,
New York, Museum purchase with funds
provided by Joan Bast, Amye and Paul S.
Gumbinner, Adele and Leonard Leight, Ann
and Bruce Bachmann, Lisa and Ron Brill,
Olivia and Harlan Fischer, George and Jane Kaiser,
Fred Sanders, and Arlene and Norman Silvers.
Photo by Jason VanFleet, courtesy of the artist

JEREMY LEPISTO

Born 1974 in Fort Belvoir, Virginia; lives in
Queanbeyan, ACT. JeremyLepisto.com

44 (pgs. 90, 91)
Further from Here, 2006
Kiln-formed glass
7 x 12 x 12 in. (17.8 x 30.5 x 30.5 cm)
Cohen Collection
Photo by Paul Foster

JESSICA LOUGHLIN

Born 1975 in Melbourne, VIC; lives in Adelaide, SA.
JessicaLoughlin.com.au

45 (pg. 82)
Horizon Line Series #14, 1997
Kiln-formed, engraved, enameled,
and wheel-cut glass
1 $^3/_4$ x 19 in. (4.4 x 48.3 cm)
Lent by The Corning Museum of Glass, Corning,
New York, gift of Irene and Robert Sinclair
(2008.6.3)
Photo courtesy of The Corning Museum of Glass

46 (pg. 85)
quietening 5, 2004
Kiln-formed and wheel-cut glass
1 x 19 $^1/_2$ in. (2.5 x 49.5 cm)
Collection of Andy and Deirdre Plummer
Photo by Grant Hancock

47 (pg. 84)
open space 28, 2005
Kiln-formed and wheel-cut glass
29 x 26 $^3/_4$ x 2 in. (73.7 x 67.9 x 5.1 cm)
Collection of the artist
Photo by Grant Hancock

48 (pg. 153)
through distance 3, 2007
Kiln-formed and wheel-cut glass
14 $^1/_2$ x 27 $^1/_2$ x 1 $^1/_4$ in. (36.8 x 69.9 x 3.2 cm)
State Art Collection, Art Gallery of Western
Australia, Perth, purchased through the Tom
Malone Prize, Art Gallery of Western Australia
Foundation, 2008
Photo courtesy of Art Gallery of Western Australia

49 (pg. 125)
in close distance, 2009
Kiln-formed glass
33 $^1/_{16}$ x 42 $^1/_2$ x 1 $^{15}/_{16}$ in. (84 x 108 x 5 cm)
Private collection
Photo by Sam Roberts

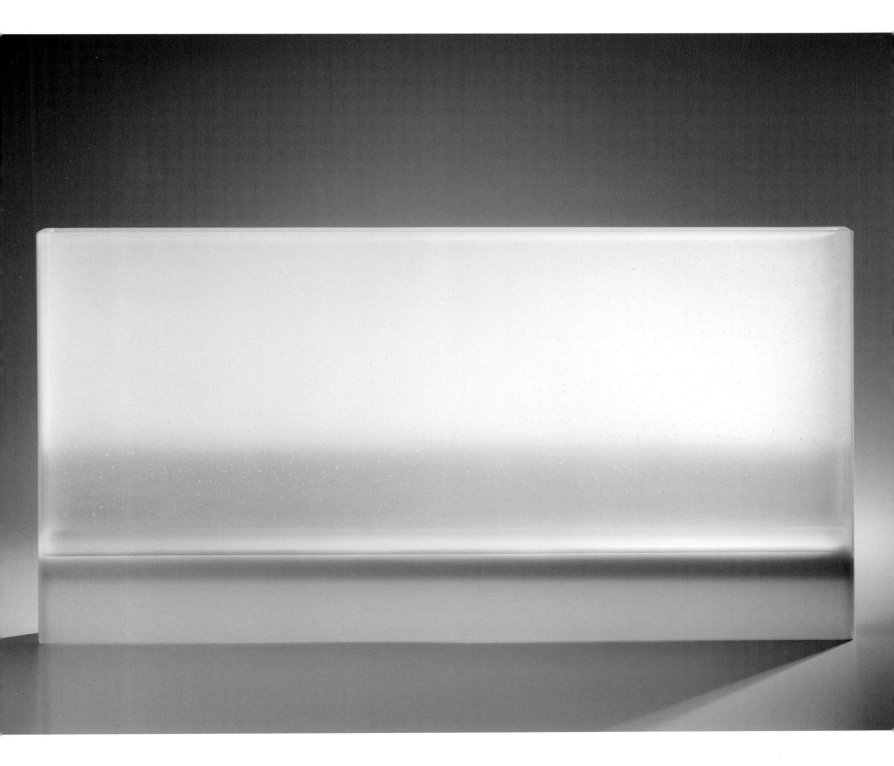

Jessica Loughlin, *through distance 3*, 2007 (cat. 48) 153

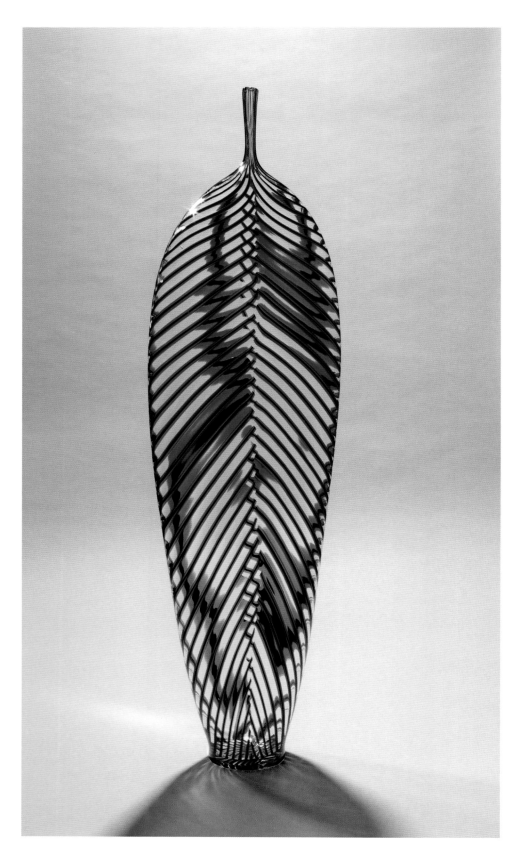

DANTE MARIONI

Born 1964 in Mill Valley, California; lives in Seattle, Washington. DanteMarioni.com

50 (pg. 154)
Blue Leaf, 2009
Blown glass
35 ³/₄ x 10 x 3 ³/₄ in. (90.8 x 25.4 x 9.5 cm)
Collection of Museum of Glass, Tacoma, Washington; gift of the artist
Photo by Duncan Price

51 (pg. 22)
Oak Leaf and Acorn, 2012
Blown glass
Oak leaf: 30 x 11 x 7 in. (76.2 x 27.9 x 17.8 cm)
Acorn: 9 x 9 x 14 in. (22.9 x 22.9 x 35.6 cm)
David Kaplan - Glenn Ostergaard Glass Collection
Photo by David Glomb

52 (pg. 20)
Vessel with Ten Handles (Homage to Martinuzzi), 2001
Blown glass
33 ¹/₂ x 12 in. (85.1 x 30.5 cm)
Collection of Dante and Alison Marioni
Photo by Russell Johnson

RICHARD MARQUIS

Born 1945 in Bumblebee, Arizona; lives on Whidbey Island, Washington. RichardMarquis.com

53 (pg. 13)
Crazy Quilt Coffeepot, 1974
Blown glass, murrine technique
8 x 6 x 4 ¹/₂ x 3 ¹/₂ in. (20.3 x 15.2 x 11.4 x 8.9 cm)
Collection of the artist
Photo by Richard Marquis

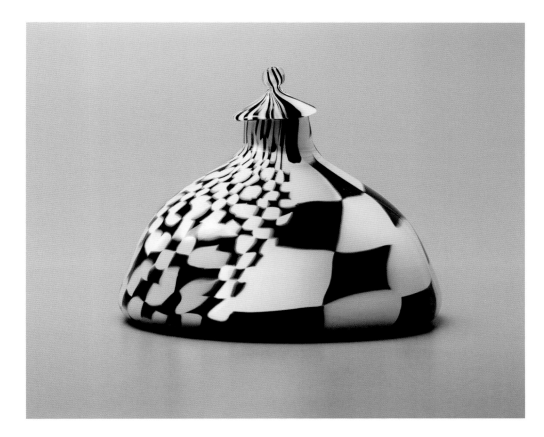

57 (pg. 156)
Razzle Dazzle Boat with Salt and Pepper Shakers, 2009
Fused and wheel-cut glass, slab technique, and found object
4 3/4 x 13 x 3 1/2 in. (12.1 x 33 x 8.9 cm)
Courtesy of the artist and Bullseye Gallery, Portland, Oregon
Photo by Richard Marquis, courtesy of the artist and Bullseye Gallery

58 (pg. 15)
Teapot Cartoon Car, 2009
Blown glass, granulare technique, painted wood, and brass
8 1/2 x 13 1/2 x 6 in. (21.6 x 34.3 x 15.2 cm)
Courtesy of the artist and Bullseye Gallery, Portland, Oregon
Photo by Richard Marquis, courtesy of the artist and Bullseye Gallery

59 (pg. 156)
Razzle Dazzle Boat with Shark Fin, 2012
Fused and wheel-cut glass, slab technique
8 1/2 x 19 1/4 x 5 in. (21.6 x 48.9 x 12.7 cm)
Collection of the artist
Photo by Richard Marquis

54 (pg. 155)
Bottle with Stopper, 1976
Fused glass and cork
6 1/2 x 8 in. (16.5 x 20.3 cm)
Collection of Powerhouse Museum, Sydney, Australia (A6552), purchased 1976
Photo courtesy of Powerhouse Museum

55 (pg. 24)
Marquiscarpa #29, 1991
Fused, slumped, blown, and wheel-cut glass, murrine technique

6 1/2 x 8 1/2 x 3 in. (16.5 x 21.6 x 7.6 cm)
Collection of Johanna Nitzke Marquis
Photo by Richard Marquis

56 (pg. 14)
Elephant in Boat on Wheels, 2004–2009
Blown and sculpted glass, granulare technique and hot-slab construction
12 3/4 x 19 1/2 x 6 1/2 in. (32.4 x 49.5 x 16.5 cm)
Collection of Dante and Alison Marioni
Photo by Russell Johnson

RICHARD MARQUIS AND DANTE MARIONI

60–62 (pg. 21)
Three Goblets, 1994
Blown glass
Tallest of three: 10 1/4 in. (26 cm)
Collection of Powerhouse Museum, Sydney, Australia (94/104/1, 94/104/2, 94/104/3)
Photo by Scott Donkin, courtesy of Powerhouse Museum

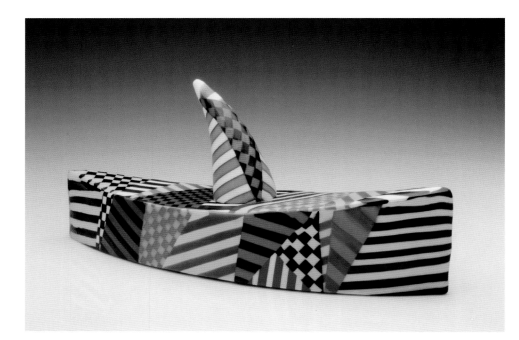

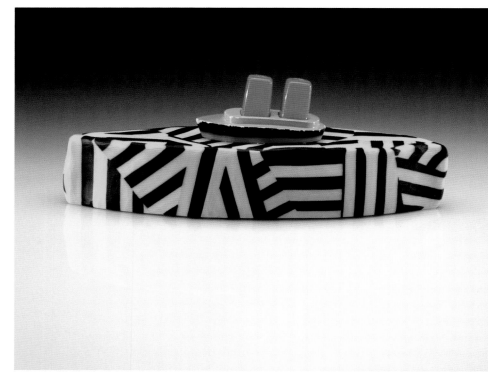

KLAUS MOJE

Born 1936 in Hamburg, Germany; lives in Wapengo, NSW.

63 (pg. 64)
Untitled, 1978
Fused, kiln-formed, and wheel-cut glass
3 x 18 ¹/₂ in. (7.6 x 47 cm)
Collection of Ruth T. Summers
and Bruce W. Bowen
Photo courtesy of Bullseye Gallery

64 (pg. 65)
Untitled [Double Diamond], 1987
Fused, kiln-formed, and wheel-cut glass
2 ¹/₂ x 19 ³/₄ in. (6.4 x 50.2 cm)
Manocherian Collection
Photo courtesy of Bullseye Gallery

65 (pg. 67)
With Dante Marioni
Orange Vessel, 1993
Fused, kiln-formed, and blown glass
22 x 8 in. (55.9 x 20.3 cm)
Collection of Dante and Alison Marioni
Photo by Russell Johnson

66 (pg. 71)
With Scott Chaseling and Kirstie Rea
Niijima 10/99-B-1, 1999
Kiln-formed and blown glass
21 ¹/₄ x 5 ³/₄ in. (54 x 14.6 cm)
Lent by The Corning Museum of Glass, Corning, New York, The 14th Rakow Commission (99.6.8)
Photo courtesy of The Corning Museum of Glass

TOP: Richard Marquis, *Razzle Dazzle Boat with Shark Fin*, 2012 (cat. 59)

BOTTOM: *Razzle Dazzle Boat with Salt and Pepper Shakers*, 2009 (cat. 57)

Born 1971 in Canberra, ACT; lives in Adelaide, SA.
MooreIsMore.com

70 (pg. 35)
Little Known Facts, 2004
Blown and solid glass
17 ³/₄ x 12 ³/₄ x 12 ¹/₄ in. (45.1 x 32.4 x 31.1 cm)
Collection of Powerhouse Museum, Sydney,
Australia (2005/188/1), purchased with funds
donated by Diana Laidlaw, 2005
Photo by Nitsa Yioupros, courtesy of
Powerhouse Museum

71 (pgs. 36–37)
Massive Hooligan, 2007
Hot-joined blown and solid glass
13 ³/₈ x 10 ¹/₄ x 5 ⁷/₈ in. (34 x 26 x 15 cm)
Collection of Queensland Art Gallery, Queensland,
Australia, purchased with funds from the Perpetual
Foundation Beryl Graham Family Memorial
Gift Fund and Robert MacPherson through the
Queensland Art Gallery Foundation (2009.126)

72 (pg. 34)
Plant-Powered Island, 2008
Blown and solid glass, steel, and wood
Without shelf: 20 ¹/₂ x 14 ³/₁₆ x 4 ³/₄ in.
(52 x 36 x 12 cm)
Collection of the artist
Photo by Grant Hancock

73 (pg. 157)
Armour 3, 2012
Blown and solid glass, steel, and wood
Without shelf: 17 ⁵/₁₆ x 13 ³/₈ x 7 ¹/₁₆ in.
(44 x 34 x 18 cm)
Collection of the artist
Photo by Grant Hancock

67 (pgs. 1, 162)
Untitled 2003–05 (from *Impact Series*), 2003
Fused, kiln-formed, and wheel-cut glass
3 x 21 in. (7.6 x 53.3 cm)
Manocherian Collection
Photo courtesy of Bullseye Gallery

68 (pg. 127)
Untitled #10, 2005
Fused, kiln-formed, and wheel-cut glass
3 x 21 in. (7.6 x 53.3 cm)
David Kaplan - Glenn Ostergaard Glass Collection
Photo courtesy of Bullseye Gallery

69 (pgs. 110–11)
The Portland Panels: Choreographed Geometry, 2007
Kiln-formed and diamond-polished glass
Each panel: 74 ¹/₂ x 47 ¹/₂ x 2 ⁵/₈ in.
(189.2 x 120.7 x 6.7 cm)
David Kaplan—Glenn Ostergaard Glass Collection,
Photo courtesy of Bullseye Gallery

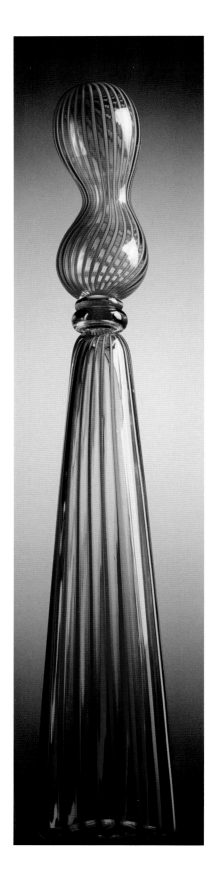

NICK MOUNT

Born 1952 in Adelaide, SA; lives in Adelaide, SA.
nickmountglass.com.au/

74 (pg. 18)
Cylinders and Funnels, 1980
Blown glass
a: 10 $^1/_4$ x 2 $^3/_4$ in. (26 x 7 cm)
b: 10 x 3 in. (25.4 x 7.6 cm)
c: 7 $^3/_4$ x 5 $^3/_4$ in. (19.7 x 14.6 cm)
d: 6 $^1/_2$ x 6 $^1/_4$ in. (16.5 x 15.9 cm)
Collection of Queensland Art Gallery,
Queensland, Australia, purchased 1980 with
funds from ACI International Limited through the
Queensland Art Gallery Foundation (4:0557a-d)
Photo courtesy of Queensland Art Gallery

75 (pg. 158)
Scent Bottle, 1997
Blown glass, cut, polished, and assembled
29 in. (73.7 cm)
Collection of Lorraine Sheppard
Photo by Grant Hancock

76 (pg. 19)
Scent Bottle, 1998
Blown glass, cut, polished, and assembled
25 $^1/_4$ in. (64.1 cm)
Collection of Barrie and Anne Harrop
Photo by Grant Hancock

77 (pg. 17)
Scent Bottle #060907, 2007
Blown glass, cut, polished, and assembled
Overall, four pieces: 15 $^3/_4$ x 17 $^3/_4$ x 3 $^1/_2$ in.
(40 x 45.1 x 8.9 cm)
Collection of the artist
Photo by Grant Hancock

STEPHEN PROCTER

Born 1946 in Sussex, England; died in 2002 in
Carwoola, SA. StephenProcter.net

78 (pgs. 54, 55)
Intermedian, 1996
Blown, cut, and engraved glass
7 $^1/_{16}$ x 27 $^9/_{16}$ x 10 $^{13}/_{16}$ in. (18 x 70 x 27.5 cm)
Collection of Canberra Museum and Gallery,
Canberra, Australia (2001.13.1)
Photo by Rob Little, courtesy of Canberra
Museum and Gallery

79 (pg. 159)
Opposite + Equal 1, 1998
Kiln-formed, blown, and carved glass
4 x 11 x 11 in. (10.2 x 27.9 x 27.9 cm)
Collection of Lani McGregor and Daniel
Schwoerer
Photo courtesy of Bullseye Gallery

80 (pg. 57)
Walking Through, 2000
Fused, blown, cut, and engraved glass
9 $^1/_{16}$ x 10 $^5/_8$ x 3 $^9/_{16}$ in. (23 x 27 x 9 cm)
Collection of Christine Procter
Photo by Rob Little, courtesy of Christine Procter

KIRSTIE REA

Born 1955 in Tamworth, NSW;
lives in Adelaide, SA.

81 (pg. 68)
Myth or Memory, 2001
Kiln-formed and lathe-cut glass

3 ¹⁵/₁₆ x 24 x 3 ³/₄ in. (10 x 61 x 9.5 cm)
Collection of Canberra Museum and Gallery,
Canberra, Australia (2001.14.1)
Photo by Rob Little, courtesy of Canberra Museum
and Gallery

82 (pg. 69)
Fine Line II, 2004
Kiln-formed and lathe-cut glass
Each of four pieces: 3 ¹/₂ x 20 ¹/₂ X 5 in. (8.89 x
52.07 x 12.7 cm)
Courtesy Palette Contemporary Art and Craft,
Albuquerque, New Mexico

Photo by David Paterson, courtesy of Palette
Contemporary Art and Craft

83 (not illustrated)
Orchard Rows II, 2012
Kiln-formed and engraved glass
Overall: 47 ¹/₄ x 23 ⁵/₈ x 1 ³/₈ in. (120 x 60 x 3.5 cm)
Courtesy of the artist and Bullseye Gallery,
Portland, Oregon

TOM ROWNEY

Born 1971 in Adelaide, SA; lives in Captains Flat
and NSW.

84 (pgs. 48, 49)
Red, black with white incalmo bowl 2008 #11, 2008
Blown glass with cane work
10 ¹/₄ x 14 ¹/₄ in. (26 x 36.2 cm)
Courtesy of the artist and Sabbia Gallery,
Sydney, Australia
Photo courtesy of Sabbia Gallery

85 (pg. 47)
Black and white merletto bowl 2008 #13,
2008
Blown glass with cane work
14 ¹/₄ x 14 ¹/₄ in. (36.2 x 36.2 cm)
Courtesy of the artist and Sabbia Gallery,
Sydney, Australia
Photo courtesy of Sabbia Gallery

86 (not illustrated)
Maelstrom series: Red oval form, 2009
Blown glass with cane work
7 ³/₄ x 16 ⁹/₁₆ x 7 in. (19.7 x 42 x 17.8 cm)
Collection of National Gallery of Australia,
Canberra, gift of Sandy and Phillip Benjamin
(2010.264)

APRIL SURGENT

Born 1982 in Missoula, Montana; lives in Seattle,
Washington. AprilSurgent.com

87 (pg. 108)
I'll Think of You From There, 2007

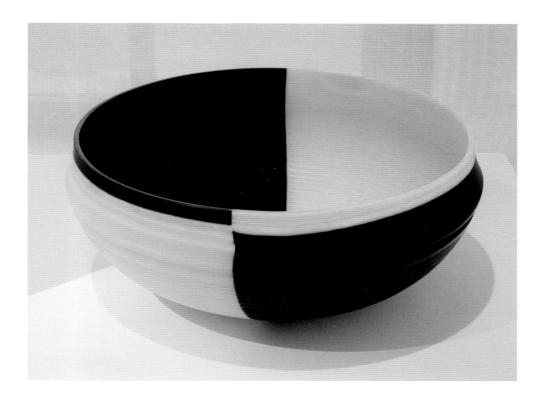

Fused and cameo-engraved glass
19 3/4 x 50 1/2 x 2 1/4 in. (50.2 x 128.3 x 5.7 cm)
Collection of Lani McGregor and Daniel Schwoerer
Photo by R. Watson, courtesy of Bullseye Gallery

JANICE VITKOVSKY

Born 1977 in Adelaide, SA; lives in Adelaide, SA.

88 (pgs. 102–3)
Transition, 2008
Fused, carved, and hand-finished glass
7 1/2 x 12 13/16 x 1 3/8 in. (19 x 32.5 x 3.5 cm)
Collection of Andy and Deidre Plummer
Photo by Christian Mushenko

89 (pg. 160)
Depth of Immersion 1-Amber, 2009
Fused, carved, and hand-finished glass
22 13/16 x 7 7/8 x 1 9/16 in. (58 x 20 x 4 cm)
David Kaplan-Glenn Ostergaard Glass Collection
Photo by David Glomb

90 (pg. 100)
Saturation II, 2010
Fused, carved, and hand-finished glass
18 7/8 x 23 1/4 x 9/16 in. (48 x 59 x 1.5 cm)
Courtesy of the artist and Sabbia Gallery,
Sydney, Australia
Photo by Grant Hancock

RICHARD WHITELEY

Born 1963 in East Dean, England; lives in
Queanbeyan, ACT. richardwhiteley.com

91 (pgs. 92–93)
Solid Light, 2005
Cast glass
6 5/16 x 11 13/16 in. (16 x 30 cm)
Collection of Jon and Judith Liebman

92 (pgs. 94, 95)
Orb, 2008
Cast and cold-worked glass
15 3/4 x 14 7/8 x 51 3/16 in. (40 x 37.8 x 130 cm)
Collection of Serge and Isabelle Wittock-Merenne

93 (pg. 6)
Light Mass, 2011
Cast glass
14 1/4 x 14 1/4 x 4 1/2 in. (36.2 x 36.2 x 11.4 cm)
Collection of Lani McGregor and Daniel Schwoerer

94 (pgs. 122, 161)
Arch, 2012
Cast glass and metal
69 x 24 x 13 in. (175.3 x 61 x 33 cm)
Courtesy of the artist and Bullseye Gallery,
Portland, Oregon

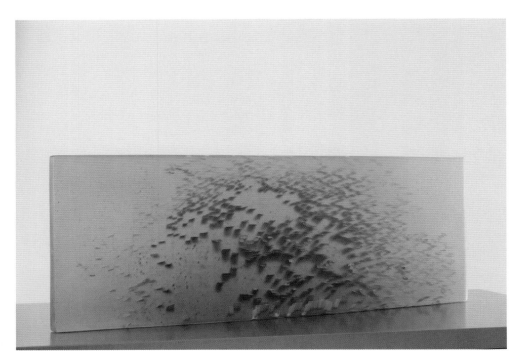

Janice Vitkovsky, *Depth of Immersion-1 Amber*,
2009 (cat 89)

OPPOSITE: Richard Whiteley, *Arch* (detail), 2012
(cat. 94)

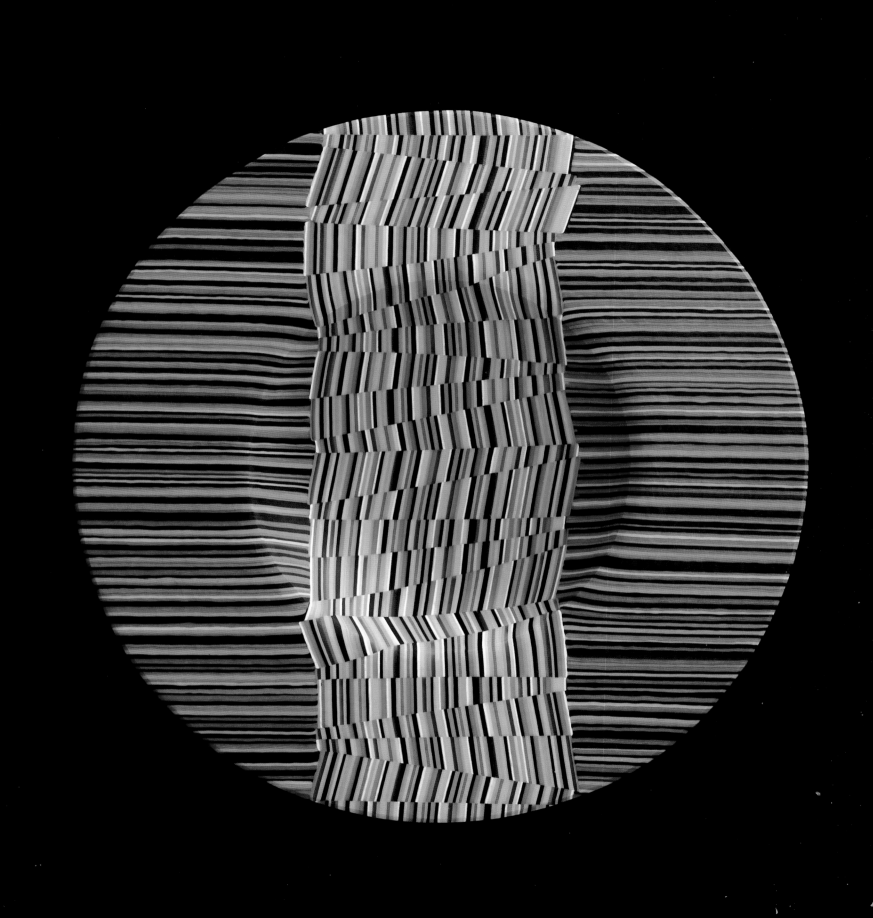

ILLUSTRATION CREDITS

p. 10 Photo courtesy of Nick Mount.

p. 11 Designed by Arthur Leydin (Australian, 1950–2002), 24 x 17 in. (61 x 43.7 cm). Collection of Richard Marquis. Photo by Richard Marquis.

p. 12 Richard Marquis, *Pistol*, 1976. Glass and candy, 11 1/2 x 5 1/2 in. (29 x 14 cm). Collection of Queen Victoria Museum and Art Gallery, Launceston, Tasmania, Australia. Photo by John Leeming.

p. 16 Nick Mount, Budgeree glass goblets, production line, 1980s. Cold-finished, mold-blown bowl with Kugler powder-colored stem; height: 7 in. (17.78 cm). Photo courtesy of Nick Mount.

p. 25 Photo courtesy of Klaus Moje.

p. 61 Photo by Russell Johnson, courtesy of Nadège Desgenétez.

p. 62 Richard Whiteley. *Klaus Moje*, 1990. Made at Pilchuck Glass School print studio. Glass plate monotype, 15 x 9 3/4 in. (38.5 x 25.5 cm). Collection of Klaus Moje. Photo by Greg Piper, courtesy of Richard Whiteley.

p. 66 Photo courtesy of Bullseye Glass Co.

p. 110 Photo courtesy of Klaus Moje.

p. 112 Photo courtesy of Bullseye Gallery.

p. 115 Photo courtesy of Klaus Moje.

p. 118 Photos courtesy of Bullseye Glass Co.

P. 119 Photo by Jerry Hart, courtesy of Bullseye Glass Co.

P. 120 Photo by Brigitte Enders.

p. 128 Photo courtesy of Stephen Skillitzi.

p. 130 top Photo by Don Gazzard.

p. 130 bottom photo by Max Dupain & Associates, Mitchell Library, State Library of NSW.

p. 131 photo by Grace Cochrane.

p. 132 left Sam Herman (American, born 1936). *Dish*, 1978. Mold-blown glass, 3 9/16 x 13 3/8 x 10 1/4 in. (9 x 34 x 26 cm). Wagga Wagga Art Gallery, National Art Glass Collection. Donated through the Australian Government's Cultural Gifts Program by Joyce Kerfoot. Photo courtesy of Wagga Wagga Art Gallery.

p. 132 right Warren Langley (Australian, born 1950), *Druid site XXXIII*, 1986. Kiln-formed glass, 18 1/4 x 17 11/16 x 2 15/16 in. (46.3 x 45.0 x 7.5 cm). Wagga Wagga Art Gallery, National Art Glass Collection. Purchase funded by Wagga Wagga City Council and NSW Ministry for the Arts. Photo courtesy of Wagga Wagga Art Gallery.

p. 133 Photo courtesy of Rob Knottenbelt.

pp. 134/5 Photo courtesy of the National Gallery of Australia Library.

p. 136 Stephen Skillitzi (Australian, born 1947), *Freedom's Dream*, 1982. Blown glass, metal, and clay, 30 5/16 x 9 1/16 in. (77 x 23 cm). Wagga Wagga Art Gallery, National Art Glass Collection. Donated through the Australian Government's Cultural Gifts Program by Joyce Kerfoot. Photo by Don Gazzard courtesy of Wagga Wagga Art Gallery.

p. 137 Maureen Cahill (Australian, born 1947), from the *Block Series*, 1975. Made in Stourbridge, UK. Kiln-fired, cut, and polished glass, 3 1/8 x 3 1/8 x 1 9/16 in. (8 x 8 x 4 cm) each. Collection of the artist. Photo by Grace Cochrane.

p. 139 Brian Hirst (Australian, born 1956), *Hunting and Gathering Bowl*, 1982. Blown, sand-cast, and engraved glass, with fired-on burnishing gold, 8 11/16 x 9 7/16 in. (22 x 24 cm). Wagga Wagga Art Gallery, National Art Glass Collection. Donated through the Australian Government's Cultural Gifts Program by Joyce Kerfoot. Photo courtesy of Wagga Wagga Art Gallery.

p. 140 Tony Hanning (Australian, born 1950), *Blue vase (Treescape)*, 1981. Carved and engraved cased glass (blown by Nick Mount), 9 7/16 x 5 1/4 x 5 1/8 in. (24 x 13.3 x 13 cm). Wagga Wagga Art Gallery, National Art Glass Collection. Purchase funded by Wagga Wagga City Council. Photo courtesy of Wagga Wagga Art Gallery.

p. 142/3 photo by Don Gazzard.

Klaus Moje, *Untitled 2003-05 (from Impact Series)*, 2003 (cat. 67)

BIBLIOGRAPHY

Abraham, Felicity, ed. *The Crafts in Australia: Report of the Committee of Enquiry into the Crafts* (the Crafts Enquiry). Sydney: Crafts Board Australia Council, 1975.

Anderson, Nola. *Australian Kilnformed Glass.* Los Angeles: Kurland/Summers Gallery, 1989.

———. "Glass Roots—Australian Studio Glass History as Contemporary Narrative." In *Craft in Society: An Anthology of Perspectives,* edited by Noris Ioannou. South Fremantle, Australia: Fremantle Arts Centre Press, 1992 (first published in Crafts NSW, 1991).

Bayley, Mark. *Material Culture: Aspects of Contemporary Australian Craft and Design.* Canberra: National Gallery of Australia, 2002.

———. *Rare Earth: Scott Chaseling and Kirstie Rea: Context and Conversation.* Sydney: Object, undated.

———. "Shadow-field: The Synthesis of Light and Shade in the Art of Kirstie Rea." In *The Colour of Air, The Scent of Light: Works by Kirstie Rea.* Canberra, 2004.

Bell, Robert. *International Directions in Glass Art.* Australian Consolidated Industries in conjunction with the Art Gallery of Western Australia, 1982.

Bottari, Megan. *Klaus Moje: Glass.* In *Living Treasures Masters of Australian Craft* series. Sydney: Craftsman House, 2006.

Cochrane, Grace. "Being Australian: Adding Value: What Makes Australian Glass Australian, and Where Is It Going?" Paper presented to Ausglass conference, Wagga Wagga, January 1999.

———. "Beyond Face Value: Richard Whiteley." *Craft Arts International* 58 (2003): 42–45.

———. "Collecting Our Thoughts." *Art Monthly Australia* (June 1993).

———. *The Crafts Movement in Australia: A History.* Sydney: New South Wales University Press, 1992.

———. "From Seat of the Pants to State of the Art: Artists, Manufacturers and Making Glass." In Osborne, *Australian Glass Today,* 30–35.

———. "Function." *Ceramics: Art and Perception* 5 (1991). Paper presented to Ausglass conference, Sydney, 1991.

———. "Giles Bettison." *Neues Glas/New Glass* 4 (1998): 26–31.

———. "Giles Bettison, Richard Whiteley, Deb Cocks." *Glass* 68 (Fall 1997).

———. *Smart Works: Design and the Handmade.* Sydney: Powerhouse Museum, 2007.

———. "Tim Edwards." *Glass Quarterly,* no. 103 (Summer 2006): 36.

Cook, Robert. *Translucence Contemporary Glass.* Perth: Art Gallery of Western Australia, 2012.

Cotton, Belinda. "Between the Lines" [Mel Douglas]. *Craft Arts International* 50 (2003): 38–40.

Duologue: Clare Belfrage and Tim Edwards. Adelaide: JamFactory Contemporary Craft and Design, 2008.

Edwards, Geoffrey. *Art of Glass: Glass in the Collection of the National Gallery of Victoria.* Melbourne: National Gallery of Victoria and Macmillan Publishers, 1998.

———. *GlassState 2001.* Adelaide: JamFactory Contemporary Craft and Design, 2001.

———. *The Glass World of Klaus Moje.* Hsunchu, Taiwan: Hsin Chu Municipal Glass Museum, 2001.

———. *Klaus Moje Glass: A Retrospective Exhibition.* Melbourne: National Gallery of Australia, 1995.

———. "Old Traditions Revived in a New Millennium." In Osborne, *Australian Glass Today,* 25–29.

"Edols and Elliott" interview. *Australian Art Review* (November 2007–February 2008): 73–77.

E-Merge 2006: A Showcase of Rising Talents in Kiln-Glass. Portland, OR: Bullseye Glass Co., 2006.

Ewington, Julie. *Moore Is More.* Adelaide: JamFactory Contemporary Craft and Design, 2009.

Finch, Karen. "Cobi Cockburn." *Artlink* 28, no. 2 (2008): 46–47.

Fitzpatrick, Kirsten. *At the Edge: Australian Glass Art.* Munich: Brisbane City Gallery and Galerie Handwerk, 2002.

———. *Aura: Clare Belfrage.* Sydney: Quadrivium Gallery, 2002.

Flux: Benjamin Edols and Kathy Elliott at Bullseye Gallery. Portland, OR: Bullseye Glass Co., 2000.

Frantz, Susanne K. *Contemporary Glass: A World Survey from the Corning Museum of Glass.* New York: Abrams, 1989.

————. "Notes from a Distant Observer." In Osborne, *Australian Glass Today*, 36–39.

Glass Art Society Journal: Adelaide, Australia. Seattle: Glass Art Society, 2005. Includes articles by Clare Belfrage, Scott Chaseling, Kathy Elliott, Jessica Loughlin, Klaus Moje, Tom Moore, and Richard Whiteley, among others.

Gavens, Fiona. *Discussion Paper on the Glass Situation in Australia.* Sydney: Crafts Board of the Australia Council, 1978.

Guenther, Bruce. "Between Gravity and Light." In *Jessica Loughlin: Shifting Views.* Portland, OR: Bullseye Glass Co., 2005.

Guenther, Bruce and Dan Klein. *Klaus Moje.* Portland, OR: Portland Art Museum, 2008.

Halper, Vicki and Diane Douglas, eds. *Choosing Craft: The Artist's Viewpoint.* Chapel Hill: University of North Carolina Press, 2009.

Hanning, Tony. *Nick Mount: The Fabric of Work, Living Treasures: Masters of Australian Craft.* Sydney: Object: Australian Centre for Craft and Design, 2012.

Hendry, Shaw. "The Shape of Breath" [Gabriella Bisetto]. *Craft Arts International* 73 (2008): 58–62.

Hinchcliffe, Meredith. "Scott Chaseling and Kirstie Rea." *Craft Arts International* 52 (2001): 56–60.

————. "Edols and Elliott." *Craft Arts International* 47 (1999–2000): 54–58.

————. "Richard Whiteley." *Craft Arts International* 50 (2000): 38–42.

Hokkaido Museum of Modern Art, *World Glass Now.* Hokkaido: Hokkaido Museum of Modern Art, catalogues of triennial surveys from 1982.

Ioannou, Noris. *Australian Studio Glass: The Movement, Its Makers and Their Art.* Sydney: Craftsman House, in association with G+B Art International, 1995.

International Young Artists in Glass: Australia (Giles Bettison, Claudia Borella, Jessica Loughlin, Mel George). Portland, OR: Bullseye Glass Co., 1998.

Jessica Loughlin at Bullseye Glass. Portland, OR: Bullseye Glass Co., 2002. Essays by Grace Cochrane and Susanne K. Frantz.

Jiri Harcuba and April Surgent: Traces of Ourselves. Portland, OR: Bullseye Glass Co., 2008.

King, Gerry. "Crafting a Career" [Clare Belfrage]. *Craft Arts International* 48 (2000): 30ff.

————. "A Fortuitous Vocation" [Nick Mount]. *Craft Arts International* 44 (1998–99): 51–56.

Klein, Dan. *Artists in Glass: Late Twentieth Century Masters in Glass.* London: Mitchell Beazley, 2001.

————. *Glass: A Contemporary Art.* New York: Rizzoli, 1989

Latitudes: Bullseye Glass in Australia. Canberra: Canberra School of Art, Australian National University, 1998. Essays by Merryn Gates, Nigel Lendon, Lani McGregor, Kirstie Rea, and David Williams.

Litson, Jo. "Fused Together: Education and Industry, Canberra School of Art Glass Workshop and the Bullseye Connection." *Object Magazine* 42 (June 2003): 49–56.

Lundstrom, Boyce and Daniel Schwoerer. *Glass Fusing, Book One.* Colton, OR: Vitreous Group/Camp Colton, 1983 (second printing 1987).

Marquis, Richard. "What I Did on My Summer Vacation in Australia 31 Years Ago," *Glass Art Society Journal,* Adelaide, Australia (2005): 9–13.

McFadden, David. "Glass Works: The Work of Giles Bettison." *Object Magazine* 39 (2003): 25–32.

McMahon, Ann. "In the Presence of Blue: Kirstie Rea's Transcendent Source of Inspiration." *Craft Arts International* 76 (2009).

Morgan, Robert C. *Jane Bruce: Contained Abstraction.* Portland, OR: Bullseye Glass Co., 2008.

National Art Glass Collection from the Collection of City Art Gallery, Wagga Wagga. Wagga Wagga, New South Wales: City Art Gallery, 1995. Essays by Robert Bell, Noris Ioannou, and Judy Le Lievre.

National Museum of Modern Art, Kyoto. *The Beauty of Contemporary Glass: Australia, Canada, the United States and Japan.* Kyoto: National Museum of Modern Art, 1981.

New Narratives: Glass Works by Scott Chaseling. Canberra: Australian National University School of Art, 2003.

Oldknow, Tina. *Dante Marioni: Blown Glass.* New York: Hudson Hills, 2000.

———. *Pilchuck: A Glass School*. Seattle: Pilchuck Glass School and University of Washington Press, 1996.

———. "The Rakow Commission (Tim Edwards)." *New Glass Review* 28 (2006): 100–101.

———. *Richard Marquis Objects*. Foreword by Vicki Halper. Seattle: Distributed by University of Washington Press, 1997.

Osborne, Margot. *Australian Glass Today*. Adelaide: Wakefield Press, 2005.

———. "The Glass Art of Klaus Moje: Disciplined Emotion." *Neues Glas/New Glass*, no. 4 (2008): 18–25.

———. "Janice Vitkovsky: A Creative Journey Comes to Fruition." *Craft Arts International* 77: 52–55.

———. "Klaus Moje: Swimming Above the Water." In Sear and Ewington, *Brought to Light II*, 140–45.

———. *Mind and Matter: Meditations on Immateriality*. Adelaide and Sydney: JamFactory Contemporary Craft and Design and Object: Australian Centre for Craft and Design, 2010.

———. *Nick Mount: Incandescence*. Adelaide: Wakefield Press, 2002.

———. *Permutations: Five Australian Glass Artists* (Clare Belfrage, Giles Bettison, Gabriella Bisetto, Tim Edwards, Mark Thiele). Adelaide and Seattle: JamFactory Contemporary Craft and Design and Foster/White Gallery, 2003.

———. *The Return of Beauty*. Adelaide: JamFactory Contemporary Craft and Design, 2000.

Peoples, Sharon. "Nostalgia of Transition: Jeremy Lepisto." *Craft Arts International* 82 (2011): 18–22.

Perreault, John. "Jane Bruce: The Search for a Place." *Glass* 64 (Fall 1996): 28ff.

Prest, Cedar. "Glass and Its Development." *Craft Australia* 3 (Spring 1979): 13–16.

Procter, Christine and Itzell Tazzyman, eds. *Stephen Procter: Lines through Light*. RLDI and Christine Procter, 2008.

Proximity: Giles Bettison. Portland, OR: Bullseye Glass Co., 2003. Essays by Giles Bettison, Lani McGregor, Margot Osborne, and Ian Were.

Ranamok Glass Prize. Sydney: Ranamok Glass Prize, Ltd., 2004–12.

Reade, Catherine. "An Irresistible Synthesis" [Tom Rowney]. *Craft Arts International* 67 (2006): 26-31.

Richard Whiteley. Canberra, 2009. Essays by Tina Oldknow and Dan Klein.

Sear, Lynne and Julie Ewington, eds. *Brought to Light II*. Brisbane: Queensland Gallery Publishing, 2007.

Smith, Penny. "'Technique is not so cheap'—Dick Marquis." *Pottery in Australia* 16, no. 2 (1977): 29–33.

Thompson, Mark. *With Care: First Ausglass Exhibition*. Adelaide: Jam Factory Workshops, 1979.

Toledo Museum of Art, *American Glass Now*. Toledo, OH: Toledo Museum of Art and American Crafts Council, 1972.

Tom Malone Prize. Perth: Art Gallery of Western Australia, 2003–12.

Tour de Force: In Case of Emergency Break Glass. Wagga Wagga: Wagga Wagga Regional Art Gallery, 2010.

Vignando, Catrina. "Leaves of Glass: New Work by Cobi Cockburn." *Craft Arts International* 69 (2007): 52ff.

———. *Whispers: Glass Works by Cobi Cockburn*. Canberra, 2007.

Waggoner, Shawn. "Fragile Colors: Scott Chaseling's New Narratives." *Glass Art* (May/June 2003): 6ff.

———. "Glass City: April Surgent's Fused and Cameo-Engraved Panels." *Glass Art* (2007).

Ward, Lucina. "Klaus Moje: Master Glass Artist in Australia." In Edwards, *The Glass World of Klaus Moje*.

White Hot: Contemporary Australian Glass. Melbourne and Canberra: Asialink, Craft ACT/Canberra Glassworks, 2008.

Whiteley, Richard. "Along a Different Parallel." In Osborne, *Australian Glass Today,* 20–24.

Whiteley, Richard and Ann Jakle. "Biographical Notes" and "Klaus Moje Thirty Years' Exploration in Glass." *Glass Art Society Journal* (2000): 46–53.

Zimmer, Jenny. *Glass from Australia and New Zealand*. Catalog for the Hessisches Landesmuseum in Darmstadt, Germany. Craft Arts Pty, 1984.

———. *Stained Glass in Australia*. Melbourne: Oxford University Press, 1984.

INDEX

Page numbers followed by an *f* denote an illustration.

THIS PUBLICATION WAS GENEROUSLY SUPPORTED BY

BEN B. CHENEY FOUNDATION

BEN B. CHENEY FOUNDATION
"Helping people and their communities"

THIS PROJECT HAS BEEN ASSISTED BY THE AUSTRALIAN GOVERNMENT THROUGH
THE AUSTRALIA COUNCIL FOR THE ARTS, ITS ARTS FUNDING AND ADVISORY BODY

Australian Government

Australia Council
for the Arts

AUSTRALIAN NATIONAL UNIVERSITY,
CANBERRA SCHOOL OF ART

Australian
National
University

SCHOOL OF ART

DAVID KAPLAN AND GLENN OSTERGAARD

CRAFT AUSTRALIA

ROBERT LEHMAN FOUNDATION

BULLSEYE GLASS CO.

BULLSEYE
GLASS CO.

MUSEUM OF GLASS BOARD OF TRUSTEES